THE FAUN
IN THE GARDEN

THE FAUN
IN THE GARDEN

Michelangelo and the
Poetic Origins
of Italian Renaissance Art

Paul Barolsky

THE PENNSYLVANIA STATE UNIVERSITY PRESS
University Park, Pennsylvania

ALSO BY PAUL BAROLSKY

Giotto's Father and the Family of Vasari's *Lives*
Why Mona Lisa Smiles and Other Tales by Vasari
Michelangelo's Nose: A Myth and Its Maker
Walter Pater's Renaissance
Daniele da Volterra: A Catalogue Raisonné
Infinite Jest: Wit and Humor in Italian Renaissance Art

Library of Congress Cataloging-in-Publication Data

Barolsky, Paul
 The faun in the garden : Michelangelo and the poetic origins of
Italian Renaissance art / Paul Barolsky.

 p. cm.
 Includes bibliographical references and index.
 ISBN 0-271-01303-6
 1. Michelangelo Buonarroti, 1475–1564. 2. Artists—Italy
—Biography. 3. Ut pictura poesis (Aesthetics) 4. Art, Renaissance
—Italy. 5. Art, Italian. I. Title.
 N6923.B9B35 1994
 700'.92—dc20
 [B] 93-27551
 CIP

Published by The Pennsylvania State University Press,
University Park, PA 16802-1003

It is the policy of The Pennsylvania State University Press to use acid-free paper for
the first printing of all clothbound books. Publications on uncoated stock satisfy the
minimum requirements of American National Standard for Information Sciences—
Permanence of Paper for Printed Library Materials, ANSI Z39.48–1984.

For all my students, past and present,
who are in many ways the originators of this book.

There the beeches stretch themselves, with other trees, toward heaven; there they spread a thick shade with their fresh green foliage; there the earth is covered with grass and dotted with flowers of a thousand colors; there, too, are clear fountains and argent brooks that fall with a gentle murmur from the mountain's breast. There are gay songbirds, and the boughs stirred to a soft sound by the wind, and playful little animals; and there are flocks and herds, the shepherd's cottage or the little hut untroubled with domestic cares; and all is filled with peace and quiet. Then, as these pleasures possess both eye and ear, they soothe the soul; then they collect the scattered energies of the mind, and renew the power of the poet's genius . . .

 —Boccaccio, *Genealogy of the Gods*

And, after all, the idea may have been no dream, but rather a poet's reminiscence of a period when man's affinity with nature was more strict, and his fellowship with every living thing more intimate and dear.

 —Nathaniel Hawthorne, *The Marble Faun*

CONTENTS

LIST OF ILLUSTRATIONS

PHOTO CREDITS

PREFACE

A pendant to *Michelangelo's Nose*, in particular, this book is a continuation of the discussion begun in general in my Vasari trilogy (which also comprised *Why Mona Lisa Smiles* and *Giotto's Father*). In the first volume, I focused on the autobiography of Michelangelo—that is, the "life" he dictated to his disciple Condivi. Art historians had always casually recognized that Condivi's biography was "autobiographical," reflecting Michelangelo's own version of his life, but, as I suggested, they radically underestimated the poetical richness of that autobiography, which we still have not fully mined. Returning to it here, I wish to emphasize that at this late date Michelangelo's autobiography is still either ignored or undervalued by scholars of literature. No matter that Condivi's voice intrudes clumsily at times in the narrative. Despite its flaws and brevity, it is a major work of Renaissance literature, if for no other reason than that it is the autobiography of one of the greatest poets and artists of all time. It is a work rich in poetic fantasy. Even so, it still has no place either in the history of Italian Renaissance literature, as currently written, or, even more remarkably, in the rapidly expanding body of criticism of biography and autobiography. This is itself an extraordinary fact, given the centrality of Michelangelo not only in the history of Italian Renaissance culture but also in the history of the modern idea of the artist.

Michelangelo's autobiography brings us back once again to Giorgio Vasari, since it was Vasari's *Lives* of the artists (1550), culminating in

the biography of the heroic Michelangelo, which seemingly prompted Vasari's hero to dictate the story of his own life to Condivi (1553). When I used "A Myth and Its Maker" as the subtitle for *Michelangelo's Nose*, I did so ambiguously, for if Michelangelo gave shape to himself in his art and behavior, influencing Vasari's manner of speaking of him, Vasari's initial biography served as the template for Michelangelo's autobiography. Michelangelo was more than happy to exploit the poetic fictions of Vasari's biography—despite his dissatisfaction with details in the earlier account. Although scholars have in recent years become increasingly sensitive to the rhetoric of Vasari's *Lives*, they still accept many fictions in this biography as literal truth, just as they yield to the tall tales in Michelangelo's version of events, as if Vasari and Condivi were telling us "what really happened." Who ever said, in our age of radical skepticism, that literal-mindedness was dead? Scholars still want to force Vasari into the mold of "documentary source," to read him as a sixteenth-century positivist, recording the facts.

It is not my purpose, however, to dwell on the misreading of Vasari or Michelangelo (through Condivi). Rather, I want to pursue the investigation of their closely interrelated poetic imaginations in order to show how their fantasies illuminate a broad network of literary and artistic phenomena of the Renaissance. By examining Vasari's biography of Michelangelo and Michelangelo's autobiography in relation to the histories of Renaissance art and literature in general, we come to see the connections between seemingly diverse phenomena that otherwise escape us. I am interested, in what follows, in poetry in the root sense of the Greek *poiesis* as "making." The "Michelangelo" of Vasari's biography is a poetical fabrication of Vasari's making, just as the Vasarian "Michelangelo" of the artist's own autobiography is such a poetical construction, based on Vasari's "Michelangelo." To ask who created "Michelangelo"—Michelangelo himself or Vasari—is like asking which came first, the chicken or the egg. The implication of our procedure here is to see biography as a branch of poetry. Such a tack is helpful in various respects. When we speak, for example, of the "myths" or legends in Vasari's biographies, the word "myth" still has negative connotations—because myth supposedly obscures reality. When we approach these myths as poetry, however, indeed as *mythopoiesis*, we recognize the positive character of these creations as imaginative acts, as art. We further come to see, in a positive light,

how Michelangelo transformed conventions—remaking them in fact. By dwelling on the poetry of biography, we can recognize poetical originality, invention, or novelty that otherwise escaped us.

Biography is story or *istoria,* the history of a person, and, since this is so, we should recognize that, like biography, history in general is a form of poetry. Just as we cannot examine the biography of Michelangelo as independent from poetry, so we cannot fully explore Michelangelo's biography, his history, apart from the larger history of Florence to which his biography belongs. Biography and history, like poetry, are about origins. How did Michelangelo come to be a great artist? How did Michelangelo's Florence come to be a great city? How did Florence shape Michelangelo? How did Michelangelo give shape to the image of Florence? Poets are, likewise, forever writing about the origins of poetry. How was poetry originally invented? How was poetry reinvented by great poets? The story of Michelangelo has everything to do with origins—biographical, historical, poetical. It is a complex story of origins, originality, and invention, of the powerful metamorphosis of conventions.

Originality, invention, and artistic metamorphosis are all indices of Renaissance self-consciousness, for they are manifestations of the ways in which the artist or poet regards himself and hopes to be seen by others. Ever aspiring to fame and glory, the artist or poet must define for the world his singularity, what makes him unique, rare or strange—*straordinario.* We need to recall that when we see such words as *raro* or *strano* in the criticism of Renaissance art and literature, words used to celebrate an artist's or poet's novelty or *novità,* his *invenzione,* they all have biographical implications, for the originality of the work reflects the singularity of the poet's self, which is different from all other selves. We should further remind ourselves that to have a "self" is necessarily to possess a memory, which gives shape to one's life-story, biography, or history, a story that is peculiarly one's own, unique. If biography has deep poetical roots, poetry and painting similarly have profound biographical roots. Both Vasari's biography of Michelangelo and Michelangelo's autobiography should sharpen our sense of some of the biographical resonances of works of art themselves and consequently of artistic self-consciousness, even in works that are not usually treated from the point of view of biography. In some instances, these biographical implications are fictional, since, as we have noted, Renaissance biographies are themselves a branch of

fiction, but this fictional character of art should not diminish our sense of its autobiographical significance, whether in the work of Michelangelo or of other artists, such as Botticelli, Signorelli, Raphael, or Titian.

It might seem strange to some that we will be considering here the biographical character of Renaissance art, since the entire biographical approach to Renaissance art has been discredited, adjudged by many a failure or trap. Critics speak of the "biographical fallacy," of the "limits of biography," pointing out what the biographical approach either obscures or does not take into account. Others are more radically dismissive of biography, since the very idea of the self is said to be a fiction; consequently, in a sense, biography is totally make-believe, is the "life" of nobody. One wonders *who* said that? No matter! For we are not concerned here with ideas of the contingency of the self in a period of psychoanalysis and linguistics, but with the Renaissance sense of the self, reflected in poetry, art, biography, history. The self is constructed or fabricated in different ways, whether in a poem, a portrait, a monument, or a biography, and we are interested here in the history of such manifestations of the self in the Renaissance. This history has never been written, only partial chapters have been sketched and scattered through the scholarship. This book, this essay, is offered as a contribution to this unfinished history of the idea of the self in the Renaissance. It makes no sense to abandon the Renaissance history of the idea of the self because some philosophers or critics have abandoned the notion of selfhood. Writing about the Renaissance, we are not exactly writing about ourselves, even though much of our sense of the past is formed in the present. Indeed, it goes without saying that current, highly complex notions of the self sharpen our sense of Renaissance self-consciousness.

Some will object that the following analysis of poetic imagination in the work of Michelangelo and his contemporaries is not history, because it is divorced from the "real world" of material concerns. The kind of history being written here can and will be charged with being a form of idealism. It will be said that the poetical ideas discussed below are divorced from physical reality. Such a charge is itself a form of idealism, since it posits a false dichotomy between mind and body. After all, ideas take place in the mind or imagination, which cannot be separated from the body. Michelangelo's ideas about himself did not rain down from heaven. They did not assume form in thin air. They

emerged within himself, within his corporeal being, which has every-
thing to do with material reality. In this respect, his fantasies are no
less real than his excretions or his expenditures or his diet of cheese
and pears. Granted, a book about ideas or poetic fantasies is only
about a part of a larger story, just as a study of an artist's social
biography is a fragment from a larger whole. Who would be so naive
as to claim that *any* approach embraced the full story?

My book is in part about Michelangelo's relations to the pastoral.
Here I should offer a word about terminology. Although I am well
aware of the specific meaning of the term "pastoral" as applied to the
genre of works ranging from Virgil's *Eclogues* to Titian's *Fête
Champêtre,* I have preferred to use the word in what follows in the
broader, also acceptable, sense pertaining to the country or to rural
life and, by analogy, to garden or woodland settings. I thereby hope to
establish connections between pastoral images (in the narrow sense)
and mythological subjects set in landscapes or bowers in order to
suggest some of the ways in which such seemingly diverse representa-
tions of nature frequently evoke in common the idea of the very
origins of art *in nature*—whether that nature is inhabited by shep-
herds, nymphs, and satyrs or by gods and goddesses, whether these
subjects are elegant or coarse-grained, whether the nature to which
they belong is untamed or highly artificial.

In this book, as in my Vasari trilogy, I have not used footnotes but
have appended a brief Bibliographical Essay at the conclusion, which
gives my major sources and situates the work in relation to previous
scholarship. I owe a great deal to the vast Michelangelo scholarship,
but I also owe more than I can say to my students at the University of
Virginia during the last twenty-five years, in both undergraduate and
graduate courses, who have said things about Michelangelo, pastoral-
ism, and related subjects, which have found their way into this book,
although I no longer remember who said what. I am particularly
grateful to the following persons and institutions for their support: Bill
Wallace, many of whose observations have found their way into my
text; Cecil Lang, who read the manuscript and made numerous valu-
able suggestions; Ralph Lieberman, who furnished me with ideas and
several of his beautiful "photographic observations"; Jenny Clay, who
directed me again to Horace; Salvatore Camporeale, whose gloss of
the first sentence in Vasari's life of Michelangelo I have appropriated

below; David Summers, whose ongoing soliloquies on art history
have been particularly nourishing; Walter Kaiser, the Faun of I Tatti,
who invited me into his gardens several years ago, when I first
dreamed of this book; both the University of Virginia and the Guggen-
heim Foundation, which sponsored such musings during that pastoral
year; and finally, but most significant, my wife, Ruth, and children,
Deborah and Daniel, who suffered my bemusement with tolerant
amusement when, still physically at the dinner table, I would momen-
tarily abandon them and lapse into the sixteenth century.

THE FAUN IN THE GARDEN

1

THE POETIC ORIGINS OF
THE ARTIST

In the Renaissance, biography often rises to the condition of poetry, as it does in the autobiography of Michelangelo. A brief, seemingly unexceptional passage from this work gives us a purchase on this poetry of autobiography, on the poetry or "making" of the self. Michelangelo's description of a single sculpture is suffused with intertwined poetical and biographical implications. Let us see how this biographical poetry works, how it comments on the artist's very origins.

Speaking of the tomb of Julius II, which is the central work in his autobiography, Michelangelo told Condivi that he made two sculptures that were placed in niches on either side of the *Moses: Active Life* and *Contemplative Life*. The figure of *Active Life* (Fig. 1), based on Dante, holds a mirror in one hand, contemplating herself, Condivi says, indicating that when we act we must do so prudently; in her left hand she holds a garland of flowers. This figure, described by Dante in *Purgatorio* XXVII, is Leah, the companion to *Contemplative Life*, Rachel. Dante says here that falling asleep he had a dream, a vision, we might say, of a woman walking through a field, gathering flowers and singing. She tells Dante that she is Leah, adding that with her "beautiful hands" she is making a garland from flowers. "I adorn myself," she explains, "in order to please myself before the mirror."

There is no need to dwell here on Michelangelo's identification with Dante, which is well established. Suffice it to say, in the mid-1540s, when Michelangelo brought the tomb of Julius to completion,

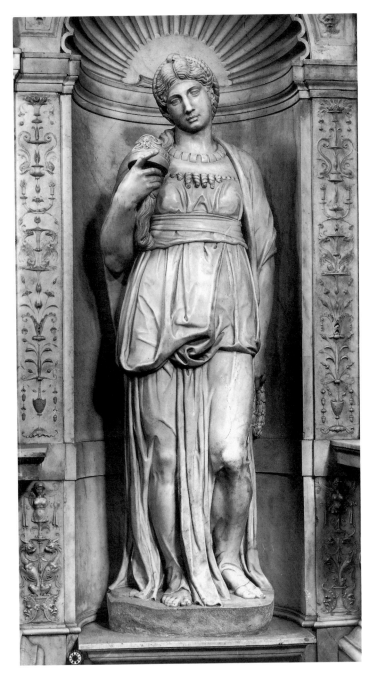

Fig. 1. Michelangelo, *Active Life*. Tomb of Pope Julius II, San
Pietro in Vincoli, Rome

carving these two allegorical figures, he appears as an expert on Dante, commenting on the fine points of the *Commedia* in dialogues composed by his friend Donato Giannotti. In these years, he planned to have his poetry published in a volume, which was to include two poems on Dante, one of which was quoted by Giannotti in his dialogues. Although this projected book of Michelangelo's foundered on the death of Michelangelo's friend Luigi del Riccio, who was largely responsible for seeing the book into print, there is evidence from Michelangelo's letters of his active role in selecting the poems for this volume, which would have squarely placed him in the tradition of Dante as lyric poet.

We should further observe that also in the same period a series of celebrative portrait prints was made of Michelangelo. A letter from Michelangelo to Luigi del Riccio in January 1545, entreating the latter to destroy a plate, has often been taken to refer to one of these portraits, which clearly dissatisfied the artist. What can be concluded from this data concerning Michelangelo c. 1545, when he carved the Dantesque *Vita Attiva*, is that, participating in the publication of his poetry as well as in the production of his portrait prints, Michelangelo was actively engaged in forging his public persona. In this context Vasari would compose his biography of Michelangelo, published in 1550, and Michelangelo, responding to Vasari, would compose his autobiography, delivered to the public in the form of a biography by Condivi, which elaborates upon Michelangelo's identification with Dante. We cannot fail to observe here the ways in which the relatively recent inventions of movable type and engraving were being exploited to promote the fame and glory of Michelangelo.

As we read Michelangelo's letters from the 1540s into the 1550s, when his autobiography was published, we find the artist preoccupied with the reputation of his family, that is, with the social status of his family. In a series of letters to his nephew Leonardo, he urges that his young relative take for a wife a woman of noble blood, worthy of the Buonarroti. He says that it is important for the family to own not only farms in the country but also a palace in the city, a conspicuous sign of a family's nobility. These familial ambitions on Michelangelo's part are inseparable from his pursuit of personal glory and fame, reminding us that in Giulio Bonasone's portrait engraving of 1545 (Fig. 2) Michelangelo is identified proudly as PATRITIUS—"patrician." In this regard, we recall one letter from Michelangelo to his nephew in January 1548,

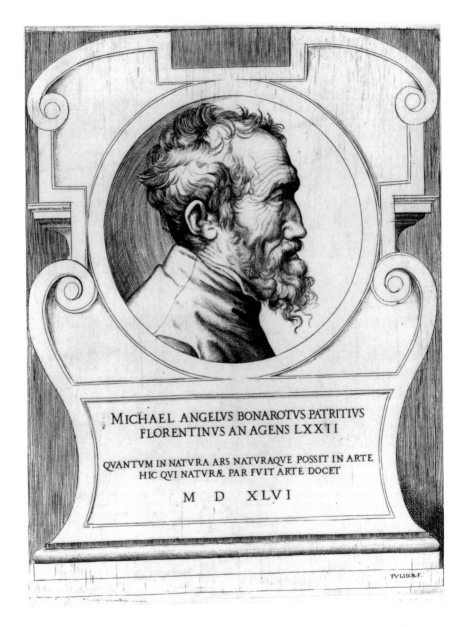

Within the engraving:

MICHAEL ANGELVS BONAROTVS PATRITIVS
FLORENTINVS AN AGENS LXXII

QVANTVM IN NATVRA ARS NATVRAQVE POSSIT IN ARTE
HIC QVI NATVRÆ PAR FVIT ARTE DOCET

M D XLVI

TVLIO·B·F·

Fig. 2. Giulio Bonasone, *Portrait of Michelangelo*. British Museum, London

in which he asks that Leonardo take care of a letter from Count Alessandro da Canossa, of the noble family from which he believed his family to have descended. In another letter to Leonardo, this one from December 1546, he speaks of his ambition to "resuscitate" his house, adding that someday he will tell Leonardo about their family's "origins." Michelangelo is clearly thinking autobiographically here, and we know from a letter of April 1548 to his nephew, when he asks for a copy of his *nativitá* or record of birth, that he is thinking as much about his personal origins as about those of his family. Like all Florentines, Michelangelo does not reflect on his own origins or glory apart from those of his house. Indeed the nobility of his family, to which he contributed so much, is part of his own. That he descends from a noble, indeed "imperial," family, or so believes, is part of his noble image.

Michelangelo's ambition to achieve the highest social station possible, which is bound up with his aspiration to artistic glory, takes us back to the *Vita Attiva*. Condivi tells us that this figure was the Countess Matilda, whereas in Dante, Matilda appears in *Purgatorio* XXVIII, the canto following that in which *Active Life* appears. According to tradition, the Matilda of *Purgatorio* was the very same Matilda whom Michelangelo claimed as his ancestor. She appears in a field as a type of Christian Persephone, singing and gathering flowers as Leah had done in the previous *canto*. What Michelangelo did, seemingly, was to conflate Leah or *Active Life* with Matilda, since both are beautiful women, appearing in consecutive cantos. Both are beheld in a field, as in a vision, gathering flowers. What Michelangelo does, therefore, is identify *Active Life* as his own illustrious ancestor. This apparent confusion, as we will presently see, may in fact have been a purposeful, poetic fusion. But first a few words on Michelangelo and the Canossa.

Michelangelo, we recall, had promised his nephew that one day he would explain the origins of their house. Dictating his autobiography to Condivi, he does just this, saying at the very beginning of this work that he was descended from the counts of Canossa, from Matilda. There is also evidence of Michelangelo's visual thinking about his noble family from an earlier moment. In the 1520s, while he was at work on the Medici Chapel, Michelangelo made a drawing, now lost, of which a copy is preserved in the British Museum, that clearly alludes to the Canossa (Fig. 3). On the helmet of an idealized effigy

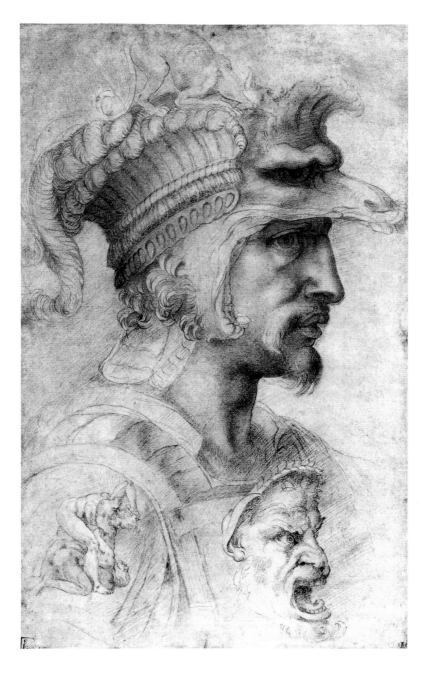

Fig. 3. Michelangelo, *The Count of Canossa* (copy after a lost drawing).
British Museum, London

there appears a dog or *cane* gnawing on a bone or *osso*, emblematic, as it was long ago observed, of the subject's identity as a count of Canossa, and also recalling Michelangelo's coat of arms as described at the beginning of Condivi's biography. We do not know the purpose of Michelangelo's drawing, but it has not unreasonably been suggested that it was made as a gift for Count Alessandro from his *parente* Michelangelo. It is particularly striking that the effigy of the count resembles those of the Medici dukes, which Michelangelo carved in this very period (Fig. 4). The comparison is appropriate, since Michelangelo's dukes conveyed the Medici's dynastic ambitions, and we might say that the portrait of the Count of Canossa, made in their image and likeness, conveyed Michelangelo's own similar dynastic thinking about his own house. By contrast to the more idealized Medici dukes, however, the nobleman of Michelangelo's drawing has a more particularized identity. Could it be, could it just be, that the drawing was intended not as an effigy of Alessandro's ancestor but as a flattering portrait of Alessandro himself?

When we return to Michelangelo's description of the *Active Life* on the tomb of Pope Julius, we discover its further implications. Michelangelo said, we remember, that he carved the figure of *Active Life* contemplating her own image in a mirror, which signifies that "in our actions, we must proceed prudently"—that is, *consideratamente*. Michelangelo is referring to Matilda as the very figure of Prudence, traditionally represented looking at herself in a mirror. He echoes what he said about Matilda at the outset of his biography, that she was "a lady of rare and singular prudence and religion." The mirror that the figure holds on Michelangelo's tomb thus alludes to Matilda's prudence, to the virtue of Michelangelo's house!

It would appear that Michelangelo ingeniously fused the *Active Life* of the papal tomb with Dante's Matilda, in part because he considered his ancestor to be the personification of Prudence, the very virtue symbolized by the mirror of *Active Life*. Michelangelo's *Active Life* emerges in his poetical autobiography as a rich poetic, compound figure, celebrating his ancestor Matilda as the personification of virtue, who, appearing in the *Commedia*, fuses his ancestry with Dante's great poem—as if to say that Dante had told part of Michelangelo's family story, that Michelangelo's family story was part of Dante's great Christian epic. In other words, just as Dante

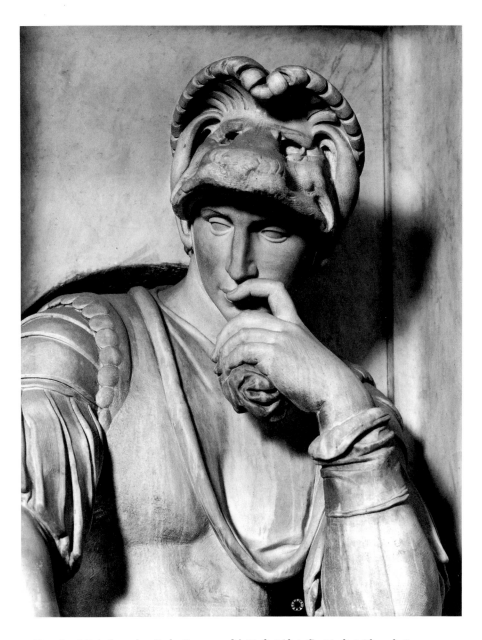

Fig. 4. Michelangelo, *Duke Lorenzo de' Medici* (detail). Medici Chapel, San Lorenzo, Florence

wrote about his own ancestors in his poem, he also wrote about Michelangelo's.

Michelangelo also told Condivi suggestively that Matilda "held the patrimony of Saint Peter's." Appearing on the tomb of Pope Julius II, originally planned for Saint Peter's, she therefore evokes her important place in the history of the very church that Julius represented and defended. By presenting the figure of Matilda on a papal tomb, or claiming that he did, Michelangelo Buonarroti Simoni da Canossa thus commented on the grandeur of his own distinguished house, binding his own family's history to that of the pope, making the papal tomb, in a sense, a monument to his own illustrious family.

Given the centrality of the tomb in Michelangelo's life (he worked on it, on and off, for a period of forty years), we can understand how he came to identify it so closely with himself. The figure of Matilda on the tomb is not only appropriate as the personification of the *patrimonio* of the church, she is also appropriate as the representative of the artist's own noble house. She also represents Michelangelo's very origins, which gives him license to connect his family's glory with that of the Pope. Michelangelo thus fashions his own identity as a descendant of the Canossa in such a way as to connect his own identity with that of the Pope, for whom he carves the figure of Matilda, and with that of the glorious Tuscan poet, whose work he not only imitates but seeks to surpass. The figure of Matilda on the tomb of Pope Julius II, properly glossed, emerges as a paradigm of Michelangelo's self-consciousness—a self-consciousness reflected in his poetical, autobiographical search for origins.

Such self-consciousness is seen in a drawing by Michelangelo known from copies, dated in the 1520s, which has a bearing on the statue of Matilda (Fig. 5). In this study, a seated figure is, like Countess Matilda, gazing into a mirror, similarly personifying Prudence, or so it seems. A putto kneels behind her, as if hiding from another putto, who looks through the mask of an old man turned upside down. A third putto leans on the woman, smirking while placing his supportive hand on the mask. In conventional images, Prudence appears as a young woman with two faces, the second visage being that of an old man, seen, for example, on the so-called Tarocchi cards of Mantegna (Fig. 6). Looking into a mirror, the woman prudently represents self-knowledge, while, on the back of her head, a bearded, aged face

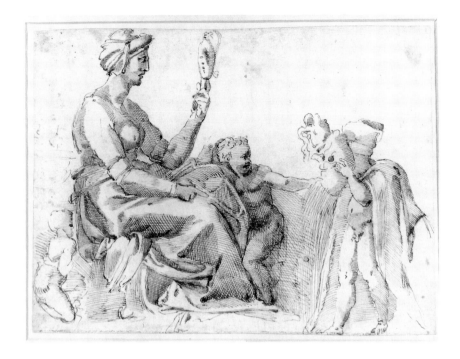

Fig. 5. Michelangelo, *Allegory of Prudence* (copy after a lost drawing). British Museum, London

stands for retrospection. The spirit of Michelangelo's ambiguous invention is, however, foreign to the decorum of such conventional images of Prudence as that on the Tarocchi cards.

In Michelangelo's drawing, the mask of the old man suggests a play on the idea of the retrospective old man who stands for Prudence. The putto who gazes playfully through the old man's mask, assuming his persona, makes light of him, eliciting our smile along with that of the putto's companion standing at the woman's knee. By turning the mask of Prudence into part of a game of hide-and-seek, and by representing it upside down, Michelangelo creates an image of the World Upside Down. In this world, Prudence is perhaps no longer Prudence or merely Prudence but is now, turned upside down, an allusion to Vanity, who, like Prudence, is traditionally shown looking into a mirror. In the "two senses" of Michelangelo's playfully ambiguous drawing, the woman who gazes into a mirror is perhaps, paradoxically,

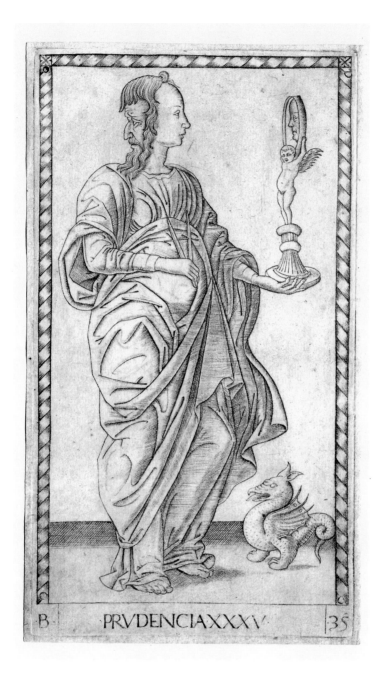

Fig. 6. Master of the E-Series Tarocchi, *Prudence*. National Gallery of Art, Washington, D.C.

both Prudence and Vanity, or should I say, Prudence metamorphosed, in jest, into Vanity. Is Michelangelo perhaps slyly hinting that the line between self-reflection as knowledge and self-reflection as vanity is as thin as a mirrored reflection?

Whatever the answer to this question, we can say that the drawing is another instance of Michelangelo's self-conscious meditation on self-knowledge, on one's self-image, only here the tone is mocking and facetious, whereas in the similar representation of Matilda as Prudence it is grave. But this disparity should not surprise us, for we recall that Michelangelo often ironically mocked his most exalted ambitions: for example, in the famous poem to Giovanni da Pistoia, in which he ridiculed his labors upon the Sistine ceiling by describing his body, hideously deformed by such efforts; in the similar poem, "Io sto rinchiuso," written years later in *terza rima*, which is a self-parody of the aged, grotesquely deformed artist himself; or, finally, in the poem written in response to one by Francesco Berni, in which Michelangelo, self-mockingly assuming the persona of Sebastiano del Piombo, the facetious friend of the artist to whom Berni wrote, says of himself, through Sebastiano's mask, that he has been "raised to heaven a thousand times an hour."

Michelangelo writes of himself here in jest, but we cannot underestimate such *scherzi*, for they reflect on Michelangelo's most serious aspiration to glory—an ambition reflected in his poetically conceived autobiography, in which he establishes his identity by fusing it with that of the Countess Matilda and with Dante's poem. It was only fitting that Michelangelo should use Dante to link his family's glory to that of the *patrimonio* of Saint Peter and the grandeur of the pope for whom he worked, making the tomb, in a sense, a monument to himself. After all, as he remarked, the tomb robbed Michelangelo of his very youth. The implicit identification of the tomb as a monument to his own family was a fitting epitaph to his mighty labor, to his own glory, to his own glorious, imperial origins. The figure of Matilda on the tomb of Julius, as interpreted in his autobiography, tells us something about the way Michelangelo saw himself in the mirror of his own art, in the poetry of autobiography, just as his lost drawing, seemingly of Prudence, might ironically comment on vanity. For like Dante in search of glory, Michelangelo was acutely conscious of the *vana gloria* of all art.

2

THE PASTORAL ORIGINS
OF ART

We can easily overlook the biographical implications in Michelangelo's uses of Dante's Matilda to explain his family's origins. Appearing to Dante in the earthly paradise of *Purgatorio* XXVIII, in a garden, Matilda is a *donna angelicata*, likened to Venus and Persephone, who, personifying wisdom and virtue, foreshadows Beatrice. She belongs to that long tradition of beautiful, virtuous, and wise women who appear to the poet in the romantic pastoral settings of Tuscan poetry, from Guido Cavalcanti, Dante, and Petrarch to Poliziano, Lorenzo de' Medici, and Botticelli.

Such pastoral romance, although fictive, is autobiographical in character, for the poet bodies forth in words or images the memory of his beloved as she once appeared to him. She is central to his life, to his life's story. Our tendency is to think about literature in terms of separate genres. Consequently, we do not adequately ponder the relations between biography and poetry, whereas one of the notable features of Tuscan poetry is its radically autobiographical character. The Renaissance is marked, as Burckhardt observed, by the flowering of biography as an increasingly prominent and significant literary genre, but because we confine "biography" and "poetry" within the borders of literary genre, we do not sufficiently appreciate the role of poetry as biography in the very tradition of writing to which Michelangelo belongs. We all know, for example, that Dante is an autobiographical poet, but we sometimes take this fact for granted, failing to

recognize the extent to which he is an exemplary figure in biographical and autobiographical writing, as in Michelangelo's autobiography, where his Matilda assumes a poetically crucial role.

As an autobiographical writer in the *Commedia*, Dante is a highly self-conscious poet, grappling with the authority of Virgil, pretending that the great classical poets of Limbo make him one of their number, alluding also to the way in which he surpasses his contemporaries. According to a widely held theory of poetic influence, great poets emerge only after they struggle with the authority of major poets of the past. The history of such poetic struggle and influence is, however, strangely foreshortened, focusing on the period that extends from the late Renaissance through Romanticism to Modernism, leaving Dante out altogether, not to mention Michelangelo, who struggles mightily with the authority of Dante. This omission is arresting, since it was Dante who essentially invented this struggle and its narrative in his agonistic autobiographical comedy, which is a profound model for the autobiography of Michelangelo, who made Dante's agon his own. Indeed, in the history of art and literature, Dante plays the Virgil to Michelangelo's Dante, and when Michelangelo says that "no greater man" than Dante was ever born, we should read between the lines, hearing him say in full, no greater man until my own advent. Dante is more than an exemplary figure for Michelangelo; he is a powerful figure of authority, who must needs be subdued by Michelangelo, assimilated to his own greatness.

Long before Michelangelo rose in battle to challenge the supremacy of Dante in Tuscan art, the powerful, autobiographical voice of Dante was to play a decisive role in the formation of Petrarch's self-consciousness. Whereas Dante assumes the persona of epic hero in the *Commedia*, picturing himself earlier as the poet in love in the *Vita Nuova*, Petrarch, following both models in his *Rime sparse*, writes his highly allegorical, fictive autobiography as both epic and romantic pastoral, describing his beloved in the green bower of a woodland setting. Whereas Dante's explicit guide in the *Comedy* was Virgil, Petrarch's implicit guide in the *Rime* is Ovid, for the myth of Apollo and Daphne, transformed into laurel in *Metamorphoses*, is central to his life-story as a poet. Laura's name alludes to the very laurel or *lauro* that becomes the poet's own crown. In other words, celebrating his love for Laura, Petrarch achieves his laurels, like Caesar's. In the

Rime Petrarch effectively writes the mythologized account of how he became a great poet, inspired by Laura, the *figura* of his laurels.

Nowhere is the romantic pastoral of Petrarch's vision more emphatically articulated than in *Rime* 126, "Chiare fresche et dolci acque," where the poet beholds his beloved near the sweet waters of a river, bordered by grass and flowers. So deeply a part of nature is she that her *belle membra*, her beautiful limbs, are one with the *ramo* or branch upon which she leans. Laura is conceived as a type of the goddess of spring, if not as the figure of Flora herself. A rain of flowers descends from the branches above, falling on her hair and dress. Reading Petrarch's description of Laura, we are reminded of Poliziano's Flora-like Simonetta in the *Stanze* and Botticelli's Flora in the *Primavera* (see Fig. 7), both of whom, wearing dresses adorned with flowers, stand in this Petrarchan tradition.

As Petrarch's life-story, his biography, the *Rime* is the story of Petrarch's origins, that is, of how he became a poet. According to his account, which is rooted in classical, pastoral ideas, he became a poet when he beheld his beloved in nature, the very embodiment of nature and its beauties. Although she personifies nature, which is the source of all imitation in art, she is also heaven-sent and, as a divine personage, she has the power to inspire the poet, whose poetry is the record of her beauty, of his love for her, and of her power to hold him in thrall.

This is one way of describing the *Rime*, but there are other ways as well. We can see the *Rime* not just as the poet's autobiography but, even more deeply, as the revelation of the poet's self-creation. If Laura is seemingly the source of the poet's creation or spiritual re-creation, we must remember that she is the poet's creation in the first place. No matter that Petrarch might have known a woman named Laura. What is significant here is that Petrarch needs a Laura from whom he can fashion his own glory or laurels, just as Dante needed a Beatrice as agent of his beatification. The figure of Laura can be seen as the personification of Petrarch's poetry or "making." Her beauty and grace are identical with the beauty and grace of Petrarch's poetry. Fashioning his poetry out of the idea of Laura, Petrarch essentially creates himself, since his greatness as a poet is defined by his ability to fashion her in words. To emphasize this artifice of the self is not to diminish the sincerity of Petrarch's love or

of his religious devotion, which are central to his poetic creation, to his conception of himself. Rather, to stress such artifice is to underscore the way in which Petrarch, inventing Laura, invents himself. Nowhere do we see more clearly such acute self-reflexivity than in the very first sonnet of the *Rime*, where the poet uses the untranslatable, piercingly self-reflexive phrase, *me medesimo meco*.

In a certain sense Petrarch, Laura, and the poetry in which she appears are one. Petrarch's readers have always recognized that his poetry is acutely self-conscious, just as Dante's students have understood that his poetry, in anticipation of Petrarch's, is highly self-reflective. Writing about themselves, about their lives in art, Dante and Petrarch are effectively writing, through their art, their very autobiographies. Yes, these autobiographies are imaginary, fictive and allegorical in character, but this fact should not diminish our sense that poetry as autobiography is closely linked to Renaissance biography, especially since this biography is itself profoundly poetical in conception. When we dissolve the artificial boundaries of genre that obscure the deep relations between poetry and biography, we recognize that as Tuscan poetry aspires to the condition of biography, Tuscan biography aspires to the condition of poetry—in both cases *mythopoiesis*.

According to the conventions of *mythopoiesis*, art and poetry are born in nature, the very world of nature which art imitates. When artists are said to be shepherds, or poets pose as herdsmen, they participate in the pastoral myth, according to which the artist creates in communion with nature. If we look at Petrarch's poetry not just for its superficial story of his love for his Flora-like Laura but for its deeper story of the origins of poetry, we recognize this same idea: the poet is inspired in a place whose physical beauties, the grass and flowers, the song of the birds and bubbling waters, all mirroring the beauty of his beloved, contribute to the poet's inspiration and re-creation. When the poet describes himself in nature, inspired by such beauty, personified by his beloved, he is writing autobiographically. Whatever else it is, the *Rime* is the story of Petrarch's origins as poet, the story of how he became a poet, when he was filled with the love of which his poetry is the record. For Petrarch, Laura serves as a nurturer, a deeply Christian, spiritualized nurturer to be sure, who inspires him in his very life and work. She stands in the line of Beatrice

and Matilda, who, appearing to Dante in an earthly paradise, brings him closer to beatification as divine pilgrim and poet.

Long before Boccaccio wrote his biography of Dante, long before Leonardo Bruni wrote his biography of the poet, before Ghiberti and Alberti wrote autobiographically, before Vasari composed his lives of the artists and Michelangelo and Cellini dictated their autobiographies, the principles of the autobiography or biography of the poet and artist were established in poetry itself, above all in the poetry of Dante and Petrarch. When Michelangelo later made Dante's Matilda his own, he transformed Dante's inspirational figure into his ancestor, interfusing poetry and his social origins.

In the autobiography of Michelangelo its most deeply poetical aspect is given over to the discussion of his origins in art—to the origins of his "poetry" in stone. We will have occasion to discuss various aspects of this narrative in subsequent chapters, but let us for the moment turn to a single, famous detail from the autobiography in order to grasp this deep relationship of autobiography to poetry. I am speaking of Michelangelo's famous words to Condivi to the effect that the "pleasure" he took in the chisel was derived from the milk of his wet-nurse. Michelangelo, who was raised in the country village of Settignano, was taken, as he told Condivi, to a wet-nurse, who was married to a stonecutter and was herself the daughter of a stonecutter. Michelangelo was thus the surrogate child of a rustic or pastoral family. As a bucolic type, the wet-nurse is a figure of Michelangelo's humble pastoral origins in the family of stonecutters. Although Michelangelo later protested in a famous remark that he did not want to have his brother spending his life behind a plow, because such activity was not worthy of their noble house, it was more than acceptable for the artist to find his bucolic origins in the family of stonecutters, because such origins were sanctioned by poetry, which always concerned itself with its own origins in nature.

Michelangelo's remark about his wet-nurse, which has never been adequately glossed, is rich in literary implications. In his *Odes* (III, 4) Horace, invoking the aid of Calliope, fondly recalls his childhood days in Vulture, beyond the borders of his old nurse, Apulia—*nutricis extra limen Apuliae*. Michelangelo, who first used the word *balia* to speak of his wet-nurse, next employs the term *nutrice* to describe her, adapting the Horatian word to describe his place of origins. By anal-

ogy to Horace, the wet-nurse in Michelangelo's account is the personi-
fication of the place where he was raised. But whereas Horace's native
place was a *locus amoenus* of rich fields, of bay and myrtle, the
location of Michelangelo's infancy, as Vasari would add in 1568, embel-
lishing Michelangelo's explanation, was one of rocks and quarries.

Michelangelo's use of the word *nutrice* cuts deeper, for it evokes
Dante's figurative uses of the word as well. After Statius says that
Virgil was his wet-nurse in poetry, *nutrice poetando*, in a famous
passage of *Purgatorio* XX, Dante returns to this image in the following
canto, where Statius speaks of the Muses as *le nostre nutrici*. In the
context of Michelangelo's autobiography, his *nutrice* or wet-nurse is
his Muse, presiding over the Parnassus, so to speak, of his bucolic
Settignano. Standing at the origins of Michelangelo's career as poet or
maker in stone, the wet-nurse epitomizes the humble pastoral realm
of Michelangelo's origins, thereby magnifying the greatness of Michel-
angelo's ascendancy from such lowly, seemingly infertile beginnings
in the world of uncultivatable rock.

Vasari adds to Michelangelo's version of events by claiming that the
latter also said he took in "the hammer and the chisels" with the wet-
nurse's milk—as if to suggest that he inherited his talent as a sculptor.
If the wet-nurse stands for the milieu of stonecutters in which Michel-
angelo was raised, the remark nevertheless deflects attention away
from Michelangelo's specific training with individual stonecutters or
sculptors. Whether of Michelangelo's invention or Vasari's, the re-
mark also beautifully brings out, in a powerful paradox, the antithesis
between the fertility of Michelangelo's art, linked to the nourishment
of the nurse from whom he takes in his tools, and the sterility of the
rock out of which he carves his figures. Vasari brings out this antithe-
sis very effectively elsewhere when he speaks of the *David*, saying
Michelangelo "resuscitated" the stone, which was "dead."

This is not the only paradox in the section of Michelangelo's biogra-
phy concerned with origins. In the description of Michelangelo's
childhood, Condivi mentions that Michelangelo was raised on lands
bought by Simone da Canossa, who was one of the noble counts of
Canossa from whom Michelangelo claimed to be descended. In other
words, Michelangelo has two genealogies. He descended paradoxi-
cally from both a noble house and a humble rustic family. This para-
dox has further resonances when we recall Vasari's earlier account in
1550 of Michelangelo's advent. Saying that when God saw Tuscan

artists laboring still in darkness, He "sent forth a spirit," *mandato uno spirito*, to redeem art, Vasari describes the "divine" Michelangelo as a type of Messiah. Michelangelo was thus like Christ, for he was figuratively both the son of God and of a humble artisan. The word *mazzuolo*, used to describe the hammer Michelangelo took in with the milk of his wet-nurse, is particularly suggestive here, for by contrast to the word *martello*, which Michelangelo used elsewhere for hammer, the *mazzuolo* was a tool used not only by stonecutters but by carpenters, reminding us further of Jesus as the son of a carpenter.

Images in poetical biography, as in poetry, are rich in associations and implications, and the wet-nurse in Michelangelo's highly imaginative biography is far more than a joking explanation of Michelangelo's disposition toward sculpture or an explanation of how he became a sculptor. The wet-nurse participates in a larger network of images, biblical, classical, and modern, that are evocative of Michelangelo's divine, noble, and bucolic origins. We can choose either to read Michelangelo's biography, which takes shape in Vasari's two versions and in the intervening autobiography recorded by Condivi, as "documentation" of what Michelangelo supposedly did or said, or to contemplate the *fantasia* of this biography, to admire especially Michelangelo's own *invenzione* as he poetically invents himself. Pursuing the latter approach, and we have scarcely set out, we gain a deeper insight into Michelangelo himself—to Michelangelo giving poetic form to himself in an autobiography, which is a fundamentally poetical work.

As we will see in the subsequent chapters, the fantastical character of Michelangelo's biography is related in its imagery and sensibility to that in his poetry. When we treat biography and poetry together, we also recognize that the origins of Michelangelo's biography lie in poetry itself, in the autobiographical verse of Dante and his followers. Long before Michelangelo spoke imaginatively of his pastoral origins in Settignano, Boccaccio wrote in his life of Dante of the poet's rustic roots. Transforming the allegorical autobiography of Dante's poetry into the allegorical poetry of biography, Boccaccio writes, in a famous passage, that during her pregnancy Dante's mother prophetically dreamed that as she lay at the foot of a laurel tree, next to a clear stream, she gave birth to a son. Eating the berries from the tree and drinking the waters of the spring, he became a great shepherd, who was fond of the leaves of the tree. That great shepherd was of course Dante himself. We might say that, aggrandizing Dante, Boccaccio

followed the example of his hero, who had already exalted himself autobiographically in the allegory of his *Comedy*—establishing a precedent for Vasari, who, revising his biography of Michelangelo, responded to the poetry of Michelangelo's pastoralizing autobiography, by stressing the bucolic place of Michelangelo's childhood, Settignano.

In the history of Renaissance biography, famously mapped out by Burckhardt, poetry plays a central role, and if we read Michelangelo's biography without taking into account its deeply penetrative poetical roots in the tradition of Dante, Petrarch, and Boccaccio, in their poetry and poetical prose, we fail to see its own poetry—to see that Michelangelo's basal fictional biography, with its pastoral allusions and other literary references, takes its place in the history of literature as itself great art, central, not marginal, to his very achievement.

3

THE AUTOBIOGRAPHY
OF POETRY

In the Renaissance, when poets wrote autobiographically, when biography was poetically conceived, painters, who were themselves poets, also worked in an autobiographical mode. If we turn to Botticelli's *Primavera* (Fig. 7), which, conceived as poetry, displays the painter's poetic virtuosity, we find the same kind of poetic consciousness that we encounter in the poetry and biography we have been discussing.

Saturated with poetical allusions, resonant with references to Horace, Lucretius, and Ovid, to Dante, Petrarch, and Poliziano, Botticelli's *Primavera* is universally recognized to be the first large-scale painted *poesia* of the Italian Renaissance. More than this, it is arguably the earliest assertion in the history of Italian painting of the artist's consciousness of himself as poet, predating in this respect the similar claim of Michelangelo, Raphael, and Titian. Establishing his identity as poet, Botticelli says something biographical, for to have an identity, a self, is to have a sense of one's "life," a biography, to have a vision of one's past, not to speak of aspirations for the future. All of this is implicit in Botticelli's picture, although we do not ordinarily look at it as a biographical *essai*.

Consideration of the *Primavera* does not turn us away from Michelangelo, for it defines the very culture in which he grew to maturity in fifteenth-century Florence. To analyze the *Primavera* from the point of view of biography is to deepen our sense of the milieu in which Michelangelo's own consciousness took form. The painting was cre-

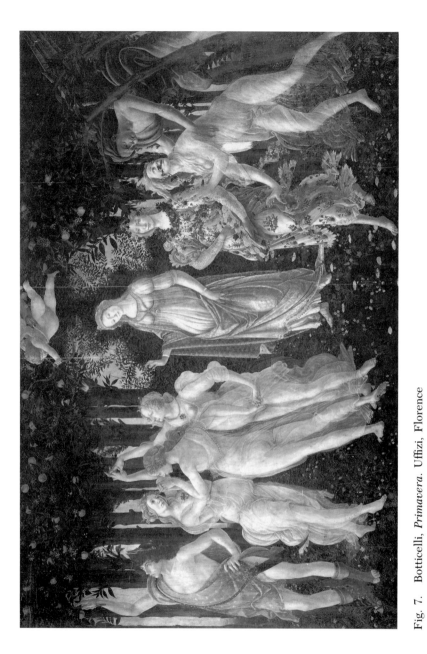

Fig. 7. Botticelli, *Primavera*. Uffizi, Florence

ated by an artist who was a friend of Michelangelo, sharing Michelangelo's enthusiasm for Dante. Like Michelangelo's fictive autobiography, the implicitly autobiographical *Primavera* stands squarely in the autobiographical tradition of Tuscan poetry.

Let us consider the passage of the painting where Botticelli emphatically asserts that he too is a poet. I refer to the remarkable section at the right of the panel, in which the painter shows the metamorphosis of Chloris, goddess of the earth, into Flora, divinity of Spring. Botticelli alludes here to the *Fasti* of Ovid, with its story of Zephyr's abduction of Chloris, who became Flora. The ancient poet does not describe the metamorphosis; rather, he has Flora say that she was once Chloris. Botticelli, however, tells the story by picturing Zephyr as if he were Apollo and Chloris were Daphne. As his Chloris/Daphne flees from Zephyr/Apollo, flowers issue forth from Chloris's mouth and, flowing copiously, become the very flowers of Flora. Picturing this metamorphosis, Botticelli not only transforms written poetry into visive form, he also metamorphoses one Ovidian text into another, transforming *Fasti* into *Metamorphoses*. This episode of painted poetry is an astonishing piece of bravura work, the display of poetic virtuosity in the extreme, where Botticelli proclaims, in a sense, that he is a new Ovid among painters. Imitating Ovid, Botticelli did what Ovid had done when he metamorphosed one myth of *Metamorphoses* into another, transforming the myth of Apollo and Daphne into that of Pan and Syrinx. By establishing the identity between his representation of metamorphoses and his own metamorphosis of Ovid, Botticelli further tells us that poetry *is* metamorphosis, indeed multiple metamorphoses, that he is himself a poet of consummate inventive power.

Botticelli's poetic skill resides in far more than his mere allusion to or transformation of poetic sources. It is visible in the very form of his painted poetry—for example, in the graceful gait of Chloris and Flora, in the gentle downward motion of their feet, and in the rhythmical repetition of their extended arms, intricately rhyming with each other. Such poetry is exhibited in the melody of Botticelli's line, in the graceful flow of drapery. It is also seen in the ambiguity of form. The silhouettes of floral forms between the legs of Chloris are perceived as both the flowers upon the ground, beheld through the veil of her garment, and, simultaneously, as the nascent flowers of her dress, like those of Flora's more fully be-

flowered frock. Similarly, the flowers that pass from Flora's dress between the fingers of Chloris's upraised hand are perceived ambiguously as both the fictive flowers "painted," as the poets say, on Flora's vestment and the real flowers, projecting into space, like those that Flora scatters upon the earth. Such ambiguity or paradox is the essence of Botticelli's exquisite poetry, as of so much written poetry, the essence of his virtuosity as a poet.

Botticelli's identity as poet is even more profound. His picture, as has always been recognized, is steeped in the tradition of Tuscan love poetry, in which the poet beholds his beloved in a greenworld. In Botticelli's picture it is Venus herself who appears, as in an epiphany, accompanied by a cast of beautiful beings—the Graces, Flora, and Chloris—all amplifying the theme of inspiring female beauty. Their presence reminds us that the poets likened their beloved to classical goddesses. Many of the other conventions of Tuscan poetry are present—the "sweet smile" of Flora, the light step or *leggerezza* of the Graces, the "suave breeze" that gently undulates their garments. Indeed, when we pause to consider Botticelli's painting in relation to the tradition of poetry from Dante to Lorenzo de' Medici and Poliziano, we realize not only that his painting participates in this tradition but that it is the only picture of the period to metamorphose its conventions into visual poetry. Not Pollaiuolo, not Piero di Cosimo, not Filippino Lippi, nor any subsequent painter realizes these poetic ideals so fully in their own form of painted poetry. The *Primavera* is *sui generis* as a painted poem, *singolare*, a *novità*, and Botticelli, alone among painters, takes his place in the history of the Italian lyric descending from the *dolce stil nuovo*.

As a proud poet in the glorious modern tradition of Italian poetry, Botticelli necessarily alludes to its deepest, indeed existential, themes. This poetry is about life and death, about the death of the poet's old self, about his rebirth in his beloved, when his "new life" or *vita nuova* commences, for it is through his "vision" of his inspiring *madonna* that he becomes a poet in the first place, that his life as a poet begins. From that great moment of epiphany onward he tries to find words adequate to describe her beauty and his love for her. Those words are his poetry. In a certain sense, the poet's lady creates him; inspired by her, he is her creation. At the same time, paradoxically, as he tries to re-create her in memory, giving form to her in words, he re-creates her anew. She is the personification of the very ideals of grace and beauty to which he

aspires as poet. Her *leggerezza, dolcezza, gentilezza*, her sheer ethereal beauty personifies the very poem. Re-creating his beloved, the poet, at bottom, creates himself. "Beatrice, I am you," the blessed Dante hints, "Laura, I am you," suggests the poet-laureate Petrarch, and, in like fashion, Botticelli intimates, "I am Venus, Flora, and the Graces, whom I have created poetically in my fantasy"—for these heavenly creatures are all consubstantial with their creators' identities as poets, with their very beings as poets.

If the *Primavera* is an allegory of love, it is, more broadly, an allegory of life itself. The rape of Chloris by Zephyr is the birth of Flora, of the new year. It is the representation of carnal love in this world. The gentle motion of the picture is, however, from this birth or rebirth toward death and spiritual rebirth, personified by Mercury, a divine lover and deity of spring, whose contemplation of the sun, reflected in his eyes, epitomizes the ascent to heavenly beauty. Whereas the earthly lover is agitated, palpably clutching his beloved, Mercury is poised in repose, as he contemplates divine beauty, which brings peace to the soul liberated from the body. Botticelli's *Primavera* pictures the universal story of life's journey told by the poets, philosophers, and theologians of the Renaissance, of the soul's heavenly ascent to the ultimate serene repose of heaven. Neoplatonically, the inspiring loveliness of Botticelli's figures alludes to a higher beauty, just as the seeming perfection of Petrarch's Laura points toward the *idea* of beauty itself, which is *universale*. Through their poetry, the poets point to the ideal of oneness with God, of whom their beloved is the earthly personification, heaven-sent to elevate the poet to God. As such the *Primavera* is the "life" of Everyman, who journeys through his earthly existence to a final resting place in heaven. It is universal biography, a "life" in which the poet participates.

As biography, as exemplary biography, the *Primavera* has a direct bearing on the lives of Botticelli's patron and family. The picture was likely painted for Lorenzo di Pierfrancesco de' Medici on the occasion of his marriage in May 1482 to Semiramide Appiani. In this context, the picture can be seen in relation to the biographies of Lorenzo and his bride. Gesturing in salutation, Venus beckons them into her world of carnal and spiritual love. Venus and the other beautiful women can also be seen appropriately as rhetorical celebrations of the bride, flattering pictorial encomia to her own beauty. The epiphany of Venus

in Botticelli's bower of love crystallizes the central sacramental moment in the lives of the bride and bridegroom.

In its particularity, the universal journey of life that Botticelli paints also takes us back to Botticelli himself and, ultimately, to his own autobiography. For if Tuscan poetry is the story of the poet's life, of Dante's, Petrarch's, Poliziano's, and Lorenzo's, the story of the momentous, central event, the moment of "transfiguration," the instant when the poet realizes himself, becomes a poet journeying toward divine beauty, then so too is the *Primavera*, by implication, such a fictive representation—that is, the epiphany to Botticelli of the beautiful deity Venus and of her emanations, Chloris, Flora, and the Graces, all of whom, infusing him with love, define the moment when he becomes a poet. The *Primavera*, by analogy to the poetry of Dante and his followers, is Botticelli's *memoria* or record of his own life, the picture being his *vita nuova*, when he is reborn in beauty, in the spring of the year, as a poet. Speaking in remembrance of their love, the poets use such self-reflexive verbs as *ricordarmi* and *rimembrarmi*. Botticelli's picture is a similarly fictive, self-reflexive memory of his own imaginative experience, of his own aspiration through divine, beautiful *madonne* to heavenly grace.

The *Primavera* does not of course record what happened in Botticelli's quotidian life (as opposed to the life of his imagination) any more than Dante's poetry transcribes actual events in his life or Petrarch exactly records incidents in his life. The poetical "lives of the poets" as embodied in their poetry are highly fictive or imaginary, and their "lives," as recounted in their poetry, are created out of the "lives" of earlier poets. As Lorenzo de' Medici created his idealized biography from Petrarch's and Petrarch generated his own imaginative biography from Dante's, Botticelli painted his autobiography in fantasy from the entire tradition of such biographical poetry. In his "life" of the poet, his own, the past is the moment remembered in the vision of the bower of love, of Venus and attending figures, similarly divine; the present is the picture itself that records this past event; and the future of this life lies in Botticelli's hope, like that of all poets, that the beauty of his *poesia* will endure. The manifestation of artifice or virtue in the *Primavera*, which we have only partially uncovered, is the very index of that aspiration to glory. The picture's theme of the "journey of life" from this world to the beyond is universal. That it was determined by the wishes of the patron, who, calling it forth, partici-

pated in it himself, should not obscure our understanding that, as in all Tuscan poetry, where images of beautiful, eternal women record great moments in the lives of the poets, the very instances when they were born again, called to poetry, the *Primavera* is, by analogy and in accord with poetical conventions, such a record. However condensed, however fictive or imaginative, it is "the portrait of the artist," the autobiography of a self-conscious Tuscan poet, whose visive poetry is the self-reflexive account of his own life as a poet—indeed, his "real life."

There is one element of self-reflexivity in the *Primavera*, which has a bearing on Michelangelo's conception of himself as an artist. I am speaking of the implicit analogy in the painting between the creation or re-creation of nature, and the creation of poetry itself. In effect, like all the Tuscan poets writing in the romantic pastoral tradition, Botticelli finds the origins of poetry in nature, identifying his own poetry or "making," displayed so proudly in the *Primavera*, with the primordial creation of nature, which bounds to life anew in the spring of the year. When Michelangelo depicts scenes of Creation in the Sistine ceiling a short time later, he similarly associates poetry or art with primordial creation. In an unfinished sonnet (G 9) composed c. 1510, when he was painting these scenes of creation (Fig. 8), he spoke of God's "divine art." The image is unexceptional, a convention, but in the context of the Sistine ceiling, it suggests that if God is an artist, Michelangelo, in His image and likeness, is divine.

Like Botticelli, Michelangelo thinks of the analogy between primordial creation, natural or divine, and the creation of art. The word "creation" as a synonym for art did not come into common usage until the Romantic period, but the analogy was implicit in the autobiographical art of Botticelli and Michelangelo, through which these artists rendered the sense of their primordial, generative powers. Both the *Primavera* and the Sistine scenes of Creation are themselves great moments in the autobiographies of Botticelli and Michelangelo. As in poetry, Botticelli and Michelangelo affirmed their exalted identities through their very inventions.

In the *Primavera* the figure of Flora, so ingeniously conceived, is the *figura* of the poet's own fertility. Before we bid farewell to the particular myth that Botticelli uses to display his own fecundity, likened to that of nature, I wish to examine subsequent instances of the myth in poetical writing. Although both of these are found in English

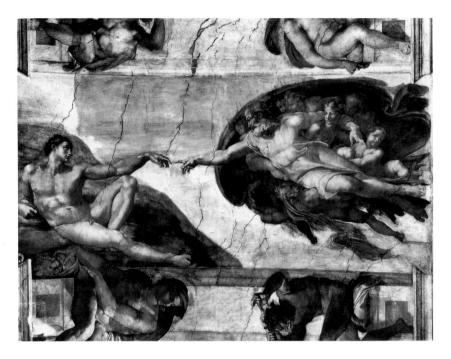

Fig. 8. Michelangelo, *Creation of Adam.* Sistine Chapel, Vatican Palace, Rome

literature, they reflect the kind of poetic self-reflexivity that we can trace from Ovid to Dante to Michelangelo. These later examples of poetic imagery reinforce our sense that in the history of art and literature "invention" has deep autobiographical significance.

When Botticelli brilliantly made visible the transformation of Chloris into Flora by metamorphosing the myth into that of Apollo and Daphne, he demonstrated, as we saw, his powers of "invention." *Invenzione* is the manifestation of the singularity of the artist, who, transforming received conventions, renders a novelty, a *nuova cosa.* He is necessarily like his own invention, which is an extension of himself, *straordinario, strano*—most rare. The history of Renaissance poetry is the story of the refashioning of conventions, through which the artist exhibits his own distinction, his own *essere* or being. Doing so, he calls attention to himself—in an art of heightened self-reflexivity!

The possibilities are prodigious and irresistible, and poet after poet

has yielded to the compulsions of the symbolic urgencies. Just as Botticelli demonstrated his own *virtù* through his artful use of the myth of Flora, so did Milton in a later period. In *L'Allegro*, Milton cunningly employs the myth without even naming Flora, as he celebrates Mirth's origins. After describing Melancholy, at "blackest midnight born," the poet sings of the birth of "heart-easing" Mirth, "Whom lovely *Venus* at a birth / With two sister Graces more / To Ivy-crowned *Bacchus* bore." But, he adds, there is another version of the story of Mirth: "The frolick Wind that breathes the Spring / *Zephir* with *Aurora* playing, / As he met her once a Maying, / There on Beds of Violets blew, / And fresh-blown Roses washt in dew, / Fill'd her with thee a daughter fair." There is no myth of Zephyr impregnating Aurora in ancient or Renaissance poetry. It is the poet's own invention, where now Aurora assumes the part of Chloris/Flora in the flower-filled month of May. The conflation of the myths of Flora and Aurora is particularly witty, for it conjoins quotidian and equinoctial rhythm, the changing times of day with the changing times of the year. Aurora now takes on the guise of Flora, incarnating the dawn of the new year. In other words, Aurora, as an incipient Flora, is the embodiment of a double birth—of the dawn of day and the inception of season.

In her very fecundity, Aurora is, we might also say, the personification of the poet himself, wittily pregnant with a new form of Flora. Milton's self-awareness, his consciousness of his own poetic singularity, is evident right before his presentation of the preferred, alternative explanation of the myth of Mirth, where he writes, "Or whether (as some sager sing)." Milton writes with alliterative irony, for he knows, as he expects his readers to know, that it is he, himself, John Milton, who has brought new meaning to the myth of Aurora, new form to the myth of Flora. The poet "sager" than the rest is Milton, for it is he who, inventing the myth of Mirth, brings together the births of the day and the year in the birth of his own poetry—finally, a triple birth. When, toward the end of the poem, Milton looks over his shoulder at "*Jonsons* learned Sock" and "sweetest *Shakespear*," he does so with acute historical self-consciousness from the heights of his own accomplishment, having achieved the Elysian or Paradisal summit of poetic glory. This glory resides in Milton's inventive powers, through which he achieves his identity as poet—defining his singularity, his quintessential self.

Let us next turn to another fiction that has biographical implications pertinent to our discussion of the autobiographical character of Tuscan poetry and of Botticelli's *Primavera*. I am speaking, perhaps surprisingly, of Henry Fielding's *The History of Tom Jones* and, more specifically, of the chapter where the author introduces his hero's future bride, Sophia Western. Let us recall that as a "history" Fielding's novel is necessarily a biography—a biography in which Fielding relies on the same poetic tradition to which Botticelli belongs biographically, the tradition which defined Botticelli's own *vita*. Fielding does not describe the epiphany of Sophia to Tom Jones but directly to the reader instead.

Like Botticelli, representing Flora, Fielding returns to the same myth, describing the wind god Zephyr "rising from his fragrant bed" as Sophia, a "lovely Flora . . . in loose attire" glides over the "verdant mead, where every flower rises to do her homage." As a new Flora, Sophia is like Botticelli's Flora and all the beautiful women from whom she descends: "bedecked with beauty, youth, sprightliness, innocence, modesty, and breathing sweetness from her sparkling eyes." In other words, Sophia is *umile, dolce, gentile*, with lights or *lumi* flashing from her eyes—a veritable catalogue incarnate of attributes of the beloved in Tuscan love lyrics, a portrait in words, evoking Botticelli's own charming goddess of flowers. This relationship is not surprising, since, as he describes her beauty, detail by detail, Fielding quotes from Sir John Suckling and John Donne, whose own poetry reflects the Petrarchan ideals of Italian poetry. Like the Italian poets, Fielding returns to classical art and poetry, comparing his beloved to the Medici *Venus*, of incomparable whiteness: *Nitor splendens Pario marmore purius*—"a gloss shining beyond the purest brightness of Parian marble." Sophia's "fairness" is thus still the *candidezza* of which Botticelli and the earlier Tuscan poets sang. Her joyous expression is worthy of Botticelli's Flora, for when she smiled "the sweetness of her temper diffused that glory over her countenance, which no regularity of feature can give."

Not only does Sophia's name mean *wisdom*, but, as Fielding insists, she had an elevated mind, mental accomplishments cultivated by art. A figure of charm, grace, delicacy, sweetness, manners, and gentility beyond compare, Sophia is one of the last in a long history of *donne angelicate* descending from the floriferous bowers of Tuscany. More to

the point, the Flora-like Sophia is the beloved of the biographer's subject, the Beatrice, so to speak, with whom Fielding's hero will be united at the end of his *commedia*. Whereas the love poetry of the Tuscans was fictive biography, now the poetry of love descending from Italy is assimilated to the sublime prose description of the heroine in Fielding's "history" or fictional biography.

Fielding, like the poets who inspire him, is writing not only about Sophia but, through her, about himself. Entitling his initial account of her in Book IV, chapter 2, "A Short Hint of What We Can Do in the Sublime, and a Description of Miss Sophia Western," he is thus referring to himself in the authorial "we." Fielding's account—to which the reader should return in full to savor its poetry—is a demonstration of his own poetic virtue or skill in a "sublime" style. "Sublime" came to mean many things in the eighteenth century, but here it clearly intends "exalted" or "lofty," referring to the author's abilities to exalt his heroine. Elevating her, he elevates himself through his art, as Petrarch demonstrated his own virtue by praising his Flora-like Laura, as Botticelli displayed his own sublime poetical skill in picturing Flora, as Milton exhibited his artifice metamorphosing Flora into Aurora. Like Botticelli, whose biography, whose life as a poet, is embedded in his poetry, Fielding introduces himself into his history of Tom Jones. Just as the *dolcezza* of Dante's Beatrice, the *grazia* of Petrarch's Laura, and the *delicatezza* of Botticelli's Flora bespeak the sweetness, grace, and delicacy of their poetry and therefore of themselves, Fielding's "sublime" hint of Sophia's beauty is the mirror image of his own sublimity.

As a Tristram Shandy *avant la lettre*, Fielding writes both autobiographically and self-mockingly as well as mock-heroically. Just before his lyrical presentation of Sophia, he includes a brief proem to his hymn, which he self-disparagingly describes as "Containing Five Pages of Paper." Nevertheless, Fielding continues, still reflexively but now more seriously, "Our intention, in short, is to introduce our heroine with the utmost solemnity in our power, with an elevation of style and all other circumstances proper to raise the veneration of our reader." Commenting on his own "similes, descriptions, and other kind of poetical embellishments," Fielding is following the tradition of the poets, like Dante, who glossed his own poetry with prose analysis in his *Vita Nuova*. Fielding thus presents himself autobiographically,

celebrating his own "solemnity," the elevating "power" of his own poetry. Fielding's fictive Flora-like Sophia embodies his own sublimity, impersonating his own skill as poet.

Fielding's sense of himself, of his own "life in art," as he creates a new Flora from Italianate poetry, is no less acute than that of an earlier poet who, autobiographically, exhibited his own *virtù* or "power," his own *energeia*, picturing Flora in a sublime visual poetry to which Fielding's "embellishments" are vitally and historically linked. Echoing the earlier Tuscan poets, through their English followers, Fielding asserts, "I, too, am a poet," and the poetry he makes as he re-creates their *madonne* anew is one of the central events in his life as an artist. What he says of Sophia, of her grace and beauty and wisdom, is true of himself, as of his poetry, for she is the personification of his very identity as poet.

We have observed that, in a sense, all poetic inventions are manifestations of the poet's self. When Michelangelo, for example, writes in the Petrarchan tradition later echoed by Fielding, he describes his beloved, hard as alpine stone, who is emblematic of his own petrified persona. The more stonelike she becomes in Michelangelo's inventions, the more Michelangelo comes to identify himself through her with his own statuary. When we turn back from the later reflexes of the Ovidian tradition in English literature to the Italy of Michelangelo, as I will in the following chapter, we will see how the latter, in his poetical figments, verbal and imagerial, transforming the conventions of classical and Tuscan poetry, endows with form his innermost self.

4

INVENTIONS OF THE SELF

Most of Michelangelo's extant poetry, both integral poems as well as fragments, was produced in the author's old age, in the 1530s and 1540s, when he was well over half a century old. From this corpus Michelangelo selected the finest examples, to be published in a single volume of *rime*, but the project, as we saw, did not come to fruition, because his friend Luigi del Riccio, who superintended plans for publication, died during the preparatory stages of the project.

Although art historians ponder Michelangelo's origins as painter and sculptor, they have little to say about his origins as poet. The question is vexed because only a handful of examples have come down to us from the period before c. 1510, when Michelangelo was already a mature artist; these are preserved on sheets of drawing or in letters. No poetry is known today that can be dated from the 1490s, and only a very few poems can be dated from the period immediately before Michelangelo began painting the Sistine ceiling, at which time he composed the well-known, grotesque, self-mocking sonnet to Giovanni da Pistoia, describing in comic detail the pains of his travail. It is perfectly possible that Michelangelo did not begin to write poetry until c. 1500, when he was twenty-five years old, but it is also possible that he had written poetry earlier, of which there is no longer a trace. Like his first efforts in sculpture, which have vanished, Michelangelo's presumed initial essays in poetry may have similarly disappeared. Not implausibly, just as he later burned his drawings in order

to conceal his labors and did away with his earliest, crude efforts in carving, he may also have cast aside his earliest efforts in poetry, deeming them unworthy of preservation.

The question of Michelangelo's poetic origins is germane to our discussion of poetic origins in general. Poets define themselves, we have observed, through their very inventions. These *invenzioni* are based on the conventions of earlier poetry, but the poet demonstrates his own individuality through the novelty in his handling of received imagery. It is safe to say that Michelangelo first exhibited his full powers as poet in the Sistine ceiling, which is a monumental work of epic poetry. The oft-cited allusion to Dante in the scene of the hanging of Haman marks Michelangelo's aspiration to transform the frescoes into a Christian epic, and the very grandeur of Michelangelo's classically inspired nudes affirms his ambition to achieve an epic scale in art. Although it is generally assumed that Michelangelo followed theological guidelines—that somebody furnished him with a "program"—his poetical novelty emerges, nonetheless, in the way in which he conceived his allegorical subjects. Many aspects of poetic metaphor in the ceiling betray the idiosyncratic impress of Michelangelo's inventive powers—metaphors consistent with poetic figures in both his later poetry and his poetical autobiography. To identify Michelangelo's poetic *invenzioni* within the framework of a received scheme is to clarify our sense of Michelangelo's identity as poet, to sharpen our perception of Michelangelo's image of himself. Poetic invention in the Sistine ceiling is, at bottom, no less autobiographical in implication than the self-reflexive metamorphoses of Botticelli's *Primavera*.

Before turning to the poetry of the Sistine ceiling and its autobiographical resonances, however, I want to pause and consider the one early poem that occasionally receives detailed attention from Michelangelo's scholars, "Quanto si gode," a sonnet written in Bologna at the end of 1507 and preserved in a letter. Although certainly not a great poem, it nonetheless reflects aspects of Michelangelo's temperament and poetic aspirations—aspects of his self-formation. Literally rendered in prose, the poem reads as follows:

> How much the garland on her golden locks enjoys itself, happy and well made from flowers, each rivaling the other to be the first to kiss her head. How contented that dress which through

the day supports her bosom and seems to swell, and the golden threads never cease to touch her cheeks and neck. But even happier is that ribbon of golden lamé, perfectly tempered, which presses and squeezes the breast, which it binds. And the belt tied in a knot seems to say to itself: "Here I wish to squeeze forever!" What, then, is there for my arms to do?

The diction of Michelangelo's poem, it has been observed, recalls that of Poliziano's *Stanze*. Echoing the latter's rhyme in the description of the exquisite Simonetta, "candida la vesta . . . aurea testa . . . avea contesta . . . la sua vesta," Michelangelo chimes in with the similar "contesta . . . testa . . . vesta." Whereas Poliziano's description of Simonetta is that of an ethereal beauty, Michelangelo's poem is rather more erotic, and in this respect its imagery recalls that in the playful picture of Mars and Venus (Fig. 9) by his older friend, Botticelli. The happy gold ribbon or *nastro dorato* of the beloved's dress in Michelangelo's poem, pressing "the breast that it binds," is evocative of Venus's dress pictured by Botticelli, the golden borders of which voluptuously encircle and define and, finally, support her assertive breasts, to which the folds of her gown suggestively conduct the unreluctant eye.

Michelangelo's poem has deeper roots in the poetry of Petrarch. Michelangelo inverts *Canzoniere* 300, rewriting it ironically. Whereas Petrarch begins enviously, "Quanta invidia," Michelangelo commences in counterpoint, "Quanto si gode," all but paradoxically concealing his envy of the dress of his beloved, since he describes its pleasure as if it were his own. Petrarch envies the "avaricious earth" that embraces ("abbracci") his beloved's remains, and he envies heaven, which binds her spirit to it, gathering her soul to itself with cupidity—"sì cupidamente à in sé raccolto." The wit of Petrarch's conceit resides in the play between spirit and flesh, in the use of a physical metaphor for spiritual union. Michelangelo ironically reduces these corporeal figures of speech to felicitous absurdity, making them literal in the squeezing or *stringere* of his beloved's breast. He expresses the very spirituality out of Petrarch's embrace.

When the dress of Michelangelo's beloved asks, "What need have I of arms," these words could almost be referring to the embracing arms of Petrarch's earth that cling to his beloved's remains. And when Michelangelo uses the verb *serrare* to suggest how the dress "holds" his beloved's breast ("serra il petto"), he coyly and mockingly uses the

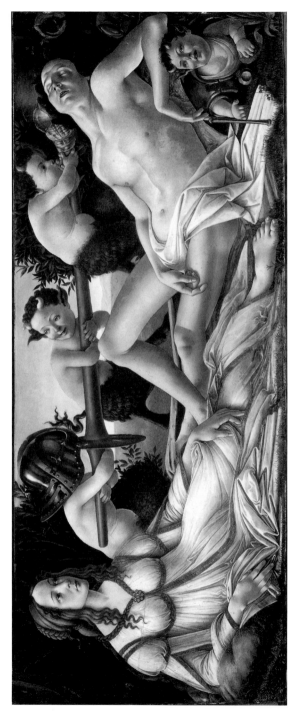

Fig. 9. Botticelli, *Mars and Venus*. National Gallery, London

same verb that Petrarch employs, saying that heaven "holds" Laura's spirit to itself. What is figurative in Petrarch becomes literal in Michelangelo. The embrace of Michelangelo's dress is no *abbraccio spirituale*. Whereas Petrarch laments his distance from his beloved, Michelangelo collapses or explodes this distance completely by imaging the dress as if it were his beloved's second skin, as if he himself were the very dress clinging to her. In short, Michelangelo divests Petrarch's poem of its old meaning, invests it with new. Particle becomes antiparticle as he transforms Petrarch's image of envy into one of arousal and fulfillment in an anti-Petrarchan *tour de force*.

Although the explicitly erotic character of the poem is atypical of Michelangelo's poetry as we know it, its tactility, rendered in the verbs *toccare, premere, allacciare, annodare,* and *stringere* (to touch, press, bind, knot, and squeeze), is closely related to the powerful sense of touch in Michelangelo's painting and sculpture. The erotic core of the playful poem suggests the sensuality of the *Bacchus*, the *Captives*, and even the *David*, not to mention the erotically charged statuary of the Medici Chapel, the copulative details of his architecture, the design for a picture of Leda and the Swan. The physical pressures of the poem, its *stringere* and *premere*, have analogues in Michelangelo's descriptions of physical pain, for example, his comic account of his body twisted into postures of great strain, his loins crushing into his belly, his belly forced to bend under his chin, his body bent into the shape of a bow when he is at work on the Sistine ceiling frescoes. Pleasure has here turned to pain, but Michelangelo is still tentatively exploring the boundaries of bodily experience, probing the horizons.

One subsequent work in Michelangelo's *oeuvre* harks back to the early poem in a surprisingly antithetical manner. I am speaking of his design for a picture of Noli Me Tangere, known from a painting after his invention by Pontormo (Fig. 10). Traditionally, when Christ appears to Mary Magdalene in Renaissance paintings, for example, in Fra Angelico's representation of the subject, he extends his arm, as if to say, "Touch me not, for I am not yet ascended to my Father." In Michelangelo's radical revision of the subject, seen in Pontormo's painting after his design, Mary has been allowed to come exceptionally close to Christ, extending *her* arm not only as if to touch but to embrace him. Michelangelo, in an extraordinarily charged reinterpretation of Christ's gesture, shows his right hand extended to repel the

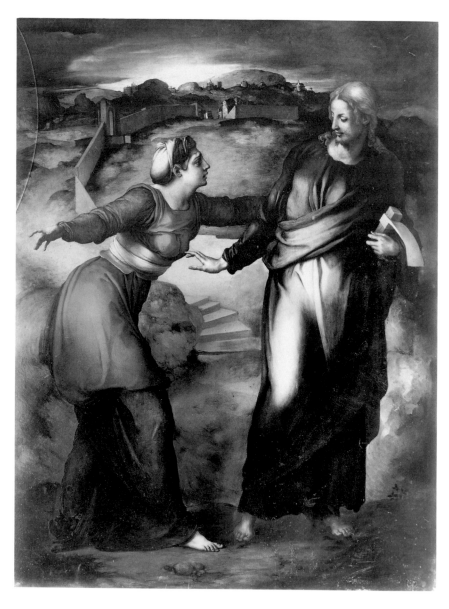

Fig. 10. Pontormo, *Noli Me Tangere*. Casa Buonarroti, Florence

Magdalene in such a way that his index finger very nearly touches her protruding breasts. The effect is profoundly erotic, but this displacement, this sexual metaphor, depending on the stunning proximity of hand to breast, apposition without appulsion, heightens, at the last, the physical remove and spirituality of Christ, the ascendancy of the resisting spirit over the alluring body. Much of this eroticism depends, we cannot fail to observe, on the effect of the tautly adhesive dress, which emphasizes the Magdalene's bosom—a dress which, in its effect, is closely related to the tightly clinging dress of Michelangelo's fictive beloved in the earlier erotic poem.

Let us advert now again to the "poetry" of the Sistine ceiling frescoes. Although there is little written poetry by Michelangelo during the period of the Sistine ceiling, as we have observed, these frescoes are themselves a supreme manifestation of Michelangelo as poet. When we examine these paintings neither for their uses of classical statuary nor for their reflection of a theological program but for their elements of poetry, we behold a crucial moment in Michelangelo's formation as a poet or, to put it differently, in Michelangelo's self-formation through his poetry. The narratives of the ceiling frescoes do not refer explicitly to particular episodes in the artist's life, but there are autobiographical resonances in their imagery. I am speaking of the way in which Michelangelo uses arboreal symbolism to render his characteristically austere, indeed physically painful, sense of sinfulness in interrelated scenes of the ceiling. The overall meaning of the trees in the Sistine ceiling has been much discussed, but important aspects of Michelangelo's uses of these symbols have been overlooked and require elucidation. To identify his neglected arboreal *invenzioni* is not only to recognize Michelangelo's sources in poetry but to see Michelangelo effectively inventing himself as an artist, inventing himself as a distinctive, highly idiosyncratic pictorial poet.

In the *Flood* (Fig. 11) Michelangelo rendered two trees, a living tree on the right (partially obliterated in the eighteenth century and now mostly invisible) and a dead tree on the left. These two trees, it has been justly observed, refer to the green and withered trees of Luke 23:31: "For if they do these things in a green tree, what shall be done in the dry?" These trees are also related to the ceiling's more general arboreal symbolism. The acorn-laden oaks throughout the ceiling are emblematic of Pope Julius's name Rovere (oak) and refer, as Vasari observed, to the revival of the Golden Age under the Pope.

Fig. 11. Michelangelo, *Flood*. Sistine Chapel, Vatican Palace, Rome

They also refer allegorically, as it has also been said, to the Tree of Life and are thus part of the ceiling's larger Christological meaning.

At the left of the flood, on high ground, Michelangelo depicted men, women, and children who have temporarily escaped their imminent death. Prominent among these figures at the base of a dead tree is a nude female. Inert, she reclines, looking downward, as if in resignation; and a child, presumably her own, brings his hand to his face, as if to wipe away tears. These figures are related to two mothers with children on either side of the tree: the one who takes her child from her spouse at the extreme left, the other who clutches one child as another holds onto her leg. In this circle of mothers, we behold a childless couple, their backs turned to us, gazing up at the dead tree into which a male figure has climbed, vainly seeking to escape his fate. This haunting, unforgettable scene of fear, resignation, and death refers, I submit, to the very passage in Luke immediately preceding the words on the green and dry trees. As Christ was led to Calvary, there was "a great company of people, and of women, which also bewailed and lamented him." Just before He spoke of the trees, Jesus turned to the crowd and said: "Daughters of Jerusalem, weep not for me, but weep for yourselves, and for your children. For behold, the days are coming in which they shall say, Blessed are the barren, and the wombs that never bore, and the paps which never gave suck" (Luke 23:27–29).

Michelangelo's scene—a "barren" world of rock and "dry" tree— includes a "great company of people," prominent among them mothers and children who recall the daughters of Jerusalem and their offspring. The crying child metaphorically evokes the tears to which Jesus refers; the child's sorrowful mother, shown with exposed breasts that no longer nurse, epitomizes the barrenness of which Jesus also speaks: as Jesus says that those women whose wombs are barren, whose breasts have never nursed, will be called blessed, so Michelangelo alludes to these words, representing as doomed the mothers who have borne children and nursed them. Like the dry tree, these mothers are dead in sin, foretelling the Last Judgment to which Jesus' words refer. In Luke 23, Jesus prophesies the horrifying eternal punishment of the sinful, and Michelangelo alludes to this prophecy in the *Flood*, which is the very type of hell in the Last Judgment. Although the *Flood* represents an Old Testament event, Michelangelo refers to the future, apocalyptic doom of the sinful through Christ's

words in Luke. We should also not fail to observe here that Michelangelo's image of a despondent mother who does not give suck to her child is the antithesis of the *balia* or *nutrice* who figures so prominently in his subsequent poetry and poetical autobiography.

Michelangelo emphasizes his theme of death in sin by depicting a dead tree stump with two chopped-off branches emerging from the leg of the reclining woman in the foreground of the *Flood*. Like Dante before him and the classical poets Virgil and Ovid, who inspired Dante, Michelangelo associates the trunk and limbs of the human body with the form of a tree. We are reminded here of *Inferno* XIII, which illustrates the circle of the suicides, wherein there was no green branch, no smooth boughs, no fruits—"non fronde verde . . . non rami schietti . . . non pomi v'eran." In Dante the sinners have been metamorphosed into trees, one of which cries out in pain when the poet snaps a branch. This passage, it has been said, echoes the Polydorus scene of the *Aeneid*, where Virgil links the limbs or *membra* of tree and human body, and when Dante speaks of the *tronco* or trunk that spoke to him, it has further been noted, he also echoed a related passage in *Metamorphoses*. In the Bible Luke only compares the green and dry tree to a humanity that is blessed or damned in a general way, whereas Dante, following Virgil and Ovid, associates humanity with trees by specifically comparing their respective limbs and trunks. Although trees and human beings are distinct in Michelangelo's image, he ingeniously reconceives the dry tree of Luke, following Dante, as Dante followed Ovid and Virgil, by focusing on the analogy between limbs and trunks of human and botanical form.

Michelangelo underscores his theme in the male figure climbing and wrapped around the dead tree above so that the man's extended arms seem to merge with a prominent branch; in fact, the limb of the tree seems a very replica of his left arm. By having the figure actually clutch the dead branch with the hand of his own outreached limb, Michelangelo establishes an identity between limb and limb that approaches their utter identity in Dante and the classical poets. To put it differently, the branch of the dead tree seems to be an extension of the male figure's own bodily limb. The tree's death is a visual echo of the man's metaphorical death in sin. Michelangelo has thus amplified the meaning of Christ's prophecy in Luke in his classicized Dantesque and biblical *invenzione* of mothers and children, his evocation of tears and of breasts that will no longer give suck; in his classicized image of

sinfulness and death, of dead trees and those dead in sin, of barren-
ness and doom.

Michelangelo also amplifies the passage at the left of the *Flood* in
two scenes painted subsequently: the *Creation of Eve* and *Original
Sin*. In the former (Fig. 12), Michelangelo has set his figures once
again in a barren, rocky setting, placing Adam's reclining body against
another dead tree stump. Rising from the stump is a dead branch with
two smaller cut-off limbs extending from it. The larger branch of this
torsolike stump, which resembles the stump below the mother in the
Flood, parallels the rising trunk and limbs of Eve. In this bleak scene,
Michelangelo comments through the dead tree on the sinfulness of
Eve, who, eating esuriently of the Tree of Knowledge, will die in sin.

Michelangelo makes this point even more evident in the fresco
Original Sin and the Expulsion (Fig. 13), where he paints Eden not as
the flowery *paradiso* of other Renaissance paintings, but as barren

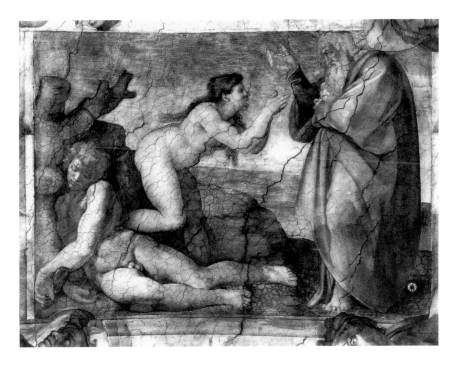

Fig. 12. Michelangelo, *Creation of Eve*. Sistine Chapel, Vatican Palace, Rome

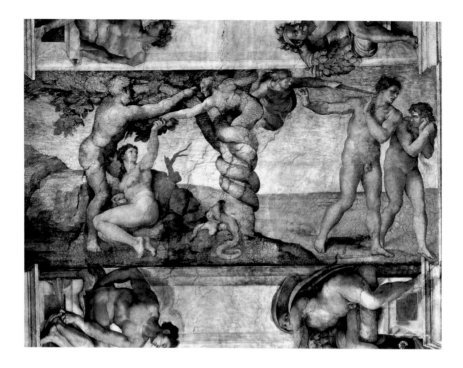

Fig. 13. Michelangelo, *Original Sin and the Expulsion*. Sistine Chapel, Vatican Palace, Rome

and rocky. His Eden is the "cursed" ground of sinfulness, and he embellishes this theme with another dead stump, which emerges from the rock at the very spot where Eve is seated. The shortened tree trunk seems to emerge from Eve's own torso. As the fruitful limb of the tree of wisdom bends toward Adam and Eve, the dead trunk bends toward the tree. This antithesis again suggests the symbolic relation of a green tree and a dry tree. From the dead trunk a limb projects over the horizon, parallel to the upper torso and head of Eve, while from this dead branch two other, smaller dead limbs project skyward. These are parallel to Eve's extended limb—significantly, her left, or "sinister," arm. The dead stump, its trunk, and branches, seen in relation to Eve's body, as in the *Creation of Eve*, clearly allude to her sinfulness, just as the tree stump and dead tree of the *Flood* signify the sinfulness of mankind.

In these images of sterile rock and dead trees, which are also found

in his poetry, Michelangelo connects original sin with the sinfulness of the human race before the Flood. In this context, all the tree stumps in the Sistine ceiling frescoes evoke Christ's words in Matthew 3:10: "Every tree which bringeth not forth good fruit is hewn down, and cast into the fire." In the larger scheme of the ceiling, the emphasis on sinfulness is seen in contrast to the prophesied grace of Christ, who redeemed mankind through His sacrifice (the central subject of Luke 23). The dead trees in Michelangelo's *Flood, Creation of Eve*, and *Original Sin*, all associated with sin, are to be seen in antithetical relation (in *contrapposto*, as it were) to the fruitful, acorn-laden boughs that conspicuously adorn the ceiling—those "golden boughs" of the Tree of Life that, bearing good fruit, stand for spiritual rebirth through the coming of Christ.

In his essay "The Poetry of Michelangelo," Walter Pater quotes Herman Grimm, who says of Michelangelo that in his art "woods, clouds, seas, and mountains disappear." Embellishing Grimm, Pater further observes that Michelangelo "traced no flowers" like Leonardo's, "no forest-scenery" like Titian's, adding that Michelangelo pictured "only blank ranges of rock and dim vegetable forms." Pater is writing poetically and suggestively about the Sistine ceiling, where dead trees predominate, where, even into the Garden of Eden, often pictured as a fertile place, Michelangelo introduces, above an austere strip of green, large boulders out of which emerges a dead tree stump in antithetical relation to the Tree of Knowledge. Michelangelo pictures here in his biblical poetry a world seemingly remote from that of the Renaissance pastoral, of Renaissance gardens, where nature is fecund and cultivated. As we will see, however, Michelangelo's emphasis on the sterility of nature, on dead trees issuing from infertile stone, is part of a larger poetic vision that is, paradoxically, a version of the pastoral, which is central to the very way in which Michelangelo defines himself.

Poetic *invenzioni* are the means through which artists give shape to their very personae. We have pondered here only a few instances, in words and visual representation, from the *oeuvre* of Michelangelo, but these are typical of the artist. Although the imagery of the erotic sonnet is not typical of Michelangelo's known poetry, its sheer physicality and tactility are true to the artist's exploration of the living body in sculpture and sculptural painting. The metaphor of dead trees in the Sistine ceiling is a poignant, haunting meditation on death and

sin, united with such imagery in his poetry. These two instances of poetic expression are central to the ultimate paradox of an artist who is the supreme hymnist of the human body in all its vibrant vitality at the same time that he is also the consummate elegist of the body's denial and eventual extinction. Over and over in Michelangelo's inventions we encounter this polarity, this struggle between affirmation and denial. Much of the fascination of his art and hence of his very persona resides in the profoundly existential, primordial conflict of will that lies at the very heart of Michelangelo's being.

5

THE PAINTED PERSONA OF THE PASTORAL POET

Let us move from the barren, infertile realm of Michelangelo's apparent antipastoral back to the lush greenworld of the pastoral itself. It is here that we find the very origins of art in nature. Such is the theme of classical pastoral poetry, where poets, retreating to the peace and solitude of nature, create their poetry surrounded by sheep or goats feeding on acorns and berries. In this rude nature, Michelangelo was raised, nurtured by a rustic wet-nurse. The tradition of the pastoral is transformed in the romantic pastoralism of medieval literature, in which the poet retires to a natural world now more refined and courtly. Nature is here domesticated, more artificial, but nature it remains, for it is in a greenworld of the bower of love that the poet beholds his beloved on a flower-fraught carpet, beneath a tree full of song birds, by a bubbling brook or stream. Such is the world of Petrarch's or Botticelli's romantic pastoral *poesia*, which, as we have seen, is autobiographical in character.

The distinction between a rough, coarse-grained pastoral and a more refined, exquisite courtly pastoral is itself artificial, since at bottom, as students of genre observe, even the most apparently humble pastoral poetry is written by poets who are themselves artful, sophisticated, and cultivated. Indeed these urbane poets enter into the countryside, masquerading as herdsmen. Paradoxically, the pastoral is always urbane, for it is defined by courtiers or city-dwellers, who retreat into the country. This urbanity is found everywhere in the

pastoral of the Renaissance, not least in the *Fête Champêtre* (Fig. 14). No less than Botticelli's *Primavera*, the Venetian picture, as a painting about poetry, is itself a *poesia* about the origins of art. It is also, as we will see, the story of the poet, that is, his life-story or biography. This biography, like that in the poetry of Dante and Botticelli or in the poetical autobiography of Michelangelo, is fictional, but biography it *is*. It is a further index of the emerging autobiographical or self-reflexive character of art during the lifetime of Michelangelo. As an analogue of Michelangelo's own impulse to autobiography, the Venetian picture commands our attention here. An analysis of it deepens our sense of the relations between autobiographical art and artful autobiography.

The Giorgionesque *Fête Champêtre*, now generally attributed to Titian, is a painting that, defying analysis, remains an enigma. This is so because it seems to tell no exact story and consequently appears to

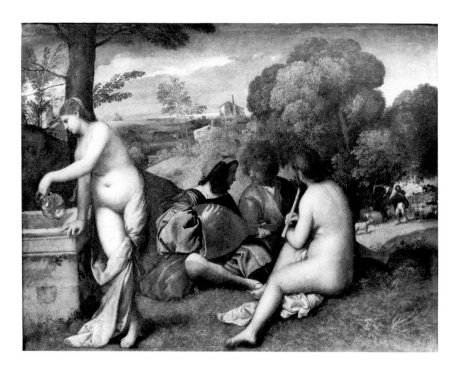

Fig. 14. Titian, *Fête Champêtre*. Musée du Louvre, Paris

be without precise meaning. The picture is, instead, evocative, its meaning generic. It proclaims itself to be, as another of its titles implies, a *Pastorale*—a particularly self-conscious one, since it stands with other works by Bellini and Giorgione and their schools as the origin of a type of picture not seen in Italy before c. 1500. It is, in the language of that day, a *novità*.

To the viewer steeped in pastoral poetry the subject of Titian's painted poem is suggestive of the genre's conventions. The lush, verdant landscape of the *Fête Champêtre* evokes the conventional *locus amoenus* or "pleasance," and the nymphs who grace this place are the woodland creatures who populate sylvan realms. As the courtier seated at the very center of this idyll plays his lute and a rustic herdsman inclines his head to listen, the viewer recalls those bowers of bucolic poetry where friends rendezvous for the sheer pleasure of each other's company. Here, too, as in the Arcadian poetry that inspired Giorgione's and Titian's own form of pictorial idyll, one further beholds in the background a herdsman, whose bagpipes distantly echo the song of the poet.

The courtier, who makes the "unheard melodies" (to which we listen with our eyes), is a richly suggestive presence in Titian's poem. He is, as it has been justly observed, the very figure of the poet. Picturing this courtly musician-poet, the artist renders his own persona, since the painter is himself a poet. In this respect, the painting is supremely self-conscious, for the poet-painter does not simply paint a poem but fictively projects the imaginative image of himself as poet. No matter that his musical doppelgänger plays the lute, while he handles a brush, for in a profoundly metaphorical sense the graceful hand of the musician, delicately suspended over his instrument, represents his own gentle hand, suspended over the canvas itself. In accord with Renaissance aesthetic notions, painters and musicians, both creating *armonia* and *concordia*, are identified with each other, painting and music being "sister arts," in the same way that music and poetry are. The rapport between the subjects of this musical picture and their modulated unison with the landscape mimics the very harmonies of music. The picture thus reverberates with the poetical painter's own musical aspirations.

Such ideals were poetically codified by Vasari in his fictive biography of the artist in whose manner the *Fête Champêtre* was painted. Speaking of Giorgione as a courteous gentleman, conversationalist,

and amorous voluptuary, who enjoyed the company of noble persons, playing the lute and singing divinely, Vasari could almost have been describing the courtly presence at the center of the Giorgionesque *Fête Champêtre*—as if the seated courtier were the exemplary figure from whom he poetically invented his "portrait of the artist." This is so because Vasari, with his engaging and characteristic sleight-of-hand, created his image of the painter from the imagery and the manner of works by Giorgione and artists of his school, whose paintings still showed the impress of Giorgione's vision. According to Renaissance fiction, the style or *maniera* is the man. Today we speak of this notion as "artistic personality"—that is, the artist portrays himself through his work. Where we use the word "personality," we can substitute "persona," the mask of the painter, and where we speak of his *maniera*, recalling the origins of the word in *mano*, we note that he fashions this mask with his own hand.

Painting a poet at the center of his idyll, Titian renders the idealized image of the very poet with whom he identifies himself as the poetical author of his own pictorial poem. He follows the highly self-reflexive tradition of Italian poetry in which poets write about themselves. In lyric poetry of the pastoral tradition, from Dante and Petrarch to Bembo, the poet sings of his love for a beautiful woman in a bucolic setting, speaking of the inspiration of the poem and thus of the creation of the poet himself. "Every painter paints himself," became proverbial in the late fifteenth and sixteenth centuries precisely because the arts were construed as self-revelatory. Just as Dante betrayed his ambition to emulate the epic poets, especially Virgil, and Michelangelo identified himself with the modern epic poet Dante, Titian aspired to make himself one with the pastoral poets, both ancient and modern, and the poet whom he pictures in his own self-reflective pastoral painting is the personification of that aspiration, of his very persona as poet. The lyric or pastoral poet sings in the first person, but that voice is necessarily fictive, for it is the artful invention of the poet. That is to say, there is both the poet and his persona, through whose voice he sings. By analogy Titian paints in the first person, making music through his persona as poet at the center of his picture. In the *Fête Champêtre*, the fictive poet's song echoes the pastoral world in which he appears and re-creates that world anew.

The self-reflectiveness of Titian's painting, evident in the projec-

tion of his own artistic persona as a poet, is related to a cluster of other indices of artistic self-consciousness in the same period. Increasingly, for example, painters quite literally left their individual "mark" on the picture, indeed autographic brush strokes. At the same time, in parallel fashion, they came to sign their works more frequently and prominently. Titian is singular in both these respects, and his subsequent paintings were distinguished more and more by such marks, what were called his *macchie* or, as we might say, his signature strokes. These strokes of the brush betray the gesture of the artist's hand in the very "making" of the picture, in the root sense of *poiesis* or poetry. The magnified manifestation of the painter's poetic process in the making of his picture is a reflection of his hand or *mano*. This exhibition of the hand reminds us that in the period the artist's hand was also glorified in words, as when Vasari spoke of Michelangelo's "divine" hands.

The word "hand" or *mano*, as we have observed elsewhere, is linked to the important word used in describing the particular manner or *maniera* of the artist. Numerous writers, notably Vasari, distinguished the individual *maniere* of painters, as did Castiglione, who, using the word *stilo* to characterize the individuality of pictorial style, observed the diversity between styles: *diversità tra se*. The word *se* brings us back to the artist's very self, what distinguishes him from all other painters. *Maniere* are versions of selves. The poetic consciousness of painters was matched at the time by the desire of patrons to collect (no matter what the subject) works "by the hand" or *mano* of specific artists—a Titian or a Raphael. In this respect, the manner of the work came to be central to its essence or being. Patrons recognized and prized the particular poetry of individual hands at work through the *maniere* of their paintings.

Returning to the *Fête Champêtre*, we recognize a seeming paradox. At the same time that Titian projects his own persona, he nevertheless makes his image so thoroughly "in the manner" of Giorgione that some still believe the picture his, and even those who now attribute it to Titian acknowledge that it is profoundly Giorgionesque—that is, in the manner of Giorgione. One might even imagine a sixteenth-century collector who, seeking a work by Giorgione, acquired the *Fête Champêtre* as an example from the artist's hand. What we might say about this ambiguity is that, projecting his persona as poet, Titian still wears the mask of Giorgione, masquerading, in a sense, as Gior-

gione the poet. Painting the *Fête Champêtre*, Titian had not yet become himself, had not yet fully given form to *himself*. In this respect, the painting represents a particular moment in the *Bildungsroman* of Titian's autobiography.

Titian's self-consciousness in the *Fête Champêtre*, where he assumes the role of Giorgionesque poet, is also closely bound to the emergence of various kinds of writings by and about art and artists. The spread of art theory in the sixteenth century, for example, is the proliferation of discussion of the practice and style of art, of how art is made and in what fashion. This discussion illuminates the consciousness of the artist, which, however technical, abstract, and seemingly impersonal it may be, is always determined by the activity of particular artists or selves. Although the word "theory" often takes on aggrandized connotations, we should recall that, in the root sense of the word, in Greek, it means "seeing" or "beholding." In other words, theory is "vision," and such vision, however generalized it may become, is rooted in the specific experiences of particular artists, in the consciousness of their own practice as artists, their sense of self.

The self-reflexive biographical and theoretical implications of the *Fête Champêtre*, which records a particular moment in the artist's formation or life and his theory or vision of painting as poetry, is linked, however imaginatively, with the flowering of Renaissance biographies and autobiographies of artists. The *Lives* by Vasari and the autobiography of Michelangelo are saturated with theory—a theory of art that emphasizes the close relations of painting to poetry and music. These biographies and autobiographies, which like Titian's autobiographical picture have their deep roots in autobiographical poetry, are also intimately connected with the increasing number of effigies of artists or self-portraits of artists in the sixteenth century. Indeed, such portraits accompany biographies in the form of woodcut prints in the second edition of Vasari's book. These portraits are often, though not always, imaginary, and in this respect correspond to the deeply poetical character of Vasari's biographies, which are exemplary fictions. His fictionalized biographies and portraits of artists are the analogues of Titian's fictive or poetical portrayal of himself as Giorgionesque poet in the *Fête Champêtre*, and, in the progressive mimesis of history, Titian's identification with Giorgione as pastoral poet is closely bound up with the autobiographical writing of Michelangelo, who, following

especially the examples of Dante and Petrarch, assumes the self-glorifying personae of poets in their fictions of the self.

In the Renaissance the rise of biography, grounded in poetry, is interconnected with the rich development of historical writing. Vasari's *Lives*, both biography and history, is a supreme example of these kinds of literature, merging one genre into the other. Biography and history fuse also in the *Fête Champêtre*. The life of the contemporary poet pictured here evokes the very origins of poetry in the distant past. Poets are forever saying that poetry was born when the poet retired to the quiet and beauty of the pastoral world, where he was able to contemplate and compose. This is the story that Titian self-reflexively paints, for it is not only his own idealized story that he tells in particular but, more universally, the history of poetry's origins long ago, in a classical Arcadian setting, which nostalgically evokes, through its exquisite harmonies, an even earlier moment, that of the Golden Age. Re-creating this earlier epoch of harmony and peace, Titian weds his own fictive history as poet to that of ancient history and myth. Although the poet, past or present, retires to the rustic realm to make his poetry, in harmony with nature, he is himself never a rustic. Indeed, as the poets insist, Titian among them, the poet is always urban as well as urbane. The highly civilized, courtly poet at the center of the *Fête Champêtre* who stands for both Titian and his ancient ancestors is the epitome of *urbanitas*.

The pastoral poet who is the very figure of the painter himself in the *Fête Champêtre* is also related to all those artists of pastoral origins in the pages of Vasari. Following Ghiberti, Vasari spoke of the young Giotto as a shepherd, tracing the pastoral origins as well of Castagno, Mantegna, Andrea Sansovino, Giovanni da Udine, Beccafumi, and even of Michelangelo, who, like Giotto, was raised on a farm, in a place "abundant in stone"—in the rustic realm of rock. Like Titian, Vasari shows us that his pastoral poets are nevertheless urbane. Giotto is gracious and courtly, witty in his utterances to the king of Naples, Sansovino becomes a patrician of sorts, Mantegna is knighted, and Michelangelo, of assumed noble origins, is presented as a lordly figure, like Giotto, witty and superior in bearing. All of Vasari's rustic painters and sculptors are figures of virtue with the exception of the satanic Castagno, their antipode, the serpent in Vasari's Edenic Arcadia.

Evoking the origins of *poesia*, of art, in the pastoral world, Titian's *Fête Champêtre* is linked in a close commissure to other contemporary paintings that sing of the rustic sources of poetry. Signorelli's *pastorale*, known as the "Kingdom of Pan," is a prominent example. Here, in a courtly scene, where the God of nature, pastoral poet *par excellence*, presides, a group of nude figures, some holding pipes, stand or recline languorously, paying homage to their rustic ruler. Rich in associations, which we will consider more fully below, the picture mournfully memorializes the very origins of poetry and music, for the prominent pipes recall the reeds into which Syrinx, subject of Pan's unrequited love, was metamorphosed most melancholically. The doleful tone of Signorelli's picture is appropriate to its elegiac purpose. Like Titian's *Fête Champêtre*, Signorelli's picture imagines an ancient world that, in turn, resonates of an age even more venerable.

At the very moment that Titian painted the *Fête Champêtre*, Raphael executed his pastoral "Origins of Poetry," known as *Parnassus* (Fig. 15), pictured in the papal apartments of Julius II. Like the *Fête Champêtre*, Raphael's fresco is at once about the springs of poetry in the past and about the creation anew of poetry in the modern world. It traces the hierarchy of poetic inspiration from the music of the heavenly spheres, pictured in the ceiling above, to Apollo, poet laureate of Parnassus, the Muses, the ancient poets, and, finally, the moderns. The *Parnassus* is, in a sense, the very history of poetry, of poetic inspiration—itself the most recent example. No wonder Bellori, writing in the following century, would imagine that Raphael had pictured himself autobiographically atop *Parnassus*—evoking the famous passage in the *Commedia*, where Dante tells us, also autobiographically, that the great classical poets called him to their company, making him one of their number. Whatever the fresco meant to the Pope and his court, it is inconceivable that its maker should not have identified himself with the poets whom he portrayed. No less than Virgil, he invokes the Muses, no less than Dante he memorializes the greatest ancient poets, no less than Titian he proclaims that painting is poetry, that he too is a poet: *"anch' io son poeta."* If Titian painted his persona as poet at the center of his painting, Raphael identifies himself, in a sense, with all the poets whom he has rendered, for although he did not in fact paint his own portrait in the *Parnassus*, his fresco is, itself, a *poesia all'antica*. Like Titian, Raphael defined himself through his

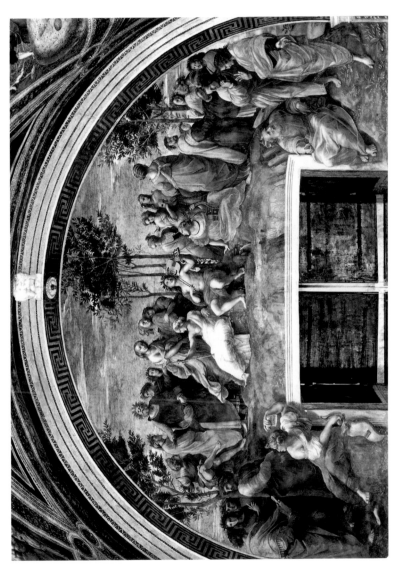

Fig. 15. Raphael, *Parnassus*. Stanza della Segnatura, Vatican Palace, Rome

very emulation of the classical poets, placing himself in the tradition of Apollo, as Titian situated himself in relation to the pastoral poets of antiquity. The emergence of the painter as poet c. 1500, epitomized by Titian's *Fête* and evident in numerous other poetical paintings, including Raphael's, is a complex phenomenon in the intertwined history of biography, theory, and historical writing and, ultimately, in the painter's emerging consciousness of himself—of his own "life," of his own place in history.

6

THE PASTORAL OF STONE

No less than Titian does Michelangelo fabricate his own pastoral persona. We have already considered Michelangelo's pastoral origins in Settignano, the bucolic setting of his infancy and childhood. In pastoral literature the poet is, we have seen, always urbane, although he enters into nature, sometimes identifying with herdsmen. Raised on a *villa* or farm, descending figuratively from the rustic family of stonecutters, Michelangelo is nevertheless born of a noble house, an aristocrat.

Michelangelo's twinned identity as aristocrat and *villein* has its roots in poetical biography. Vasari finds the same combination of courtly grace and bucolic simplicity in the biography of Giotto. In the first edition of the *Lives* he tells us that Giotto, who was raised on a *villa* or farm, was the son of a farmer, "valorous" in the "art of agriculture." Giotto's father handled his "irons," by which he means his plow, not in a "rustic manner" but with the "gentle hand" of a craftsman or engraver. The suggestion here is that he worked the earth with the same skill as an engraver rendering hatch marks. He is the appropriate father of the shepherd-boy "inclined by nature to the art of design," who used a simple stone to draw sheep. We should further note that Giotto's father was, according to Vasari, noble in comportment. Thus, when Cimabue asked him if he could take the boy to Florence to train him in art, Giotto's father released him to the artist "with singular grace." In other words, Giotto's father, though a mere

rustic, was valorous and gracious, a man of gentility or *gentilezza*. Not surprisingly, Giotto grew up to be a man of courtly refinement, and Vasari portrays him as a commanding presence at court, delivering himself of vivacious sallies to the King. Michelangelo similarly rises from the simplicity of his provincial childhood, entering in his youth into the domestic comity of Lorenzo il Magnifico, cultivated by persons of high station and eventually emerging himself a princely figure.

But we do not forget Michelangelo's incondite origins. The rustic is necessarily rude in manner, that is, *rozzo* (from *rudis*), by contrast to the aristocrat, who is polite (from *politus*). In art this antithesis of manners is brought out by the contrast between *rozzezza* or rudeness and *pulitezza* or polish. Authors conventionally speak modestly of their work as *rozzo*, as does Michelangelo, in his rude tramontane persona, writing of his *rozzo martello* or rough hammer. Although of a noble house, Michelangelo artfully adapts the persona of a bumpkin in art, who is *rozzo*, having taken in his simple tools with the milk of a wet-nurse from the family of simple stonecutters. In many of his most highly finished or polished works, he leaves traces of the unfinished stone or rude rock.

In literature there are two basic types of the pastoral, the eclogue and the georgic, which deal, respectively, with the domestication of animals and the cultivation of the earth. The story of Michelangelo raised in Settignano, in a region of rocks and quarries, is a variant type of the pastoral, a new form of the pastoral—what we might speak of as the pastoral of rock. Whereas the farmer cultivates the earth and the herdsman domesticates his flocks, Michelangelo domesticates or cultivates the rude rocks extracted from the local quarries. This pastoral autobiography, which has its resonances in Michelangelo's poetry and sculpture, comes to the fore especially in the one poem by him that is said to lie squarely in the rustic tradition, "Nuovo piacere e di maggiore stima" (G 67). This poem is not so strikingly anomalous if seen in relation to the pastoral poetry of his autobiography, of his persona as figurative descendant of a family of rustic carvers of rock, who are, in their art, like farmers.

Michelangelo pictures the blissful life of the country bumpkin, who lives in peace, in a humble abode, content to till the soil, to herd animals, to sleep on hay, to eat acorns—free from obligations, cares, and quarrels. He loves God, praying to him in thanksgiving for his pastures, herd, and work. He lives a life of simple faith, bountiful and

free of need. Into his poem, but not directly into his pastoral Eden, Michelangelo introduces blind Avarice, endlessly in pursuit of riches, with other personifications of vice, Falsehood and Adulation, accompanied by the impersonations of Uncertainty, Doubt, Why, How, and Perhaps, all set off against the glorious figure of Truth. A hybrid of bucolic poetry and Christian allegory, Michelangelo's poem is an anomalous experiment, which has not been much favored by his critics, hence the absence of a close, analytical reading. If we turn, however, to some of its themes and the tradition to which it belongs, we will be rewarded with a deeper understanding of its autobiographical implications.

Particularly striking is the first stanza, where Michelangelo, introducing his happy rustic as herdsman, pictures his goats pasturing above a *sasso* or rock. As in his autobiography, Michelangelo focuses here on the pastoral of stone. He speaks of the herdsman singing his harsh poem, *rozza rima*, with rough notes, *aspre note*, repeating this characterization of the herdsman's *cantar rozzo* or harsh song. The rough voice of the herdsman is analogous to the rough work done by Michelangelo with his *rozzo martello* or rough hammer. When Michelangelo speaks of the herdsman's song as *rozza rima*, harsh rhyme, he is in effect identifying himself with the rude poet, for his own poem is *rozzo*, roughly hewn from a language notable for its asperity. He associates himself throughout the poem with the *villein*-poet and his life, free of deceptions or *inganni*, of strife, fraud, discord, lies, adulation. We are reminded here that throughout his letters Michelangelo is vexed by such conflict and deception. Now becoming his uncultivated subject, he takes on the idealized persona of this simple bucolic figure, who lives without such cares or stress.

Deception comes to the fore toward the end of the poem with the appearance of Fraud, Mendacity, and Adulation, personifications all of vice, attending Falsehood, who is always in court. Most notable here is the figure of Adulation. A cunning young person "of beautiful persona," she employs sweet deceptions, adoring with her eyes while looting with her hands. She is like the treacherous Fraud in Bronzino's *Venus, Cupid, Folly, and Time*, bestial of body but beautiful of countenance, proffering a honeycomb of sweet deception with one hand, while concealing the sting of a scorpion with the other. When Michelangelo repeats the observation that she flourishes at court, he

reminds us of his own distaste for life at court. In his final words, he calls Adulation the "wet-nurse" of all the horrendous deeds at court, employing the wet-nurse here as a source of evil, antithetical to the wet-nurse in the poetry of his autobiography, who is a source of virtue, of nourishment. The shift within the poem between the world of money, greed, and duplicity and the realm of pastoral innocence and ease reveals the tension within Michelangelo, who must needs make his way in the world of greed but who aspires to be exempt from its tension and vices.

The strictly pastoral part of Michelangelo's poem is so conventional that we cannot, indeed should not, attempt to link it too closely with specific antecedents in the genre. His desire to flee the court, to retreat to the bucolic realm, puts us in mind of Lorenzo de' Medici's sonnet, in which he flees the *pompe* of the city for the woodlands. Lorenzo's poem lies squarely in the tradition of Horace, who escapes the "noisy tempest" of Rome, retreating to a sylvan spot where he can compose without distraction. Even more closely, the spirit of Michelangelo's poem celebrating the simplicity of rustic life evokes that in Horace's second Epode. "Happy the man," *Beatus ille*, Horace writes, who, far from the affairs of the Forum, finds himself in a secluded dale, where there are ranging herds. This happy man sleeps on the matted ground, like Michelangelo's *beatus*, who sleeps on hay. The Horatian joy in seeing the sheep heading homeward and the oxen pulling a plow brings to mind Michelangelo's rustic *villanel*, dwelling in felicity among the oxen and goats.

Horace's epode is ironic, for it is the song of a usurer, who, singing of the farmer's simple life, is about to take all his funds and invest them. In Michelangelo's poem there is no such irony, although his poem, like Horace's, also moves between the poles of wealth, with its attendant cares, and poverty, with its freedom from such worry. The irony here lies in the contrast between Michelangelo's aspiration in his poetry to rid himself of material concerns and his constant preoccupation with the accumulation of capital or property in real life. The anti-idealist, who dwells on only Michelangelo's investments and financial preoccupations, ignoring his distaste for these financial matters reflected in his poetry, misses the tension within, as does the scholar of literature, who looks at Michelangelo's aspiration to pastoral bliss in his poetry without considering Michelangelo's real worries about family finances.

Although Michelangelo does not write at length or often about pastoral themes, the imagery of some of his grotesque poetry has extensive affinities with the pastoral and can thus be considered as part of his pastoral imaginings, to which his rustic origins and persona are related. In a series of *ottave rime* (G 68), closely related to the pastoral poem we have just discussed, Michelangelo presents a horrifying, hairy giant, so large that a whale would seem a fly to him. He is accompanied by a gigantic old woman, who suckles him, encouraging him in his prideful daring. Is the giant not Michelangelo himself, who elsewhere describes his own ugliness and hairy pelt, who, as a creator of giants, aspires to gigantic stature, who is proud, forever condemning himself for his *superbia*? The giant's female mate, who suckles him, also bears him seven baby giants, presumably the seven deadly sins, who travel throughout the world. Living in a cave, surrounded by great rocks, she is a grotesque transmogrification of the wet-nurse who suckled Michelangelo in Settignano, in a stony region, as Vasari said, full of *cavi* or quarries. Whereas Michelangelo's wet-nurse was fertile, providing him with the virtue of her milk, from which he received the hammer and chisels, the wet-nurse of the giant, her very antipode, was monstrous and vicious. She nourishes Michelangelo, we might say, in his gigantic pride.

The giants of Michelangelo's poetry have been associated with his earlier idea of carving a giant from the mountains of Carrara. When Michelangelo went into the mountains to quarry stone, he wrote in his letters of his desire to "domesticate" these very mountains. His use of *domesticare* is suggestive, for it evokes the taming of something that is wild or primordial, an original nature. This vision of domestication is one of cultivation and the bringing forth of good fruits, which is part of Michelangelo's pastoral of stone. Such domestication is a variant of the georgic, as we have said, but also a variation of the eclogue, since the domesticating of rock is also linked to the domestication of wild animals. We can imagine Michelangelo, atop these lofty eminences, the mountain goats his only companions, proudly, monstrously dreaming of bringing the gigantic creations of nature under his dominion.

The play in Michelangelo's art between the raw and the refined is an indication of the social implications of artistic practice, of the physical act of making art. It is also a reminder that Renaissance culture in general, courtly art, literature, and pageantry, continually plays back

and forth between the polish of manners and the rudeness that such manners eschew or mask. This play is evident in the ironies of court masques, festivities, and literature, in which rulers and courtiers are represented as simple shepherds and shepherdesses who flee from the cares of the court to the greenworld. When Lorenzo de' Medici wrote in praise of his beloved Nencia da Barberino, describing her teeth as whiter than those of a horse, her ballerina-like gait as that of a leaping goat, he teased the courtly ideal of his own socially refined Petrarchan poetry. In like fashion, and with greater gusto, Michelangelo, echoing Lorenzo, burlesques this courtly ideal in his essentially bucolic sonnet (G 20) in which he likens the face of his beloved to a turnip, her blond hair to a leek, her teeth to beans, the whiteness of her cheeks to flour, and her breasts to two melons—creating a farcical Arcimboldesque word-portrait. The crudity of his beloved here is measured in inverse proportion to the sheer grace and beauty of the beloved in his Petrarchan poems. In a similar way, when Michelangelo speaks of his own *rozzezza*, of his physical deformities, he is, paradoxically, pointing toward the refinement of his art, embodied in his finest, most polished statuary, which, like his poetry, is the epitome of *bella maniera*—not only in the sense of style, but of elegant, graceful manners.

We should not fail to recognize, however, that in polishing himself through his art Michelangelo is exploiting the pastoral, developing his own form of the pastoral, creating a novel type of the convention, not that of farmer or herdsman but of one who cultivates or domesticates stone. The pastoral was a means by which Michelangelo could chart his ascent through art from a simple nature to the dizziest reaches of artifice. As in the pastoral poetry and art of his contemporaries, in which the artist took on the persona of the humble shepherd or entered into the bucolic world, as Titian did in courtly guise, Michelangelo defined the pastoral origins of art, of his own art. Working the raw rock with his rough hammer, he converted the hand of the pastoral cultivator of the earth into what Vasari would call a "divine hand," achieving the *grazia* and *gentilezza* of an exalted *maniera*—transforming (or transfiguring) the rustic's humble hand into that of a gauntleted *galantuomo*.

7

THE POETRY OF THE
NON FINITO

The gentle hand of the artist, which refines the rude stone out of which the sculpture emerges, is present by implication, especially in those works left unfinished, revealing the marks of the chisels, the very gestures of the hand. In a well-known passage of his biography of Michelangelo, Ascanio Condivi remarks that Michelangelo left the original surface of the stone unworked both on the head of the *David* and on the base of the statue. He did this, Condivi says, to demonstrate that he had carved the work from the original damaged block of marble without adding pieces to it—in other words, to demonstrate his skill in quickening the flawed stone into a vivified presence. Condivi also says that Michelangelo followed the practice of leaving traces of rough, unworked surface in other pieces, including the figure of *Contemplative Life* for the tomb of Julius II. Michelangelo, Condivi concludes, learned this procedure from other *maestri*, who, the carving inchoate, the marble inviolate, demonstrated their command of the stone, asserting their very status as *padroni* of art. By leaving a trace of what the statue once was, Michelangelo revealed the *virtù* of his hand in bringing mere marble into the likeness of a living, breathing being. In this way, he exhibited his own manual skill as a *padrone* of art. The presence of the *scorza vecchia*, the "old skin" of the original stone, heightened the viewer's sense of the artist's virtuosity, his animative power or *forza* as artist. To show the *scorza vecchia* of the stone is to magnify our sense of what, by contrast, had

been, of what has been fined and refined. The vestigial presence of the "old" intensifies our consciousness of the new, of what the artist-thaumaturge has wrought with his marvel-making hands.

In Michelangelo's *oeuvre*, the *Bacchus* (Fig. 16), the early *Pietà*, and the Bruges *Madonna* are the most finished of his works, brought to a high degree of concinnity. With pumice stone Michelangelo produces the illusion of flesh and stuffs. In the language of the day the sculptor achieves *nettezza*, what we call "neatness," through the dexterity of the hand, which is paradoxically both implicitly exhibited and disguised, disappearing in the "finish" of the work, where there is no longer a trace of the mark of the tools, only a shining surface—reminding us that *nettezza* comes from *nitidus* for "shining." To finish something is to bring it to perfection; it is *perfectus*, carried through to completion. The work is *fine*, "fine," exhibiting *finezza*, finesse.

"Finish" is one of the principal criteria of Renaissance art, a criterion of both style, *maniera*, and practice, *pratica*, what the dexterous hand achieves, *perfezione*. Although in the most highly refined statues the surfaces are so polished that there is scarcely the mark of a chisel left on the surface, sometimes we find both polished form and fine, vestigial marks of the chisel together. This is certainly the case, for example, in Michelangelo's *Battle of the Lapiths and the Centaurs* (Fig. 17). Many of the bodies in this relief are polished, but not so polished as to obliterate the marks of the tools on the surface, which resemble the hatch marks of drawings. Traces inhere of the gestures of Michelangelo's hand. Here we see both "finish" and the effect of the *non finito*. No wonder some have claimed that the sculpture was uncompleted, even though Condivi probably conveyed Michelangelo's sense that the work was indeed finished when he used the word *finita* to describe it.

Michelangelo's early battle relief is already concerned with the relation of the finished to the unfinished, and not only in its surface effects. His sculpture displays figures in various levels of relief—very shallow relief in the background figures, high relief in the foreground. Numerous warriors in the front of the battle seem to be emerging from the marble from which they are carved, coming into being before our very eyes. Michelangelo leaves the upper register of his relief, as well as portions of the surface between figures, very roughly worked, and some of the nudes are more polished than others. In other words, we view forms in different degrees of finish. The impli-

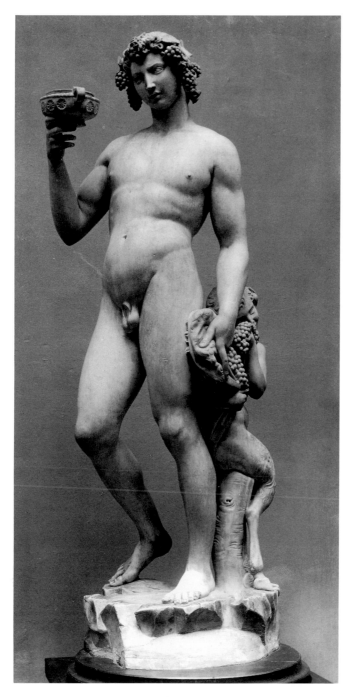

Fig. 16. Michelangelo, *Bacchus*. Bargello, Florence

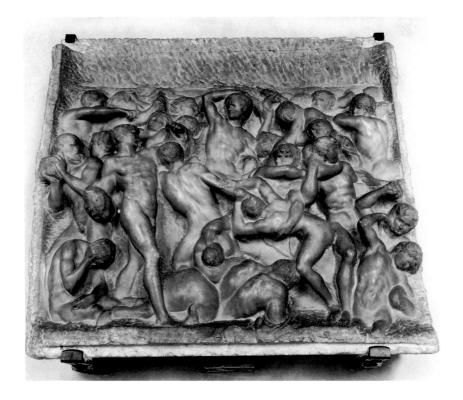

Fig. 17. Michelangelo, *The Battle of the Lapiths and the Centaurs*. Casa Buonarroti, Florence

cations of this fact are considerable, for Michelangelo, by showing the work in different stages of completion, is in effect revealing its making—its transformation from the rough to the smooth. He is displaying his poetry, in the root sense of *poiesis*, "making."

The reverse of accidental, Michelangelo's display is purposeful, highly self-conscious. It is an index of a degree of self-reflexivity made particularly manifest in the figure at the extreme left-hand side of the relief, the only aged person in a group of two dozen warriors, all the others being decidedly youthful (Fig. 18). The bald old man, who supports a stone with two hands, alludes, as I have previously suggested, to Plutarch's account of a battle relief by Phidias, in which the artist signed the work, in effect, by portraying himself as a bald old man, holding a large stone with both hands. The allusion to Phidias in

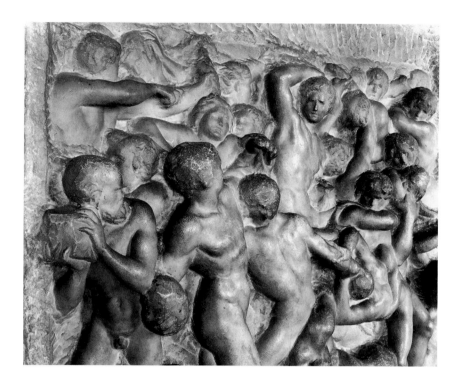

Fig. 18. Michelangelo, *The Battle of the Lapiths and the Centaurs* (detail of Phidias). Casa Buonarroti, Florence

the classicizing culture of Florence is highly suggestive of Michelangelo's ambitions as a prodigy, aspiring to rival and thus identify himself with the great Greek artist, both aged and ancient. The figure is in a sense Michelangelo's signature, the sign of his identity as a new Phidias, a modern Phidias, whose own sculpture in the classical, epic manner rivals that of the great ancient artist. His fictive self-portrait or *autoritratto* as Phidias is closely tied to the autographic character of the work, where we see marks of the sculptor's tools on the surface of the stone, evidential proof of his technical virtuosity as he works from the rough block to the figures emerging from it, in different degrees of finish—signs of *poiesis*, of Michelangelo's poetry.

Another feature of the figure of Phidias has a bearing on the sculptor's status as poet. I refer to the large stone that he holds. This stone is both the illusion of stone, of a particular stone of specific dimen-

sions and faceting, and the stone itself from which it is carved. This identity is established at the very point at which the illusionistic stone emerges from the rougher stone from which it is wrought. Playing between the artificial stone and the real stone, the illusion calls attention to itself, to the artifice of its artificer, poet, maker, to Michelangelo, who identifies himself with the very figure holding it.

Michelangelo's fictive stone and the other stones in the relief bring to mind the similarly illusionistic stones carved by the artist at the base of his *Bacchus, David, Pietà*, and Bruges *Madonna*. In all these instances Michelangelo is self-consciously calling attention to his own poetry by implicitly comparing the illusionistic rock to the real stone from which it is carved. The fictive stone thus intensifies our sense of Michelangelo as poet in stone, his transformative powers, for it is a metaphor in the petrification of Michelangelo's poetry. This self-conscious artifice is especially manifest in the down-turned heads of the fallen figures in the battle relief. Roughly blocked, these heads evoke both the stones being hurled in battle and the raw rock from which they are hewn. Although Vasari speaks of Michelangelo rendering *carne* or flesh in marble, he does not fail to observe that this illusion appears in *marmo* or *sasso*, stone. In other words, in the poetry of Michelangelo's sculpture, his poetry in stone, we, like Vasari, are always aware of the "two senses" or *due sensi* of the figures, ambiguously both flesh and stone. No wonder we have come to think of Michelangelo, who creates himself in and through his work as a lithic being, as one who, like his creations, was in accord with the very paradoxes of his poetry, flesh petrified, stone incarnate.

Michelangelo's sonnets dealing with sculpture can be read as a commentary on his art in stone, addressing the very stoniness of his beloved. Like Michelangelo's own carved figures, his beloved is both flesh and marble. Michelangelo poetically conjures up in words what he poetically carves with his chisel, a form of being that is paradoxically *carne* and *sasso*. But with his "rough hammer" he needs divine guidance in order to complete his sculpture and, therefore, by analogy, himself, for he remains, as he suggests, *non finito*. By invoking the divine hammer, it is as if he were himself a sculpture of *duri sassi*, in need of completion. Michelangelo assumes the very persona of his own sculpture when he speaks in his poetry in the voice of his own *Night*, becoming an *essere di sasso*, a "being in stone." He follows Petrarch, who, playing on his own name, says that he is *petra*, petri-

fied by his Medusa-like beloved, just as Petrarch had echoed Dante's
stony rhymes in the *rime petrose*, where Dante is transformed by his
lady, *Petra*, into a "man in marble." Transfigured into stone, Michelan-
gelo, like Dante and Petrarch, writes in the tradition of the poet of
Metamorphoses.

Ovid is forever recounting myths of people turned into stone, and
in one of these we find the nascent taste for the *non finito* that would
contribute in some measure to Michelangelo's way of conceiving the
poetic implications of the unfinished effect of his sculpture. I am
speaking of Ovid's fable at the beginning of *Metamorphoses* of the
rebirth of the human race after the flood, when Deucalion and Pyrrha
tossed stones behind them that grew and took form as unfinished
sculptures: "as statues just begun out of marble, not fully defined,
very roughly blocked out." The key phrase in Ovid's description is
non exacta satis, literally, "not sufficiently carried out," which can be
translated as *non finito*. This is precisely the way the phrase was
rendered by Lorenzo de' Medici, who wrote an Ovidian metamorpho-
sis in his poem *Ambra*, which celebrates the mythic nymph of Poggio
a Caiano, the site of Lorenzo's villa. As Ambra flees Ombrone, her
limbs changed (*vedi mutar le membra*) and, as she turned to stone,
she appeared as a "sketched figure unfinished in hard stone": *figura
abbozzata e non finita*. Lorenzo's figure, like a statue that is *non
finito*, appears in other words, *non exacta satis*. In Lorenzo's poem,
the pursuit of the myth is a variation of the story of Apollo and
Daphne, but the myth undergoes metamorphosis, for when Ambra is
turned to stone she is like the unfinished statues in the stones of
Deucalion and Pyrrha. Illustrating the Ovidian story of the Lapiths in
his relief, Michelangelo similarly transforms his narrative, since his
figures, still embedded in stone, are like the unfinished statues emerg-
ing from stone.

The aesthetics of Ovid would have contributed to Michelangelo's
perception of the poetical implications of unfinished sculpture—
instances not only of metamorphosis but of the poet's role in metamor-
phosing sculpture. Michelangelo is said to have worked not just for
Lorenzo il Magnifico, supposedly executing his battle relief during his
seminal stay in Lorenzo's garden, but he is also believed to have
worked for Lorenzo's cousin, Lorenzo di Pierfrancesco. The lesser
Lorenzo was a patron of Michelangelo's older friend, Botticelli, whose
Primavera, as we have observed, is profoundly Ovidian, mutating the

myth of Apollo and Daphne into that of Zephyr and Chloris in a stunning poetical metamorphosis. Michelangelo's battle relief is also deeply Ovidian, not only illustrating a fable from *Metamorphoses* but also, as we have seen, in its very stages of *non finito*, displaying the metamorphosis of stone. If the *Primavera* is the illustration of metamorphosis and also at the same time the metamorphosis, like Lorenzo's poems, of one Ovidian myth into another, parading the poet's virtuoso, metamorphical skills, Michelangelo's relief is an exhibition of technical metamorphosis, the display of the transformation of his medium, stone, by his very hand.

That Michelangelo contrived the effect of the *non finito* for poetical reasons does not mean that many of his unfinished works were not just that—unfinished. The unfinished *prigioni* or so-called *Slaves* (Fig. 19) and the *Matthew* for the Cathedral, only roughly blocked out, were meant to be given further definition. Even so, there is evidence that certain unfinished works were appreciated in just this way, as *non finito*. The *Pitti Madonna* (Fig. 20), for example, has been justly called a virtual "academy" of sculpture, revealing all the phases in the *poiesis* of stone, from the still very roughly worked surface to the more highly developed form. We are reminded here of what Vasari said of the *Saint Matthew*, that it contained within its condition as sketch the idea of its own eventual perfection. Carved for Bartolommeo Pitti, the tondo was for a time afterward in the hands of the Pitti family, as Vasari tells us, suggesting that the patron was willing to accept it as *non finito*, that Michelangelo was willing to turn it over to him in such a state of metamorphosis. More affirmatively, we can say that the relief was a display of artistic virtuosity and that the patron surely appreciated it as such.

Michelangelo's *Night* (Fig. 21), though essentially finished, indeed brought to a state of high polish, is nevertheless another instance of the *non finito*. The artist leaves the edge of stone beneath her body roughly worked, heightening the contrast between the illusion of her flesh and the rough stone from which she was wrought, and he also leaves only roughly worked the area of stone directly above the exquisitely finished mask of *Night* (Fig. 22). Michelangelo made this mask with such care and refinement that he even created an inner shell visible through the hollowed eyes. Thus we see a block of stone roughly hewn with bold strokes of the chisel, from which a soft cloth descends to the even finer face, from which a plumose beard, softer

Fig. 19. Michelangelo, *Slave* (unfinished).
Accademia, Florence

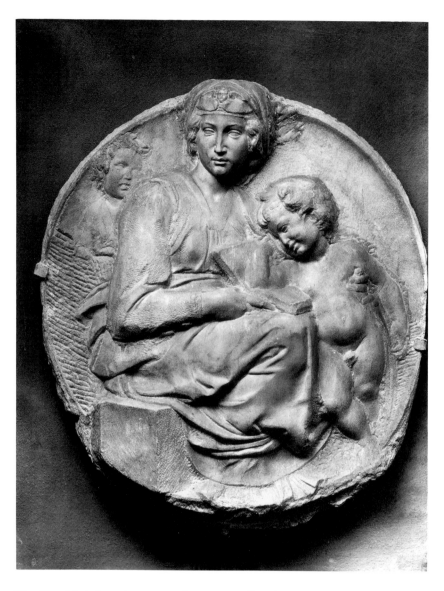

Fig. 20. Michelangelo, *Pitti Madonna*. Bargello, Florence

Fig. 21. Michelangelo, *Night*. Medici Chapel, San Lorenzo, Florence

still, flows forth. Form is defined and refined before our very eyes. By leaving the stone *non finito* here, as in the Pitti tondo and in the battle relief, Michelangelo sharpens our vision of his dexterity in metamorphosing the stone, exhibiting his *poesia* in the "making" of art, leaving traces of the work's very origins.

The appreciation of the *non finito* was particularly evident in the second half of the sixteenth century when Michelangelo's unfinished *Slaves* were placed in Buontalenti's grotto in the gardens of the Pitti Palace (Fig. 23). In this setting, they were seen as part of a rough, unfinished nature. They were not only Atlas-like in their supporting role, but they evoked in the mind of Francesco Bocchi the beings in stone in Ovid's myth of Deucalion and Pyrrha—the very Ovidian myth, as we have seen, that lies behind the nascent taste for the *non finito* at the end of the fifteenth century. If Ovid had encouraged

Fig. 22. Michelangelo, mask of *Night*. Medici Chapel, San Lorenzo, Florence

Fig. 23. Bernardo Buontalenti, *Grotto*. Boboli Gardens, Palazzo Pitti, Florence

Michelangelo and other poets to see the poetical implications of unfinished statuary, in such sculpture now Ovid gets his own back, repaid in coin of the realm.

The emergence of the *non finito* in the sculpture of Michelangelo and in the related Ovidian poetry of the period is, as we have seen, profoundly important in the story of art as poetry. The roughly worked surfaces of stone are traces of the artist's hand at work, not in the sense of mere *maneggiare* or management of his tools but as the manifestation of the exalted skill of the hand, which in Michelangelo's memorable words, "follows the intellect." As an indication of metamorphosis, the *non finito* also has temporal implications for the very "life" of the poet, for it heightens our sense of the artist's activity in time. The different phases of work evident in the *non finito* mirror the very rhythms of his activity, the melodic line of his inquiring hands as they possess and bring form to his work. In this respect, the marks of the unfinished work in stone, which connote the gradual rendering of the artist's idea or conceit, are radically biographical. We ordinarily speak of various episodes in the "life" of the poet, from his birth to his death: the time of his training, his travels, his association with important people. But what are the supreme moments in the life of the poet, the moments that make his life meaningful or special to us? Are these moments not those when he actually made his works, moments that are present to us in his unfinished works, works that in their allusion to the rhythm of time sharpen our sense of the artist's life as it is lived in the making of his work? Cellini can vividly recall the moment when he undertook the making of his *Perseus*, but his autobiography is less immediate, less intimate than that inhering in Michelangelo's unfinished works. Michelangelo does not *represent* the moment of his work, as does Cellini in the "life," which he dictated; rather, the moment of his making is *present*, actual still, in the sculpture itself. The biographical implications of Michelangelo's sculpture remind us of the deeper significance of Ovid's poetry for Michelangelo. The Ovidian *non finito* of his art tells us that the classical author's poetry is central to Michelangelo's sense of himself as *non finito*, and, thus, to the autobiography embodied in his statuary.

8

THE GROTESQUE AND
THE PASTORAL

We have spoken in two senses of the origins of art. There are the origins of the work of art itself, visible in the marks of the artist's tools, particularly in completed works where details are left unfinished. These rude marks give the beholder a sense of the stone before it was refined, and they trace the activity of the hand in the making of the work, calling the viewer back to its very origins. This is the story of the work's own making, of its own poetry, the story that the work of art itself mutely tells. Then, too, there are the pastoral stories of the origins of artists themselves, who, imitating nature, emerge directly from the world of nature that they imitate, as do, for example, Giotto, Dante, Petrarch, Botticelli, Signorelli, Raphael, Titian, and Michelangelo, all of whom participate, in different ways and degrees, in the origins of the history of art.

Sometimes the story of art's pastoral beginnings remain obscured to us because the pastoral story is transmogrified in fantasy, no longer recognized for what it is. Such is the case in Vasari's tale of Michelangelo's youthful copy of a print of the Temptation of Saint Anthony by Schongauer (Fig. 24). In Vasari's biography of Michelangelo the *Saint Anthony* is Michelangelo's very first painting. It epitomizes the artist's origins as painter. But what are the origins of Vasari's account, and what do they tell us?

This print is deeply embedded in the biography of the artist. We look at it today and through it admire Michelangelo's skill in making,

Fig. 24. Martin Schongauer, *Temptation of Saint Anthony*. Museum of Fine Arts, Boston

in Vasari's word, a "counterfeit." Vasari focused on the "strange forms" of the devils tormenting the saint, reminding us that strangeness, that which is *strano, raro*, or *straordinario*, was prized for its poetic imagination or *fantasia*. We have come to see Schongauer's fantasy as Michelangelo's own—as if, thanks to Vasari, it had been assimilated to the young prodigy. Vasari writes of Michelangelo's imitation of the print as a copy, but when he speaks of the original's "strange" and "bizarre" forms, it is easy for the reader to project Schongauer's fantasy directly onto his copyist. The print has become an icon of Michelangelo's own imaginative powers, an emblem of his abilities in the rendering of the grotesque.

The question remains, however, did Michelangelo in fact make a copy of the print by Schongauer and, if so, was it his very first work, as the account suggests, or did Vasari invent the idea of the imitation of the print as Michelangelo's original painting because he saw the image as emblematic of Michelangelo's poetic gifts of grotesque invention? Michelangelo essentially repeats Vasari's account of the Saint Anthony in his autobiography, but we need to recall that Michelangelo frequently adapts exemplary fictions from Vasari to his autobiography, recognizing their fictive significance and rhetorical power. Notwithstanding the nearly universal belief in the truth of the assertion that Michelangelo copied the Schongauer print, writers have sometimes implicitly, if not unconsciously, raised questions about its place in Michelangelo's biography. One leading scholar of Michelangelo, speaking about the print, suggestively remarked that Michelangelo's memory was one of his greatest "creative faculties"— as if to suggest the poetic character of Michelangelo's story. Another distinguished writer on Michelangelo, dwelling on the copy of the print as a type of the grotesque in Michelangelo's art, says, also suggestively, that the story of the copy after the print appeared well over half a century after "the fact that it purports to record." Although this writer passively accepts the truth of the story, his language, notably the word *purports*, reflects a shadow of implicit doubt concerning the historicity of the episode.

No contemporary evidence corroborates the claim that Michelangelo made a copy of Schongauer's print, but Vasari's highly rhetorical approach to history should encourage us to question whether Michelangelo ever made such a copy. Does anything about the account lead us to doubt its veracity? The answer lies in a comparison of Vasari's

story of the *Saint Anthony* with his fable of Leonardo's *Medusa*, a story properly recognized as legend or fiction long ago by Walter Pater and now widely accepted as an exemplary fiction. The comparison of the two tales is pointed, for Vasari's tale of the *Medusa* is similarly about the first, stunning, independent work by a youthful prodigy. It, too, is an account of grotesque fantasy. Vasari says that in his horrifying *Medusa* Leonardo imitated lizards, crickets, serpents, butterflies, and other strange species. In like fashion, and probably not coincidentally, he observes that in order to render the forms of his devils, Michelangelo went to the market to buy fish, whose bizarre scales he appropriately imitated, copying nature directly, as did Leonardo. Since this detail of Vasari's story of the copy of the Schongauer as a grotesque fantasy by a youthful prodigy is almost certainly based on his own earlier fable of the *Medusa*, we must wonder whether the story of the copy of *Saint Anthony* is also a fiction, an exemplary fiction, created from the story of Leonardo.

When we turn from Michelangelo's *Saint Anthony* back to the fable of Leonardo's *Medusa*, we see how both stories of art retain their roots deep in nature. We are usually so taken by the account of Leonardo confabulating his fictitious beast and by the story of its astonishing effect that we easily lose sight of the bucolic context. Vasari tells us that Piero da Vinci (whom he calls Leonardo's uncle in 1550, his father in 1568) had a peasant who worked his farm, hunting and fishing for him as well. The bumpkin clumsily cut a piece of wood from a fig tree into the shape of a buckler, which he brought to Piero, asking that he have it painted in Florence. Piero, grateful to the peasant for his services, was pleased to oblige him and gave the wood to Leonardo, who, reworking it, made it more delicate, before painting his amazing Medusa upon it. The fable makes explicit the pastoral origins of art, for the primordial Medusa originates in the desire of a peasant to have a painting on an object fashioned by his own rude hands. Although the image is, finally, painted in the city, by an artist, who is therefore urban, the pastoral theme of nature is sustained in the very subject, abounding in serpents and insects, studied directly from nature.

Conceived by Vasari as an analogue of the *Medusa*, the *Saint Anthony* plays in Vasari's biography of Michelangelo the same role that the *Faun* (Fig. 25) came to play in Michelangelo's autobiography. Embellishing Vasari, who sees the *Saint Anthony* as the first stunning exhibition of the master's skill in painting, Michelangelo introduces

Fig. 25. Michelangelo, *Faun* (said to be a copy after the lost original). Bargello, Florence

the story of the *Faun* as his very first sculpture, which he carved in the garden of the Medici, in imitation of an ancient work. Just as Michelangelo blithely took over Vasari's account of the *Saint Anthony*, Vasari was pleased to use the fable of the *Faun* in his revised biography.

The story of the *Faun*, it has justly been said, resonates with stories in Pliny's influential *Natural History*, for example, the latter's description of the painting of Polygnotis, which showed the open mouth of the figure, revealing the teeth—an account suggestive of Michelangelo's carving his *Faun* with an open mouth, similarly displaying such dental details. Pliny elsewhere speaks of a block of stone, cracked open, revealing a Silenus within. A Silenus is not a Faun, but such woodland creatures are generically related, and, although Michelangelo carved his statue, whereas the ancient work was discovered in the cracked marble, we cannot fail to recall here that, according to Michelangelo's legendary theory of art, embodied in his poetry, sculpture lies embedded in the stone, even before it is realized. Inventing his own *Faun*, Michelangelo, in a sense, discovered it in the marble block. Cicero, it has also been noted, tells the related story of a block of stone which, cracked open, revealed a Pan, the personification of nature, to whom both the *Silenus* and the *Faun* are related. Michelangelo's autobiographical fable of the *Faun* as his first work is a poetical variation on a topos—the story of a woodland creature who emerges from the "living stone," thus directly from nature.

Just as the classical *Pan* and *Silenus* are found in nature, directly in the rock, so too in a sense is Michelangelo's *Faun*. Like the classical statues of *Silenus* and *Pan*, god of nature, Michelangelo's *Faun*, a bucolic creature of natural appetites, epitomizes nature. Set in a garden, a type of the pastoral world, Michelangelo's fable of his first work in stone, a *Faun*, is the story of his own invention or discovery of a creature who epitomizes the pastoral world, reinforcing his own pastoral origins. Not only is Michelangelo's discovery of the antique, which he imitates, the basis for his discovery of the *Faun* in stone, it is the basis of his own discovery by Lorenzo il Magnifico, who discovers in the *Faun* Michelangelo's talent.

As an icon of Michelangelo's pastoral origins, the *Faun* calls our attention back to his childhood in a rustic region of rocks and quarries, to his origins in a bucolic family of rude stonecutters. He composes the fable of the *Faun*, which is the imitation of another

work, in relation to Vasari's story of the *Saint Anthony*, similarly a youthful virtuoso imitation of another work of art. He freely rewrites Vasari as Vasari had rewritten his own fiction, metamorphosing the story of Leonardo's *Medusa*, with its grotesque animal forms, into the fable of Michelangelo's *Saint Anthony*, which is filled with similarly marvelous, grotesque forms. The *Faun*, we should note, is no less a grotesque than the devils of Saint Anthony or the *Medusa*, being a compound creature, part human, part beast.

In all of these stories of youthful virtuosity the themes of pastoralism and the direct imitation of nature are intimately linked. Although Michelangelo's *Faun* and *Saint Anthony* are both copies, they are, what is more, significantly based on the appearances in nature. Like Leonardo before him, imitating lizards, serpents, and other creatures in order to render his Medusa, Michelangelo imitates the forms of real fish as a means of representing monstrous devils. In other words, copying another work of art is not enough in the making of art. One must rely on nature itself. This point is made as well in the fable of the *Faun*. When Michelangelo's copy of an ancient faun is examined by Lorenzo, the patron teasingly criticizes the young artist for rendering the old *Faun* with all his teeth, since creatures of that age are missing some. At this, Michelangelo knocks out a tooth of his *Faun*, drilling a hole where it had been—to the delight and satisfaction of Lorenzo, who, not coincidentally, wears a smile like that of the *Faun* itself. In effect, Lorenzo, in his criticism of the *Faun*, turned the young artist's attention to the laws of nature and natural decay, to natural appearances, and Michelangelo was quick to respond to this excellent advice, grounded in the principle of *imitare la natura*.

Vasari's and Michelangelo's stories, in which a primitive nature and the direct study of nature are intertwined in fables of childhood virtuosity, are tales of the display of poetic imagination in the rendering of grotesque subjects. Like Leonardo's gorgon, Michelangelo's devils of Saint Anthony and the *Faun* are exhibitions of fantasy. Such *fantasia* is rooted in the imitation of that primordial nature, which, according to the conventions of the pastoral, is the very source of art. Even Saint Anthony's devils emerge in that solitary nature into which the saint was said to have retired. Fabulous though they may be, these diabolical creatures, in their animal forms, like those of the *Faun*, suggest the primordial origins of Michelangelo's poetry in nature.

As grotesques, Michelangelo's piscine devils of Saint Anthony and

goatish faun both evoke a primitive nature. Emblematic of the artist's fantasy, the grotesque represents the inchoate wildness of nature at its origins, a realm of the wildest beasts or monsters. It is the simple, raw nature of his pastoral poetry in which Michelangelo's monstrous giants dwell, in which his peasant lives a simple life, attentive to grass, water, and milk. The peasant's song is crude, his hands are callused— "e 'l cantar rozzo, e'calli delle mani." Michelangelo also pictures himself in a primitive, grotesque world in the delightful, comic poem "Io sto rinchiuso" (G 267), which, in its imagery, is an extension of the rustic imagination informing his poetry with monsters and peasants. Describing himself in old age as living in a sort of Dantesque hell, Michelangelo creates further monstrosities that take him directly into a solitary nature, like Saint Anthony's. When he finds gigantic heaps of dung at his threshold, he evokes the giants who have dropped them there in a monstrous synecdoche. Like his Nencia da Barberino-ish beloved of his earlier poetry, he is himself the production of nature, the mere pulp of fruit. Although he lives in a hovel in the city, the poetic imagery suggests the pastoral world, in a sort of grotesque urban pastoral. He keeps a bumblebee inside a jug, and its imagined buzzing is to be heard in relation to the song of a cricket in one ear, to the sight of a spiderweb in the other. Michelangelo emerges here as himself a monster, a grotesque head, like those "scribbles of grottoes," like the devils he pictured tempting Saint Anthony, like the grotesque, laughing old *Faun*.

The encounter in the garden between Lorenzo and Michelangelo not only represents the encounter of an old man and a youth, it also epitomizes the confrontation between the urbane, cultivated patron and his innocent disciple from the countryside, who, despite his gifts, is not yet fully cultivated or sophisticated—not fully refined. Although Lorenzo criticizes Michelangelo for naively representing the old *Faun* with all its teeth, at which Michelangelo knocks out one of them, Lorenzo laughs, according to Michelangelo's account to Condivi, at the "simplicity of the child." This *simplicità* is also that of an artist, who comes from the simplicity of nature itself, from the rustic realm of Settignano, from a *villa* or farm in a harsh world of stonecutters, farmers, and herdsmen, still close to the very wilds of nature, primitive and undomesticated.

Whereas the grotesque devils of Michelangelo's very first painting, the *Temptation of Saint Anthony*, are still emblematic of the wildness

of a primordial nature, and whereas Michelangelo's first sculpture, the *Faun*, points back to that wild nature, the latter work, as a creation of Lorenzo's garden, which epitomizes high culture, is, paradoxically, also a display of art, of the triumph of art over nature. The *Faun* is not really Michelangelo's first work in stone; that work surely disappeared long ago, probably destroyed by the artist. He is exactly the *Falstaff* of the octogenarian Verdi (son of an innkeeper), the paper-cutout dancers of the old, bedridden Matisse, the charming, playful animal poems of Matthew Arnold's latter years, the second *Faust* of the eighty-two-year-old Goethe, *The Tempest* of the aging Shakespeare, who, born in the very year of Michelangelo's death, assumed the mask of his own Prospero.

The *Faun* is a final work, Michelangelo's retrospective poetic reflection on his own rude pastoral origins—a fiction invented by Michelangelo as part of his "autobiography," when he was over seventy-five years old, aged, like the very faun of the fable. Writing his own "history," when he composed his autobiography in response to Vasari's biography, Michelangelo invented his beginnings in nature. The *Faun*, like the wild, grotesque devils of his first painting, is an index of Michelangelo's highly self-conscious attempt to situate his origins in the pathless wildness of nature, defining his own life and art in the broad sense in the pastoral tradition, which has everything to do with the origins of art.

9

VERSIONS OF THE PASTORAL

We have thus far considered Michelangelo's life as a version of the pastoral in the broad context of paintings of pastoral subjects, which have biographical implications: Botticelli's *Primavera*, Titian's *Fête Champêtre*, Raphael's *Parnassus*. As an artist who was raised in the rustic world of the countryside where rude stone was tamed and whose first *essai* in marble was a *Faun* in a garden, a sort of domesticated *pastorale*, Michelangelo emerges in a pastoral milieu, which has more distant ramifications, both in his own work and in the paintings of other contemporary pastoralists, notably Piero di Cosimo and Luca Signorelli.

Let us turn first to Michelangelo's famous drawing of a Bacchanal (Fig. 26), where we encounter a primordial world of primitive sacrifice. At the left, an aged "she-Pan," as she has been called, suckles one of her offspring with her strikingly withered dugs, while a second child sleeps. This decrepit mother-satyr is another *nutrice* from the gallery of such nurses in the grotesque imagination of Michelangelo, reminiscent, for example, of the pastoral wet-nurse of a giant in Michelangelo's poetry. The micturitional humor of the putto, pissing into a cup otherwise intended for wine in the background, evokes the stench of urine in Michelangelo's grotesque rhymes, equally somber and comic at the same time. As in the poetry, which graphically records the primitive conditions in which Michelangelo lives, the drawing, as it has been said, illustrates "primitive natural

Fig. 26. Michelangelo, *Bacchanal*. Royal Library, Windsor Castle

functions"—nursing, eating, drinking, and sleep. This primitive world, it has also been remarked, is derived from that of Piero di Cosimo, for the satyr-nurse of Michelangelo's drawing is strikingly reminiscent of a similar creature, suckling her *satirino*, also on the left, of Piero's *Discovery of Honey* (Fig. 27). Like Piero's more overtly cheerful picture, Michelangelo's drawing, which illustrates a Bacchic sacrifice, is about the world of Bacchus and Silenus.

When we turn to Piero's Ovidian *Discovery of Honey*, we enter into a world of satyrs, in a nature, primitive and raucous, over which Bacchus and his Sancho Panza-like companion, *Silenus*, preside. Banging on their utensils, the satyrs drive the bees back to the hive, where they locate the source of honey. Bacchus is the god who presides over the introduction of "the modest amenities of pastoral life"—honey and wine. Next to Silenus, a lady-satyr stands improbably in the guise of a satyr-court-lady, her hand resting on her hip so artfully, her elbow extended, as in countless Renaissance portraits, in which the sitter is

Fig. 27. Piero di Cosimo, *Discovery of Honey*. Worcester Art Museum, Worcester, Mass.

so posed, in accord with the conventions of courtly refinement. In other words, this is not the gesture we expect from a primitive satyr, who is paradoxically or oxymoronically a satyr-*cortigiana*, embodying the antithesis of natural simplicity and courtly complexity. Piero di Cosimo is no quattrocento Edward Hicks. Rather, like Lorenzo de' Medici, whose invention of the rustic Nencia da Barberino is a mockery of the idealized beloved in the poet's own love poetry, Piero's satyr-lady, in courtly pose, is an ironic travesty of art, bespeaking a self-consciousness typical of the period. Said to be the "antipode" of his contemporary Botticelli, Piero is nevertheless no less sophisticated than his poetical contemporary.

Considering Piero's mythological pictures in general, we are dealing with what has been called his "early history of man." These pictures, in various pairs or series, are dedicated to Bacchus, Vulcan, and Prometheus and are thus about the birth of culture, society, and art in a primitive world. These painted histories are closely linked to Renaissance biographies of artists and poets, since biography, a form of history, is concerned, as we have seen, with the birth of art and culture in the primordial pastoral world of nature. Just as Michelangelo traces his own origins from a primitive nature, which he seeks to domesticate, Piero, echoing historical writers, records the emergence of art in a primordial, undomesticated world. Although our usual tendency is to dwell on the fascinating and beguiling primitiveness of Piero's pictures, we will consider here Piero's attention to the historical origins of art in nature, his self-consciousness and irony as artist, a striking analogue of Michelangelo's self-reflexive musings on his own origins in art. The very primitiveness of Piero's pastorals throws into relief the development of art in such simple circumstances.

Piero elaborates on the mythic origins of art in his panels of the legend of Prometheus. In one picture (Fig. 28), we see Prometheus molding a clay figure of man, to the amazement of an onlooker, while a simian creature climbs a tree in the background (an allusion to the commonplace that art is the ape of nature). At the center of the picture, a sculpture by Prometheus upon a pedestal dominates the composition. The painting is in effect an allegory of the origins of art, of the art of sculpture. In the pendant picture (Fig. 29), Prometheus, lighting his torch at the wheels of the sun in the heavens above, is also shown applying his torch to the heart of his statue in the foreground. Thus, both pictures are about the origins of sculpture.

Fig. 28. Piero di Cosimo, *Legend of Prometheus*. Alte Pinakothek, Munich

Fig. 29. Piero di Cosimo, *Legend of Prometheus*. Musée des Beaux-Arts, Strasbourg

Even Piero's seemingly most primitive scenes are to be understood in relation to art, for they are the perception of a primitive world before culture, viewed from the perspective of culture itself. When Piero portrays primitive man as hunter, he depicts mankind before it achieved the status of culture. This primitive world is informed, like Piero's other rustic images, by Piero's poetry. In the Oxford painting of a forest filled with wild beasts, some of these creatures are most strange, notably a sow with the face of a woman, a goat with the face of a man. These grotesques, which evoke Leonardo's fabled *Medusa* and his drawings of *animali composti*, are manifestations of Piero's own grotesque poetry, of his fantasy. Innocence does not blemish this poetically self-conscious image.

What we call eccentricity in Piero's delightful early histories of man, Vasari called *stranezza*, by which he meant the poetic faculty of imagination. In other words, Vasari praised Piero as a poet. But what kind of person was Piero? The answer to this question is, we do not know. It will be objected, however, that, since Vasari wrote a detailed biography of Piero, we do know something about him. As one of Piero's greatest scholars wrote, "Piero is better known to us today than almost any other artist of the period." Piero's personality is said to have lived on, as if in oral tradition, and Vasari is supposed to have immortalized his character "by a most convincing psychological por-trait" of an artist who "re-experienced the emotions of primeval man," the very "passions and fears of the caveman and savage."

What Vasari did, in actuality, is something quite different. He ex-presses Piero's biography out of his paintings and siphons it off, as the ancient Egyptians used to suck the brains from a corpse before embalm-ing it. Vasari was a poet, and just as Piero transmuted the pastoral myths of antiquity into pictorial form, Vasari metamorphosed Piero's painted pastoral poetry into the rustic poetry of biography. Although Vasari's Piero is a figure of prodigious poetic imagination, who, *fantas-ticando*, created castles in the air, he is "bestial" and "savage," like the bestial, primitive humanity pictured in his mythologies. Piero, Vasari tells us, never had his rooms swept, he let his garden run to seed, he left his fig trees unpruned. He preferred everything wild, Vasari adds, like his own nature. Piero emerges in this fictive biography as a Wild Man, like those whom he painted in his early history of man—as a paradoxical figure, for he is both a primitive or bestial and sophisticated and poetic. He is the very figure of poetry, both natural and artful.

Two features of Piero and his art have a bearing on our general discussion of Michelangelo and autobiography. First, his pictorial histories of mankind, which dwell on the development of art and culture in a primitive world, provide us with the larger historical context in which the stories of individuals are told—tales of artists who arise in similar primitive circumstances, from Giotto the shepherd to Michelangelo the cultivator of stone. Second, Piero's biography, as rendered by Vasari's poetic fiction, is based not on facts but on Piero's own art, as cannibalized by Vasari. In this respect, Piero's biography, in which the pastoral dominates, is itself bucolic poetry, parallel to Michelangelo's equally poetic biography and autobiography and autobiographical poetry, grounded, as we have seen, in the traditions of pastoral poetry. The biography of Piero, as written by Vasari, on the basis of the painter's pictorial histories, is the analogue of Vasari's other biographical histories of artists, who, similarly emerging from nature, bring culture to mankind.

It has been said that Piero's art has been called "atavistic"—not the "polite nostalgia of a civilized man" but the work of "a primitive who happened to live in a period of sophisticated civilization." The artifice and irony of his work, as we have noted, however, suggest a different sort of sensibility, rather closer to that of the highly urbane Lorenzo de' Medici or Michelangelo, both of whom indulged in crude pastoral musings, scarcely with innocence. Piero's pictures are part of the very milieu in which Luca Signorelli painted one of the greatest pastorals of the Renaissance, the so-called *Kingdom of Pan* (Fig. 30), known variously as *Pan, The God Pan, Pan as the God of Nature,* and *The School of Pan.* Generally believed to have been painted for Lorenzo de' Medici, the picture is contemporary with Piero's mythologies and coincides with the moment when Michelangelo is said to have worked in the Medici garden, when he pretended to have made his initial essay in the poetry of stone, in the form of a creature of Pan—a *Faun.*

Puzzled by this beautiful and haunting work, students of the Renaissance are unable to decode Signorelli's painting iconographically—to fix its fugitive meaning in a precise way. They are left with the impression of one preeminent scholar who, speaking for all of them, justly said that the painting "has never been adequately interpreted." This is so because scholars have failed to listen adequately to Signorelli's subtle "voice," to yield themselves to the musical nuances of the painter's allusive meaning.

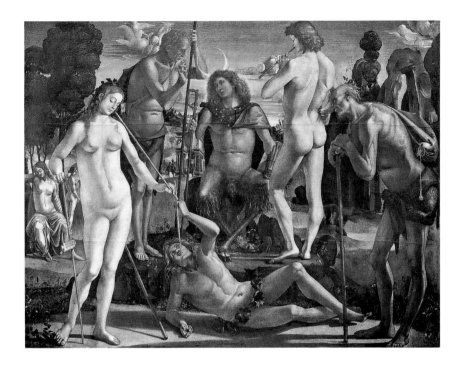

Fig. 30. Luca Signorelli, *The Kingdom of Pan* (destroyed). Formerly Kaiser Friedrich Museum, Berlin

To understand Signorelli's general purpose is to recognize the genre of his work, which is a form of bucolic poetry, an eclogue or *pastorale*, not unrelated in kind to the dreamy Giorgionesque *Fête Champêtre* or *Pastorale*, similarly permeated by the pastoral music of pipes. Like this Venetian painting and the rustic poetry that inspired it, Signorelli's picture is itself a highly cultivated form of painted poetry or music, the deeply sophisticated vision of the pagan god and his entourage serenely and harmoniously one with nature. In the root sense of "eidyllion," which comes from the Greek verb "to see," Signorelli's painting is such an idyll—an urbane painter's nostalgic vision of a lost pastoral world.

No less is Signorelli's painting an "elegy," a mournful, melancholic *poesia*. With deep sad eyes Pan looks dolorously upward, and the other figures in his court are no less soulful and inward in counte-

nance. In the middle distance a nymph, seated, rests her cheek on her hand, evoking (as it has been said) the melancholic lover of Lorenzo de' Medici's poetry, "col braccio alla guancia"—his cheek resting on his hand, as he is deep in sorrow. For Lorenzo and Signorelli the pastoral realm of love, the *vita amorosa*, is filled with something like oxymora, "sweet tears," "hard thoughts," "bitter sighs," and "laments": *dolci lacrime, duri pensieri, amari sospiri*, and *pianti*, like those of Lorenzo's *Selve* and eclogue "Apollo e Pan." If this rustic realm is *dolce* or sweet, it is also *doloroso*, filled with sorrow.

Yielding ourselves to Signorelli's bittersweet musical vision of Arcadia, we might well ask ourselves, adopting the words of a modern pastoral poet: "Quelle est cette langueur qui pénètre le coeur de Pan, le coeur de peine?" What is this languor that pierces the heart of Pan, the heart of pain? The painter points to the answer by rendering the pipes in the god's lowered hand, thus alluding to Pan's unrequited love.

Signorelli calls us back to *Metamorphoses* I, where Ovid sings with sweet pathos of Pan's love for Syrinx, who fled from him and prayed to her sisters to change her form in order that she might be spared his embrace. When Pan thought that he had caught her, he found that his arms held not Syrinx but marsh reeds. He then exclaimed: "This union with you will remain to me." The pipes of unequal reeds, fitted and joined together, thereafter took her name.

Ovid united Pan and Syrinx in the soft sweet sonorities of his musical poetry, weaving together the sounds of their names or, more precisely, of the first letters of their names. Describing Pan crowned by sharp pine needles and then thinking that he held Syrinx, Ovid plays on the P sound of Pan's name ("Pan . . . pinuque . . . praecinctus . . . Panaque . . . prensam . . . putaret), harmonizing it with the sonorous glissando of Syrinx's S, as when she prayed to her sisters, Pan sighed and the air in the reeds echoed this sound: "orasse sorores . . . suspirat . . . effecisse . . . sonum . . . similemque."

Listening to the music of Signorelli's profoundly mournful pastoral poetry, the sad piping of Pan's woodland companions, the dulcet rhythms that inform their suave bodies, we can still almost hear the air whispering in the reeds, echoing the gentle sigh of the god whose unrequited love was the origin of the *ars nova* of the bucolic pipes. If a Renaissance poet once wrote that from music love is born, "dalla musica nasce amore," Signorelli was saying, more deeply in the man-

ner of Ovid, that music is born of love, "dall'amore nasce musica," for the melancholic music of his painted elegy, like the doleful strains from the pipes of Pan, plaintively and longingly memorializes the bittersweetness of fugitive love. The only difference between a caprice and a lifelong passion, as Oscar Wilde famously said, is that a caprice lasts a little longer. For all love is doomed. Although Syrinx is present in Signorelli's painting only in her metamorphosed form (as the pipes of Pan), her spirit and memory pervade, suffuse, the painting—a pictorial elegy composed with a Catullan tenderness that translates musical sound into color and visible pattern, an "eidyllion" that conjures up the remembrance of all the lost loves that ever were—"so sad, so strange, the days that are no more," "atque in perpetuum . . . ave atque vale."

To contemplate Signorelli's Ovidian picture in its broader context is to recognize that, like Vasari's biographies of artists who arise from the pastoral world, like Piero's "histories" of the emergence of artists in such a primitive, pastoral realm, like Titian's *Fête Champêtre*, where the painter assumes the persona of a pastoral poet in nature, like Botticelli's *Primavera* or the sonnets of Petrarch, which depict the romanticized pastoral greenworld of the poet, the *Kingdom of Pan* is, at bottom, about the origins of art—more specifically about the origins of music or *poesia*, with which the painting is itself imbued. Painting this primitive world, Signorelli evokes historically his own distant origins as a poet descending from classical antiquity, the self-conscious sense of his own place in the tradition of classical poetry. As a highly poetic allusion to the myth of Pan, Signorelli's picture reminds us, finally, of another poetical version of the myth—that of Michelangelo, who, carving a *Faun* for Signorelli's presumed patron, Lorenzo, created himself as a sculptor. Michelangelo's fable of his first work in stone in a garden is a fable of the origins of art, a mythopoeic, pastoral legend, which, like Signorelli's picture, transports us once more to the primigenial realm of the God of nature.

10

THE MYTH OF MICHELANGELO AND IL MAGNIFICO

Let us circle back one last time to Michelangelo's laughing *Faun* in the garden, recalling that the story of its fashioning by Michelangelo stems directly from the artist himself. Michelangelo embellished Vasari's early account of discovery of the young artist by Lorenzo de' Medici by introducing the fable of the faun, just as Vasari elaborated on Michelangelo's version of events in his revised biography. Even at this late date, Vasari's two biographies of Michelangelo and Michelangelo's autobiography are still read as our principal "sources" of knowledge of Michelangelo, although by now we should know better. Sometimes it is even observed, remarkably, that when Vasari and Condivi "agree," what they say must be *true*. No matter that Renaissance biography is deeply poetical, that Michelangelo and Vasari are delighted to appropriate each other's fictions in the service of the glory of art.

We believe the highly fictionalized accounts of Vasari and Condivi because of our intellectual inertia, which causes our minds to cleave to received ideas. We believe what we are told, we oversimplify historical reality, we are reluctant to confess our uncertainty, less than willing to admit the limits of our knowledge. We accept the exemplary fictions of Renaissance history as literally true because we want to be fooled: *Populus vult decepi, ergo decipiatur.* Yet our so-called "sources" probably tell us more about Vasari's poetical glorification of Michelangelo when the artist was seventy-five years old and

about Michelangelo's no less poetical image of himself in old age than they do about what in fact happened early in Michelangelo's career. Let us turn to these fictive versions of events once again in order to see more deeply into the imaginative, poetic character of Renaissance biography and history—no less fictive than the *istorie* painted by Vasari and Michelangelo, no less fabulous than the poetry of Michelangelo and his other contemporaries.

What do we find in Vasari and Condivi? Vasari first tells us that Lorenzo wished to establish a "school" of art in the Medici garden, to which Michelangelo was sent. When the young artist made a copy of an ancient head, the story continues, the delighted Lorenzo celebrated Michelangelo's accomplishment by offering his father a job in the customs house, and also providing a salary to the artist, who was given a key to the garden. Michelangelo "improved" Vasari's version of events in his account to Condivi, saying that he made in the Medici garden a copy of an ancient head of a laughing old faun that filled Lorenzo with wonder. He made this sculpture from marble intended to adorn Lorenzo's unfinished library, a work, Michelangelo says, which was completed later by Clement VII. Michelangelo also claims that he was taken into the Medici household, given a good room, treated like a son of Lorenzo's, adding that at table he often sat above Lorenzo's own sons and other important personages and that, recognizing his genius and judgment, Lorenzo called him several times a day to show off the famous gems and medals in the family collection. At this time, Michelangelo also says, he carved the relief of the battle of the Lapiths and the Centaurs. Accepting Michelangelo's adornments of the original narrative, Vasari adds (in the revised biography) that in the same period of Michelangelo's stay in the Medici household, he also carved a relief of what is now called the *Madonna of the Steps.*

Years ago it was pointed out that when Vasari spoke of Lorenzo's "school" of art in the Medici garden he was creating a fictional precedent for his own academy of art sponsored by the Medici, and we no longer believe that there ever was a formal school in the garden. In a similar vein, it has been recently urged that Michelangelo's story about the *Faun* made in the garden, which Lorenzo admired and which brought the artist favor, is not "history" but a fable. Other elements of the general story encourage us to regard it as rhetorical. Michelangelo claims to have carved the *Faun* from marbles intended to adorn a library of Lorenzo's, which was planned but never built.

When Michelangelo links Lorenzo's library to the actual library he later built for Clement VII at San Lorenzo (playing on the relationship of Lorenzo's name to the site of the library in the church of Lorenzo's name saint), he is associating his later, glorious work with his patron's own glorious ambitions—an early example of the "aura effect." And, if Michelangelo carved his *Madonna* and battle relief during his time in the Medici household, why did they both remain in the possession of Michelangelo and *his* family (until the former was given to Duke Cosimo by Michelangelo's nephew after the artist's death)? Are we to imagine Michelangelo carting them away from the Medici garden or palace after Lorenzo's death? Furthermore, do we really believe that Michelangelo sat at the table above Lorenzo's sons or that Lorenzo summoned Michelangelo several times a day to admire the display of gems and medals? If we question such details as these in the narrative, what then do we finally believe?

It is perfectly possible, perhaps even likely, that there were some relations between Michelangelo and Lorenzo il Magnifico, for they were distantly related by marriage. Michelangelo's maternal grandfather, Neri del Sera, was married to Bonda Rucellai, whose relative, Bernardo, was married to Lorenzo's sister, Lucrezia. Such relations, tenuous as they may seem to us, were important in the social fabric of Renaissance Florence. Indeed, a letter from Michelangelo's father, Ludovico, to Giuliano de' Medici, from 1513, alludes to Lorenzo's good offices in securing a post for Ludovico. There is evidence, however, to suggest that Michelangelo resorted to fiction, bragging that he was responsible, through Lorenzo's intervention, for his father's job in the office of the *dogana*. The documentation available to us indicates that Ludovico already held an important post in the customs house in 1479, when Michelangelo was four years old. Michelangelo's story appears to be a merging of events that encapsulates a truth, for he was, during most of his life, responsible for the financial well-being of his father and entire family. Such lifelong financial support seems to have colored his recollection of the past, and his fictional account was an effective means of transforming a dreary tale of financial dependency into a retrospective fable of aid to his father, of his own magnificence through il Magnifico. Moreover, when Michelangelo reports to Condivi that Lorenzo, before giving his father a job, put his hand on Ludovico's shoulder and said, smilingly, "You will always be poor," the tone of this remark is suggestively reminiscent of Michelangelo's

condescending letters to his father concerning family finances. It is as if Michelangelo, inventing this conversation, assumed the persona of Lorenzo, whose condescension toward Ludovico is, in effect, his own. If we cannot believe Michelangelo when he lies about assisting his father to a post, why should we believe other details of his narrative?

Michelangelo presumably did study or even work in the Medici garden, since he is referred to in an often-cited source of 1494 as "sculptor from the garden," and it is not impossible he made some work that was brought to the attention of Lorenzo, who offered an encouraging word. Perhaps Michelangelo was invited to dinner in the Medici palace, where, as a guest, he was given a place of honor, and perhaps Lorenzo once showed him some of the fine objects in the fabled collection. It does not follow, however, even if there were connections between the Buonarroti and the Medici and might have been connections between Michelangelo and il Magnifico himself that Vasari's or Michelangelo's versions of events correspond in detail to historical "reality" or that they are innocent of rhetorical hyperbole.

We are so deeply credulous that we seldom pause to ask what documentation outside of Vasari's biography of Michelangelo and all the embellishments corroborates the details of the story linking Michelangelo and il Magnifico. Suspending disbelief, we shirk the question, even though we are aware of Vasari's rhetoric and his exemplary fictions, of Michelangelo's autobiographical tidal urge toward hyperbole and fantasy. Vasari tells us that Michelangelo worked for il Magnifico's cousin, Lorenzo di Pierfrancesco, and we have evidence of this relationship in the form of Michelangelo's earliest extant letter, addressed to Lorenzo di Pierfrancesco from Rome. *Outside of Vasari and Condivi there is no evidence of Michelangelo's direct association with Lorenzo il Magnifico.* Could it just be that Vasari invented the circumstantially well-founded story of Michelangelo's dealings with Lorenzo il Magnifico in part from knowledge of Michelangelo's relations with Lorenzo's lesser namesake? Could it be that the story of Lorenzo and Michelangelo is a fable—a fiction invented by Vasari and blithely embraced by Michelangelo?

If there are reasons to question the particulars of the story linking Michelangelo and Lorenzo il Magnifico, then there are reasons why we might suspect the account of being imaginary. What, in fact, does the narrative do? It brings directly together, in a momentous event, two of the greatest figures in the history of Florence, whose lives

overlapped only briefly at the end of the fifteenth century: the great Medici statesman, poet, and patron, at the very culmination of his career, and the greatest artist of all time, at the very beginning of his. By having Lorenzo discover and cultivate Michelangelo's sculptural gifts, the story magnifies the Magnifico's magnificence, since it reveals him to be a shrewd judge and sponsor of genius, and, in a similar fashion, it socially aggrandizes the glory of Michelangelo by placing him not in the vicinity but in the very household of the most illustrious patron of the day, Lorenzo il Magnifico, showered with lordly favor and surrounded by persons of high station. Each of these great figures, Michelangelo and il Magnifico, is, thus, greater by virtue of his association with the other, and for a comparison one can only recall David, young, ruddy, and of humble origin, playing his harp and finding favor in the sight of King Saul, who "took him that day, and would let him go no more to his father's house."

It is instructive, if not amusing, to observe the tergiversations in the various descriptions of Michelangelo's age in the different versions of the tale of Michelangelo and Lorenzo. When Vasari first says that Michelangelo was called to the Medici garden, he is among the *giovani* or "youths" who were sent. Condivi says that Michelangelo was fifteen or sixteen years old when he went to the Medici household, but he elsewhere says that at this time he was a *fanciullo*, a mere boy. In the revised biography Vasari tells us that for the funeral of Michelangelo a painting was made under his supervision, which showed il Magnifico receiving the reverent Michelangelo as a *fanciulletto*—a little boy! As the story grows older and older, Michelangelo grows younger and smaller. Outdoing Peter Pan, who was fixed in time, he is actually juvenescent. The effect is pointed, for it encourages us to think of the moment when Michelangelo, a mere child and untutored in sculpture, made a virtuoso imitation of a classical sculpture, encouraging us further to suspend what questions we might have had about exactly how he evolved into the gifted sculptor who carved the *Bacchus* and *Pietà* at the age of just over twenty, in the second half of the 1490s.

To contemplate Michelangelo's formation as a sculptor we must picture his initial essays in carving, considering even their tentativeness and flaws. We might well imagine early work, lost or even destroyed, like the drawings he burned, concealing his initial, feeble efforts. It is indeed ironic that in *The Agony and the Ecstasy* Irving

Stone should be exceptional among writers on Michelangelo, pondering the artist's presumed initial essays with a chisel when still a child in Settignano. He proceeded more plausibly than the myriad scholars who repeat the versions of events from Vasari and Condivi, which surely oversimplify what in fact happened, without reflecting on Michelangelo's presumably humble origins as stonecutter in a region dense with such carvers. Following Vasari and Condivi, the supposedly tough-minded art historians are even more romantic than the novelist, swallowing whole the fiction of the child prodigy, who emerged as a virtuoso without any training whatsoever. Occasionally art historians have speculated that Michelangelo might have been trained by Benedetto da Maiano or by his friend, Giuliano da San Gallo, but such speculations remain tangential to the Vasarian narrative followed in most accounts of the artist. We must still wonder about the training of the artist before he was supposedly discovered as a highly gifted prodigy by Lorenzo. Where did he learn to carve? When and by whom was he trained?

What then do we know about Michelangelo's development as sculptor in his early years? Very little indeed. Numerous works said to be by him, including the famous *Cupid*, are lost. The attribution of the *Crucifix* from Santo Spirito is still hotly contested, and the dating of both the *Madonna of the Steps* and the battle relief has been seriously questioned (by Longhi, who wondered whether they might in fact date from after 1500); indeed, the very attribution of the former relief is by no means secure. There are, of course, the sculptures Michelangelo produced in San Domenico in Bologna in 1494, but because they conform to the conventions of the earlier work on the monument to which they belong, they are not, though skillful, truly remarkable. If they are remarkable, it is not because of their quality but because they are from the "divine" Michelangelo. In other words, the story of Michelangelo's evolution as a sculptor prior to his maturity in the second half of the decade remains highly conjectural and problematic, tenebrous if not obscured.

Acceptance of the mythologized version of Michelangelo's youth allows us to avoid confronting our ignorance of his *Bildung*, since it encourages us to think of Michelangelo emerging as a full-blown talent all at once in Lorenzo's garden. Of course we know better, or should know better. But, then, what *do* we believe? Do we really believe that Lorenzo discovered Michelangelo's talent as sculptor,

cultivating this talent by encouraging him to study the great collection of antiquities, and that this is how Michelangelo came to be the mature classicizing sculptor of the *Bacchus*? It is perfectly possible, as we have observed, that there were connections between Michelangelo and il Magnifico of a different sort from those described by Vasari and Condivi. Even so, we do not know what such relations might have been, and there are no compelling reasons to believe that the stories of Vasari and Condivi conform closely to the facts, whatever they were. It is possible, if not probable, that the story of Lorenzo's discovery and cultivation of Michelangelo, however rooted in reality, is a legend—one of the greatest (and most useful) of such stories in all of Renaissance literature!

The notion of abandoning the narrative of Michelangelo and il Magnifico will be resisted, for to give up this tale is to relinquish a story familiar and well loved, and to leave a gaping hole in the narrative of Michelangelo's early years. Those who are prepared to suppose the story a fiction might well say, "There goes another myth." But to divine the presence of a myth is not just to subtract something from the larger narrative to which it belongs but to supply something in its stead. What we discover in a myth is a form of poetry or *mythopoiesis*—in this case, Michelangelo's imaginative use of Vasari to shape his own autobiography. What is lost at one end of the biography, at the beginning, as an account of "what really happened," is replaced, at the other end of the biography, when, in old age, Michelangelo created a meaningful fiction.

Although we know that Renaissance history is rhetorical, we nevertheless lapse, despite ourselves, into accepting as fact many of its exemplary fictions, taking them too literally. Nevertheless, by now it should be clear that, however many facts they contain, we cannot read such texts as Vasari's and Condivi's biographies of Michelangelo as mere documentation. It is one thing to regard such texts as "primary sources." It is quite another to know how to read them. One could fill a substantial book with references to art-historical literature that misuse Vasari as documentation, as the basis for the assertion of historical fact, although it should be evident that this procedure is misguided. Art historians need to know not only how to look but also how to read—reminding themselves of their desire to be fooled, despite their professional skepticism. *Populus vult decepi, ergo decipiatur.*

11

ART AS DECEPTION

The fictions of Vasari's biographies and Michelangelo's autobiography are "deceptions," what were called *inganni*. Such deceptions are closely linked to those in painting and are no less artful than the illusions of portraiture. The quality of verisimilitude gives Renaissance biography the illusion that what it reports is true, yet, like a portrait, it artfully refashions what it describes. We easily delude ourselves, although we know better, into the belief that a Renaissance portrait is a faithful likeness of the sitter because it conforms to other portraits of the same subject, forgetting that all such portraits, while imitative in varying degrees, are highly conventional. Portraits of Dante in Renaissance art conform less than we think to Dante's actual appearance(s) than to the received, fixed convention of what he looked like. By analogy, Renaissance biographies are highly conventional and, although we believe them, yielding to their verisimilitude, they are, like paintings, powerful deceptions, whose devices of artifice hold us in thrall.

We need to dissolve the boundaries between the Renaissance biography of the artist, itself a branch of art, of literary art, and the very arts that these biographies describe. Just as, for example, the appearance of Niccolò da Tolentino in Paolo Uccello's *Battle of San Romano* is that of a real person in a fictional version of events, so the artists, including Michelangelo, who appear in Vasari's biographies are real personages represented in fictionalized *istorie*. Such fictions are de-

ceptions, and they belong to the unwritten history of Renaissance deceptions, a global history that includes not only fictions of art and literature, but the "real-life" deceptions of forgery and fraud, including those of Michelangelo discussed in the following chapters.

In this chapter I present a sort of prolegomenon to such a future history, focusing on the stories of the deceptions of painters in relation to the deceptions of their art. Although these stories are fictional, *novelle*, we should not regard them as existing apart from what we call reality, for such fictions are created *in* reality. All fiction emerges in the real world and is as much a part of reality as is the protective coloration of insects and animals, the deceptions of nature herself. We should make note, as we proceed, that many of these deceptions of art are about the self, the very self of the artist that was coming to the fore in Renaissance biography and in autobiographical poetry or art. To explore the self or its seeming effacement in illusionistic devices is another sense in which we return to "origins," for the self is the seat of fiction and illusion, of its own poetic beginnings. But first some simple definitions.

"Ingannano gli occhi," says Baldassare Castiglione in the *Book of the Courtier:* "Paintings deceive the eyes." In a similar vein, Vasari writes in the introduction to the *Lives* that painting is a "most pleasurable deception," *piacevolissimo inganno*, since pictures delightfully and magically create the illusion of three-dimensional form and space on a flat surface. A marvelous example of such illusion is cited by Vasari in his biography of Giotto. Here, he pretends that Giotto fooled Cimabue by painting a fly on one of his teacher's figures. Vasari's fiction, his own illusion in words, is of course a reworking of those famous anecdotes from antiquity about similar pictorial deceptions.

We all know that the term "illusion" is related to the Latin word for play, *ludere*, and, although the word "illusion" has been used to translate Vasari's *inganno*, it could also have been translated as "deception" or even as "trick." The verb *ingannare*, to deceive or trick, can also be translated as "to fool" and is closely related to *uccellare*, which comes from *uccello*, bird. The sense of this word is reflected in our own language, when we speak of a fool as a turkey, loon, or dodo, a birdbrain or featherhead. Paolo Uccello was supposedly such a figure. When Vasari says that, in painting a fresco in Santa Maria Novella, Uccello screwed up the perspective, he observes that Uccello fooled himself, *ingannossi*. Uccello *uccellato*, we might say.

To admit that Renaissance paintings fool or trick us, to place paint-ing in the realm of folly or trickery, is to understand why Plato wanted to banish painting from his ideal Republic and why iconoclas-tic reformers of the sixteenth century wished to destroy paintings, to understand why art historians prefer to speak of "art and illusion," not of "art and trickery," of "art and folly." Although art historians have delved deeply into the rhetoric and language of art theory, using Vasari to explicate *disegno, colorito, idea, difficultà, grazia, chiaroscuro, furia, maniera, fantasia, maraviglia, giudizio, splen-dore*, they have strikingly left the word *inganno* alone. How odd, since it is so basic to the vocabulary of art. It is, as Vasari says, a synonym for art itself. It is a very jape. No wonder Vasari presents Leonardo, the inventor of the perfect manner of painting, as a type of magician, who performed marvelous tricks, one of the greatest of which was the *Medusa* painted on a shield, a work that fooled his father, who could not believe that what he saw was painted.

Just as artists represented the personifications of Painting, Sculp-ture, and Architecture in their works, Bronzino depicted the artful personification of Deception in his *Venus, Cupid, Folly, and Time* (Fig. 31). Vasari calls her Fraud or *Fraude*, whom Bronzino has neatly paired with *Giuoco* at the right of the picture. The latter's name has been translated as Folly, and appropriately so, since the bracelet of bells that he wears on his ankles evokes those worn by court fools. This smirking lad is, therefore, a jester or Jest. The name Vasari gives him, *Giuoco* or Play, also suggests joke, reminding us that in our deck of playing cards, the court jester or fool appears as the Joker. Folly, Jest, Play, Joker, call him what you will, he partially and suggestively conceals the dissembling Fraud, a particularly treacherous form of *Inganno*, Deception or Trick. Deceptively beauteous of countenance but appearing in an animal's body, Fraud descends from Dante's Geryon, similarly comely of visage but bestial of body. Geryon pre-sides over Malebolge, where the fraudulent, vicious tricksters are punished. It is no doubt significant that Bronzino's Fraud is identified with Play, for tricks or deceptions, even vicious ones, are manifesta-tions of play.

Boccaccio and his followers bring out this relationship. They comi-cally catalogue the duplicities of the vicious in tale after tale, espe-cially in fables about greed, gluttony, and sexual deception—for example, the story of the abbot who, having tricked Ferondo into

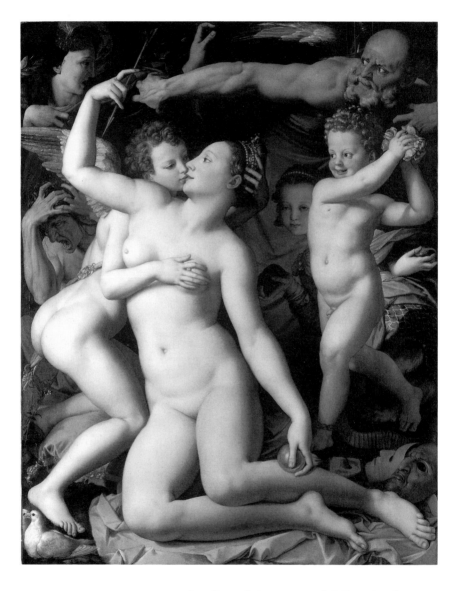

Fig. 31. Bronzino, *Venus, Cupid, Folly, and Time*. National Gallery, London

believing he is in Purgatory, has free rein to seduce Ferondo's wife, or the famous story of Fra Alberto, who, masquerading as the angel Gabriel, has his way with a beautiful but simple woman. Analyzing such fraudulence or deception, we can speak of the abbot and Alberto as artists, poets who create powerful illusions: the illusion of Purgatory, in the manner of Dante, the masquerade of the angel Gabriel, like those from the hands of Renaissance painters.

No wonder Machiavelli, a close reader of Boccaccio and student of human psychology, urged that in a world of viciousness the ideal prince needed to resort to deception for the sake of maintaining order. He must know how to trick men, he must be a great liar and cheater, exploiting the fact that common people, judging with their eyes, are impressed by appearances. The perfect prince is closely related, therefore, to Castiglione's ideal courtier, who also exploits appearances artfully, making difficult things seem to have been done easily and without effort. Like the paradigmatic prince, the perfect courtier conceals and dissembles, relying on the tricks of art. Dissembling, lying, cheating, fraud, deception, masquerading are a way of life in Renaissance Italy, and a close scrutiny of published sources, forged documents, fake classical inscriptions, forged works of ancient art and literature, all sorts of swindles and duplicities in church, court, and commune, indicate that however fictionalized the writing about fraudulence or deception in the literature of the period from Dante to Vasari, this vast body of writing mirrors the real world of deception, the arts of deception in the real world.

Of all Renaissance artists or deceivers, the divine Michelangelo most nearly epitomizes such duplicity. He forged an ancient *Cupid* to increase the monetary value of his work, or so the story goes, and he burned many of his drawings, as Vasari tells us, presumably to conceal the effort that went into his labor. We overlook other evidence of his deceptions (more about which below), however, because we prefer to believe the fiction of his saintly ways. Forger and cheat, Michelangelo is a very connoisseur of the art of deception. He is forever worrying about being cheated by others, taken in by muleteers, notaries, patrons, assistants. His letters are filled with the vocabulary of duplicity—*gabbare, giuntare, ingannare,* and *uccellare.* He flies into a rage after he is cheated by his helper Lapo, who, under the "appearance of goodness," *colore di buono,* is a scoundrel. He urges his family to protect themselves from deception—by being themselves

deceptive. "Pretend not to understand," *fate le vista di nol vedere*, he tells his father. Fight deception with deception, he insists.

Nowhere in the literature of the Renaissance do we find more stories about artists as tricksters than in the pages of Vasari's *Lives*. We all recall, to cite a single example, the story of how, after his disciple Biagio had painted a *Madonna and Child with Angels*, Botticelli, with another assistant, Iacopo, attached paper hats to the angels, like those worn by the citizens of Florence. When Biagio returned to his picture, it suddenly seemed as if the Madonna were seated in the *Signoria*. Let in on the trick, Biagio's patron praised the painting, whereas the duped artist was befuddled. When Biagio went away again, Botticelli removed the hats and his poor disciple returned only to be doubly amazed by this second transformation—at which he asked if he could be dreaming. Botticelli next teased Biagio by saying that the money he has earned for the picture has gone to his head.

The whole episode, Biagio proclaims, has been a "strange thing." Indeed it has, but not in a way that he understands. "Strangeness," Vasari says over and over, is one of the primary qualities of art itself, which, in its "novelty," is "extraordinary." Turning angels into citizens, Botticelli transformed one illusion into another, a greater work of art, an illusion even more powerful and stupefying than Biagio's original painting, and Botticelli's final transformation of the citizens back into angels only magnifies the stunning effect of his trickery.

Vasari's tale of Botticelli's trick on Biagio descends from a whole family of such fables, which take us back to the pages of Boccaccio, to Boccaccio's tales of the redoubtable painter-trickster, Buffalmacco. One of the most splendid of these tales concerns the occasion when Buffalmacco tricked his fellow-painter Calandrino into believing in the existence of valuable stones that made one invisible. Sure enough, Calandrino finds these stones, thanks to Buffalmacco's duplicity, and is convinced by Buffalmacco that he is now invisible. A lesser illusionist than Buffalmacco, Calandrino thinks that he can slip away unseen, but such of course is not the case. He is pursued by Buffalmacco and their companion, the painter Bruno, who pelt him with stones, thus ending their cruel joke.

The crudity of the joke belies its wit. Boccaccio plays on the very deceptiveness of art by wittily inverting its function. Whereas painters make nonexistent things materialize, willing them into visibility, Buffalmacco makes Calandrino disappear. Boccaccio does not fail to

give a motive to Calandrino's gullibility, for the silly artist is made to believe that the magic stones will make him rich, which means that he will no longer have to work.

Franco Sacchetti, who exploited Buffalmacco in his own tales that were later adapted by Vasari, wrote a delightful story about a painter, Bartolo Gioggi, which is a variation on Calandrino's invisibility. According to Sacchetti, a certain Pino Brunelleschi commissioned Bartolo to paint a room with a view of birds in trees, the kind of painting that is still preserved, for example, in the Palazzo Davanzati in Florence. Pino went to the country for a month during which time the work was completed, but when he returned and examined the painting, he objected, "Bartolo, you have not served me well, you have not painted as many birds as I wanted." To this Bartolo replied, "Sir, I painted more, but your servants kept the window open and most of them flew away." In a delightful inversion of Pliny's account of how real birds were attracted to paintings, Bartolo's fictive birds become real and fly out of the painting. Of course the real bird, birdbrain or *uccello*, in this story is Pino.

When Bartolo asks to be paid for his labors, Pino refuses. At this Bartolo suggests that Pino let a certain Pescione decide the matter, and the simple Pino agrees to this idea, even though Pescione is blind. "How can you leave this matter to me?" Pescione protests, "I cannot see." After getting the opinions of various painters, Pescione decides in favor of Bartolo, saying that Pino should be satisfied with the birds that remain. Enraged, Pino throws Pescione out, but since it is night he has his servant Gianni, who has only one eye, lead the way with a lamp. "But," the blind Pescione protests, "I have no need of light." We have here a cast of characters (familiar to us all in the films of the Marx Brothers) who are in varying respects blind, most of all the dimwitted patron, Pino, whose simplicity is emblematically embedded in the birds that flew away, since (as we noted) *uccelli* stand for fools.

Arguably the greatest figure in this Florentine family of gulls is the sublime Fat Carpenter, the protagonist of an early fifteenth-century story attributed to Antonio Manetti. According to the tale, the architect Brunelleschi is annoyed when the Fat Carpenter does not appear at the weekly festivities of a band of artists. With the help of his friend Donatello, he decides to play a trick on the carpenter by convincing him that he is not himself. As Calandrino was made to think that he

was invisible, so the Fat Carpenter is made to believe that he is not who he thought he was. Brunelleschi's scheme goes like this. When the Fat Carpenter returns home, he finds himself locked out. Brunelleschi, inside, impersonates the Fat Carpenter to the Fat Carpenter, imitating his very voice, asking who is there. When he answers that it is himself, Grasso, Brunelleschi tells him not to be ridiculous, calling him Matteo instead. The Fat Carpenter exits in utter confusion, next running into Donatello, who greets him, "Good evening, Matteo." The Fat Carpenter asks himself, "Am I now a Calandrino, since I have become somebody else without knowing it?" And so the story unfolds, in further artful complications, until the Fat Carpenter "loses his very person" in a metamorphosis that the author likens to those of classical myth, suggesting that his own delightful tale is an ingenious modern variation on a theme from Ovid's *Metamorphoses*.

The classical roots of such stories sometimes climb to the surface. This is the case in a verse story briefly antecedent to the tale of the Fat Carpenter, *Geta e Birria*. It is a reworking of Plautus's *Amphitryon*, in which Jupiter, inflamed by the beauty of the general's wife, Alcmena, makes love to her when her husband is away in battle. He does so by disguising himself as Amphitryon, while Mercury, the supreme trickster of antiquity, keeps guard during this tryst, pretending that he is the servant Geta. When Geta comes upon Mercury, who says he is Geta, the real Geta asks if he is dreaming (as Biagio later would when tricked in Vasari's tale by Botticelli). Wondering if he has been deceived, he says, "I am nobody . . . of me nothing remains." This neo-Plautine farce playfully calls attention to the power of names. If Mercury is Geta, then Geta is not Geta, is not himself, is not his own *essenzia*, his own being. A type of Calandrino, Geta is a close relative, so to speak, of the Fat Carpenter. It is particularly significant that the story of Geta and Birria was falsely attributed to Filippo Brunelleschi, the cunning deceiver of the Fat Carpenter, here seen as an inventor of an earlier, comparable trick.

"Every painter paints himself." So Vasari said Michelangelo said. Michelangelo's words, perhaps put into his mouth by Vasari, descend from the *Bel Libretto*, a collection of sayings from the second half of the fifteenth century attributed to Poliziano. The proverb is attributed there to Cosimo de' Medici, whose contemporary, Leon Battista Alberti, spoke in similar terms. In *Della Pittura*, Alberti claimed that, falling in love with his reflected image in a pool,

Narcissus was therefore the first painter. Thinking the reflection was reality, he was deceived by this illusion, by this false "picture" of himself. In the language of the stories of Geta and Birria and of the Fat Carpenter, Narcissus lost his own *persona* or very being, because he saw himself as another. Alberti's invocation of Ovid's myth sharpens our sense that all of these stories from Boccaccio's tale of Calandrino to Vasari's *novella* of Biagio are fables of metamorphosis, metamorphosis of the self.

Such stories about the loss of the self are, thus, paradoxically fables about self-consciousness. Just as the imminence of death sharpens the sense of one's self, the self that is about to exist no longer, the apparent loss of identity heightens the consciousness of the very self that is disappearing. In inverted form, these charming fables are all instances of Burckhardt's "discovery of the individual" in the Renaissance, and they play on the deep philosophical and psychological probing in the period of subjectivity, what philosophers have called the "subject-object problem." No wonder Brunelleschi is associated with two of these tales, as author or character. As the inventor of perspective, which magnifies the beholder's sense of himself as he gazes at the illusion of the painting from the fixed point of view calculated for him by the deceptive artist, Brunelleschi also negates or nullifies the beholder's consciousness of self, for suspending disbelief, the beholder in a sense loses himself in the very illusion. What Brunelleschi giveth, Brunelleschi taketh away.

There are countless variations on the theme of the artist playing illusionistically with the self or the self-consciousness of a simple fellow. One of the finest is found in the story told by Vasari's contemporary, Lasca, about Lorenzo il Magnifico in *Le Cene*. Legendary for his facetious spirit, reflected in his comic poetry and his *novella* of Giaccopo, which possibly played a role in the formation of Machiavelli's classic of sexual deception, *La Mandragola*, Lorenzo is memorialized for his facetiousness by Machiavelli in his *History of Florence* and by Vasari in the *Lives*. In Lasca's entertaining fable, when a certain physician, Manente, gets drunk, Lorenzo has him secretly carried into a dark room in his palace. Awakening in this lightless place, Manente is informed that he is dead. Believing this illusion, he is like Ferondo in Boccaccio's *novella*, who is tricked into believing he is in Purgatory. But this is not the half of it.

By staging a fake funeral, Lorenzo sees to it that all of Florence is

tricked into believing that Manente is dead. Thus, after Lorenzo
finally has Manente released outside Florence and the poor gull re-
turns home, his wife thinks he is a ghost. Lorenzo next brings in a
magician named Nepo, who, compounding the illusion, explains that
in revenge against Manente for an earlier injury, an evil spirit has
created this false ghost of Manente. Nepo is in a sense the creature of
Lorenzo, the real *magus* behind this magisterial illusion. Every
painter paints himself. Manente is, not surprisingly, terrified by all
this, but, finally, when he is recognized for himself, it is decided that
Nepo should be captured and burned at the stake. Lorenzo protests,
however, that it is not worth the bother, since the magician has count-
less ways of escaping, including that of rendering himself invisible.
(And where have we encountered this illusion before?)

Lasca's story is an encyclopedia of devices and motifs from the great
tradition of Calandrino. We fail to appreciate the significance of the
story if we ignore the fact that Lorenzo, himself a magician-poet in the
tradition of Virgil, not only tricked the simple Manente but fooled all
of Florence. Lasca's story is thus about more than Lorenzo's tricky art;
it is also about his ability to control the beliefs of the Florentines with
his artful illusions.

There are other stories in Vasari not obviously related to the group
of tales we have been discussing but that in fact are connected to
them. Take, for example, Vasari's story about the copy Andrea del
Sarto made of Raphael's portrait of Pope Leo X. According to Vasari,
when the Duke of Mantua, Federigo Gonzaga, came to Florence, he
visited the Medici Palace, where he saw Raphael's portrait over a
door. Covetously, he requested it as a gift from the Pope, who sent
orders to Florence that the picture be packed up and shipped to
Mantua. Ottaviano de' Medici, who could not bear to part with the
painting, called upon Andrea del Sarto to make a counterfeit of the
picture, which he did, even imitating the very dust on its surface,
before the undetected fake was sent to Mantua. Years later, when
Vasari was visiting Mantua, he told Giulio Romano the story. "How
can this be," Giulio replied, "how should I not recognize my own
brush strokes in this painting?"

The story is about a double duplicity. Both the recipient of the
forgery, Federigo Gonzaga, and the artist who worked on it with
Raphael, Giulio Romano, are tricked. Not being able to distinguish
the imitation of his work from his own brush strokes, Giulio, in a

sense, does not recognize himself. The style is the man—or so it seemed. The artist, who is a deceiver, creating an illusion, is tricked by another illusionist, who creates the perfect semblance of his own deception. He is as stupefied by this deception as Biagio and the Fat Carpenter were by the tricks of Botticelli and Brunelleschi.

As a storyteller, Vasari is closer to Boccaccio and his followers than to modern scholars. Even so, as readers of Vasari's fictions, we often respond to him as Boccaccio's readers did to the earlier writer's *novelle*, by suspending disbelief, yielding to the rhetorical illusions of his fiction. Vasari says that when Uccello's wife called him to bed, he did not come, proclaiming, "Oh what a sweet thing is this perspective," as he continued to pursue his studies, and the author of a leading textbook of Renaissance art reports Vasari's account as if it were true. In the same vein, some have taken seriously Vasari's anecdote that Raphael refused to paint in Agostino Chigi's villa until the patron allowed him to bring his lover there to stay with him while he completed his work. Likewise, in a recent book on Andrea del Castagno, the author accepts at face value Vasari's story that the painter flew into a rage when a boy shook his ladder while he was at work on the fresco of Niccolò da Tolentino.

Walter Pater most effectively captured our willingness as readers to submit to Vasari's illusions when he discussed in *The Renaissance* Vasari's fable of the *Medusa* that Leonardo painted in his youth by imaginatively imitating various serpents and insects, creating an image so seemingly real that it fooled his father, who could not believe that what he saw was painted. As a critical historian, as a skeptic, Pater properly sensed that Vasari's story was a fiction, remarking that it was "perhaps an invention." The key word here is "perhaps," because Pater nevertheless wants to believe that the story is true, adding that it "has more of the air of truth about it than anything else in the whole legend." He submits to the "air of truth" in Vasari's legend of Leonardo, just as modern scholars have responded believingly to Vasari's tall tales. We do not pause to consider how Vasari could have known Uccello's words, which are so appropriate to the obsessive concern with perspective in the painter's art. Similarly, we do not notice that Vasari's story of Raphael's passions is a variation on his earlier tale of Fra Filippo Lippi's escapades. We do not see that Vasari invents Raphael's sexual urges from the erotic subject of his frescoes for Chigi, the story of Cupid and Psyche, linking the painter's

voluptas to the sensuousness of his painting. In like fashion, we yield so fully to Vasari's spell that we do not consider the equation between the rage of Castagno and the fury of his subject, a scowling warrior. So credulous is one recent writer of Vasari's fable of Castagno that, he insists, had Vasari himself been on the ladder shaken by the youth, he too would have been furious! Embellishing Vasari's story, the modern scholar adds that Castagno never caught the boy because he lacked the adequate stamina.

Our ability to believe Vasari's fables, our willingness to do so, our compliancy, points to an essential fact about illusionistic art, whether painting or fiction. It takes two to play the game of illusionism. It not only requires a painter or poet to create an illusion; it demands a beholder or reader willing to surrender to the illusion. In art, as in life, which is inseparable from art, the duplicity of the deceiver goes hand and hand with the complicity of the deceived. The ability to fool or trick somebody depends on that individual's capacity to be tricked. This fundamental point brings us back to Vasari's Biagio and to the Fat Carpenter, Geta, Pino Brunelleschi, and Manente, all of whom I should like to call Calandrino's children. To the list of tricksters—Buffalmacco, Botticelli, Bartolo Gioggi, Filippo Brunelleschi, Lorenzo de' Medici—I should add their inventors, the Renaissance storytellers themselves, including Michelangelo and the incomparable Vasari. This, then, is the deeper meaning of all these Florentine fables about the art of deception, the deception of art, culminating in Vasari's tales, which are delightful allegories of art, of what art does to us, fooling us and filling us with pleasure and wonder. For we too are Calandrino's children, suspending disbelief as we read Vasari's pages, believing his illusions despite ourselves, as Calandrino believes he is invisible, Biagio believes his angels have become Florentines, and the Fat Carpenter believes he is no longer himself. For we too, all of us, are fools in art, believing Vasari's fables, even though (like Pater) we know or should know that they are themselves poetic inventions—*piacevolissimi inganni*—most pleasing tricks, no less imaginary and imaginative than the fictitious fly painted by Giotto: the illusion of an illusion.

12

THE FINE ART OF LYING

Michelangelo was a liar. The suggestion offends. It smacks of hero-bashing, typical of our antiheroic age. But it's true. We know it's true, or should know it's true, because Michelangelo confesses on more than one occasion that he lied. His motives were honorable, he insists, and harsh judgments against him are unwarranted, he implies, since he lied to one party in order to fulfill his obligations to another. Even so, Michelangelo was a liar.

I underscore the point here precisely because Michelangelo's propensity to lie has been radically underestimated by his scholars. It is not surprising that they have failed to observe his mendacity, since they are engaged in celebrating the artist, not in revealing his flaws. It is odd, however, that tougher-minded, hard-nosed, anti-idealist historians have had relatively little to say on the subject. By themselves Michelangelo's fibs, fabrications, and falsehoods might not seem of importance. What should interest us in them nonetheless is the artifice that informs them, just as it informs his very poetry and art. Michelangelo's deceptions take us back to the "origins" in art of Michelangelo's deceptive persona.

Michelangelo's lying is part of our more general story of the deceptions or *inganni* of art, for Michelangelo's lies are *inganni*, and these lies have about them the very qualities of poetry. Often we cannot tell if Michelangelo is lying, but starting from his confessed lies we can speculate further that his admitted untruths are not his only lies. The

lie is an instrument of rhetorical self-aggrandizement. It is closely related to the fable, another instrument that Michelangelo artfully used to mold himself.

Let us begin our analysis of Michelangelo's lack of veracity by considering the classic story of his flight from Rome during the time he was working on the tomb of Pope Julius II. We sometimes forget that we have five versions of the event recorded over a period of forty years. The first is Michelangelo's letter to Giuliano da San Gallo from 1506, which justifies his hasty departure. The next are Michelangelo's two drafts of a letter to Giovan Francesco Fattucci from December 1523, which recall this episode. Then follows a letter to an unknown prelate in 1542, which again rehearses the story. Finally, we have the "autobiography" that Michelangelo dictated to Condivi, which was published in 1553, offering still another account of the artist's flight. Particularly striking in these various versions of events are the changes of rhetoric, what is added or subtracted, from one account to the next. Let us here pursue the letters in sequence, noting what these changes might reveal.

The basic story is that Michelangelo fled Rome after he was refused access to the Pope, from whom he was requesting money for work on the papal tomb. In the initial version of what happened, Michelangelo tells Giuliano da San Gallo in 1506, shortly after his flight, that at dinner he asked the Pope for money and was told to return the next Monday. Michelangelo goes on to say that he returned on Monday, with no results, then again on Tuesday, Wednesday, Thursday, and, finally, on Friday and was sent away—at which point, in utter despair, he departed Rome. In no subsequent account of his flight does Michelangelo describe himself returning to the Pope day in and day out for an entire week before giving up his efforts, and we can only wonder whether, in the heat of the event, Michelangelo initially exaggerated what in fact happened by repeating the number of rejections— Monday, Tuesday, Wednesday, Thursday, and Friday!—in order to justify his indignation.

Then there is another detail that borders on mendacity. Michelangelo says the Pope's refusal to see him and pay him was not the only reason for his flight. There is something else about which he does not wish to tell Giuliano that also explains his departure. "Suffice it to say," he tells Giuliano, "if I stayed in Rome, my own tomb would be made sooner than that of the Pope." From this cryptic remark it has

even been concluded that Michelangelo's life was threatened, that he saw himself as the prospective victim of an assassination attempt. But are we really to believe this, that Michelangelo's life was actually threatened? Could it just be that Michelangelo added this mysterious detail in order to legitimize his departure, to give another reason for his flight? When he speaks of his own death and tomb in relation to the Pope's, Michelangelo does something rather typical. For later, if in a different way, he identifies the Pope's tomb with his own family tomb, as we have already observed, when he speaks of a figure on it as Matilda, his own ancestor. On the tomb Michelangelo was to present *Victories* and *Prisoners*, and later, as if exploiting this imagery, he would speak of himself as a prisoner of the Pope. In a sense, just as he was in imagination a prisoner or captive of the Pope, his own death, like the Pope's, was imminent—or so he would have us believe.

Let us consider another aspect of Michelangelo's letter to Giuliano that escapes commentary. At the very beginning Michelangelo acknowledges what Giuliano had told him, that the Pope was now ready to place the money at the artist's disposal and that he was to return to Rome without any worry. If the Pope was ready to make things right, then why did Michelangelo resist returning? Michelangelo gives an official, fictive excuse when he focuses on his humiliation and fear of assassination. But why does he prefer to remain in Florence? Why did he depart in the first place? In the final part of the letter, he explains his real reasons, which override his other excuses. He says that if the Pope will put the money at his disposal in Florence, he will be able to do the work more cheaply. In no way, he insists, can he work so inexpensively in Rome, for in Florence he has facilities available to him not to be found in Rome. When he talks about cutting costs, he is presumably referring to a reduction of the overhead. Then there is a further explanation for his remaining in Florence. "I will work better here," he says, "since I will not have so many things to worry about." We recall from his other letters that Michelangelo superintended his family's finances and was concerned with various affairs of his father and brothers. It would be much easier to attend to these matters if he were near at hand, in Florence.

In other words, it is perfectly possible that the whole episode of the flight is a subterfuge—a pretext for returning to Florence, where he really wants to be. Although the Pope wants Michelangelo in Rome, Michelangelo "creates a scene," we might say, in order to justify his

departure. He found an excuse for rushing back to Florence. Once there, he hopes that he can persuade the Pope to let him remain, since, as he observes, he can work more effectively and efficiently. He had needed money from the Pope in the first place to cover the housing of stonecutters from Florence. In Florence he would not have to pay such costs. He hopes that his friend Giuliano da San Gallo will make his case with the Pope.

We next hear about the tomb from Michelangelo in December 1523, when he writes to Giovan Francesco Fattucci in Rome, justifying himself in two drafts of a letter. He introduces the financial problem, saying that he is a creditor, not a debtor—defending himself from the charge that he is indebted to the heirs of the Pope, not having fulfilled the responsibilities for which he had been paid. He explains that he had brought stonecutters to Rome, whom he had paid in advance, adding that when he went to the Pope for reimbursement, he was turned away, at which point he fled. He next says that when the Pope went to Bologna, he was asked to go there to beg his patron's forgiveness. He says this not in simple neutral language but in figurative terms, observing that he went to Bologna with "a halter around my neck"—in other words, as if were a prisoner. The metaphor is suggestive, for it plays on the major theme of the tomb, the *prigioni* or prisoners.

Although in Vasari's rhetoric Michelangelo is a victor or *vincitore*, Michelangelo is forever representing himself as a prisoner or slave. In a letter to his father he says he would subject himself to slavery if necessary on Ludovico's behalf, and he elsewhere writes of having the weight of his family on his shoulders. More to the point, he pretends that Alfonso d' Este later said to him, "You are my prisoner," adding that, if he wanted to go "free," Michelangelo had to make a work of sculpture or painting. Michelangelo easily assumes the persona of slave or prisoner. Vasari initially said that the *prigioni* of the tomb stood for the states subjugated by the Pope, in a plausible explanation of such figures, which have a long history of antecedents, going back to the triumphal arches of antiquity, which provide the basic typology of the tomb. When Michelangelo later said that the *Prisoners* were the arts, he was perhaps projecting onto them his own sense as an artist of being a prisoner of the Pope, since he was forced to go to the Pope with a yoke around his neck. His figure of speech here is suggestive of the way in which he identifies himself with the victims on the tomb.

Michelangelo next turns to the matter of the Sistine ceiling, and again his language is figurative. When he was requested to portray only the Apostles in the ceiling, he writes to Fattucci, he told the Pope that this would be a "poor thing." Asked why this was so, he explained, "because they were themselves poor." The reported witticism, it has often been observed, is the basis for a related witticism in his autobiography. He later told Condivi that when asked to add gold to the holy figures of the ceiling he rejected the idea, saying it was inappropriate to do so, since they were poor. Moving from the rhetoric of the letter to that of the autobiography, we trace the genesis of autobiographical poetry.

There is a further, deeper resonance to Michelangelo's purported remarks on the Apostles and other holy personages as exemplary figures of poverty. The observation not only tells us of Michelangelo's self-fictionalizing eschewal of money, his own aspiration to be saint-like, it also more deeply reminds us of his obsession with money, his stinginess and very fear of poverty, all abundantly evident from his letters. We cannot fail to observe in this context that immediately after invoking poverty in a discussion of the Sistine ceiling he discusses the fact that when he was working on the cartoons he was not adequately paid. In a letter about finances, it is not surprising that a quip about the poverty of holy persons should spring to mind, since such poverty is, in effect, Michelangelo's own, if in imagination.

Another detail concerning the language of Michelangelo's letter, in both drafts, probably demonstrates the "art of lying." I am speaking of the very subject matter of the decoration. After he persuaded the Pope to abandon the scheme of the Apostles as "too poor," the Pope, he says, "gave me a new commission to do what I liked, as it pleased me." This remark is generally either ignored or rejected by modern scholars, because they reasonably suppose that Michelangelo must have been given a general scheme to follow. Various theologians have been put forward as the inventors of the ceiling's subject matter, which is not to say that Michelangelo was without license in rendering the narrative. Rather than merely rejecting Michelangelo's claim as false, we might look at it again as evidence of his ability to brag artfully, to lie! He is in effect insisting that he is the originator of the scheme of the ceiling. Once again we have in his claim a story of origins, the origins of the ceiling in Michelangelo himself! The lie is parallel to the Vasarian legend according to which he painted the ceiling unassisted.

The sheer rage and indignation of the artist had increased by 1542, when Michelangelo wrote to an unknown prelate asking that the latter defend him from the false charges leveled against him by the heirs of Pope Julius II. Michelangelo writes with a flourish: "Every day I am stoned, as if I had crucified Christ." He complains that in his negotiations with Pope Clement VII he had been deceived, insisting that the Pope had not seen the contract for the tomb of Julius. He also insists that one thousand ducats were added to the contract that were in fact not justified, and even his own house was included in the document, to his great surprise—as if the contract had been designed to "ruin" him. Clement VII, Michelangelo insists, would never have tolerated such terms. Again with a flourish Michelangelo claims that his good friend Sebastiano del Piombo wished to defend his honor by having the notary who prepared the document hanged! Michelangelo "swears" he did not receive the extra one thousand ducats added to the document, that he has "a clean conscience," that he is "telling the truth."

But let us read on. When Michelangelo also writes that Pope Julius II owed him five thousand ducats since, as an artist, he did not know how to "manage" his affairs, we hear him criticizing himself, as he had criticized his father Ludovico, his brother Buonarroto, and his nephew Leonardo. He continues to use a suggestive diction, observing that, according to his accusers, "I have enriched myself and robbed the sanctuary." Saying that he "lost the whole of my youth chained to the tomb," he sees himself again as one of its very *prigioni*, like the very prisoners he carved, and he sees the tomb as robbing him of his very life. This figure of speech takes us back to the earlier references to Rome as his tomb and to those who helped save his life—to the language of life and death.

In a particularly revealing remark toward the end of the first part of his letter, Michelangelo says, "I see many people with an income of two or three thousand ducats, who lie in bed, while I strive with the greatest effort to rise above poverty." There is more than a little *invidia* or envy in all this, not to mention the bold-faced lie concerning his poverty, since at this stage in his life Michelangelo was very prosperous indeed. He brags that he has been excessively "honest," and this honesty has brought him to "ruin."

But has he been so honest? In the second part of the letter, Michelangelo explicitly states that he has been unjustly accused of lending

money at interest from the money he received for the tomb of Pope Julius without doing the work for which he was paid, and that he has grown rich on the interest. Like a famous man of our time, Michelangelo insists, "I am not a crook." He is not, he cries out, "a usurer." Perhaps he betrays the sense that he has committed a Jewish vice when he elsewhere says that he is treated as if he were responsible for crucifying Christ. He further claims that Leo X, who called him to Florence, "pretended" he wanted Michelangelo to execute the facade of San Lorenzo because he did not want Michelangelo to execute the tomb of Julius. Michelangelo says that he nonetheless continued to work on the tomb, but (and let us pay heed) he "confesses" a deception of his own. While he was at Carrara continuing his work on the tomb, he writes, he made excuses to Leo, pretending there were difficulties, delaying his work for the Pope. He also admits to having spent one thousand ducats, received from Leo X for the facade, to cover his expenditures on the tomb of Julius II. This is not the only time Michelangelo was deceptive in dealings with patrons, and the confession raises a question: If Michelangelo admits to a deception here, what do we believe? Do we blithely believe everything he says except when he tells us that he engaged in fraud?

What is at stake in Michelangelo's self-defense is his "honor." He is a "citizen of a noble house," not just "somebody from Cagli," as the idiom goes, meaning from nowhere. He goes on to say that one of his accusers tells him that he should examine his conscience. To this the indignant artist responds that his accuser "has fabricated a Michelangelo of his own, made of the same stuff as himself." This response is a variation on the remark Vasari attributes to Michelangelo: "Every painter paints himself." What is particularly striking in Michelangelo's remark is the use of the verb *fabbricare*, to fabricate. Michelangelo is acutely aware of how an image of himself is being fashioned, and his letter, like his previous letters, is written to fabricate, to fashion an alternative persona or mask, that of a martyred saint, who lives in misery, is persecuted and unjustly mocked. One might even say that Michelangelo takes advantage of this negative fabrication of himself as a thief and usurer, exploiting it as part of a campaign to fashion the persona of a persecuted saint, "stoned every day."

Michelangelo next turns to the incident of his flight from Rome, adding details not in previous accounts. This time, when he speaks of how he went to the Pope for money in 1506, he mentions, as he had

not done in his earlier letters, that a Bishop of Lucca said to the groom who refused the artist entry to the Pope, "Do you know who this is?" Maybe the Bishop was really there and uttered these words, but it is also not impossible that Michelangelo added this figure of authority to the account, dramatically magnifying his own importance. There seems to be such hyperbole immediately below when, after Michelangelo flees from Rome, the Signoria of Florence says to him, or so he claims, "We do not propose to go to war with Pope Julius over you." Do we believe that the Pope would really have gone to war to obtain an artist who refused to work for him? Such rhetoric thrusts the activity of art into the highest sphere of significance, giving one the impression that Michelangelo is uppermost in the minds of two leaders of state, who presumably have more serious matters on their minds than a project for a tomb. The words that Michelangelo probably puts into the mouth of the Signoria would have us believe that Michelangelo is at the very center of concern of two rulers, that art is the highest priority in the life of the state.

When Michelangelo next writes that his stones for the papal tomb, which lay in the piazza of Saint Peter's, had been stolen and that this cost him one thousand ducats, he is suggestively using the same sum that he says was later unfairly added to the contract he never saw—as if to say, even if a debit of one thousand ducats is now in the contract, the Pope owed him one thousand ducats for the stones that, left unprotected, disappeared forever. Michelangelo quickly adds, to underscore his position, that the Pope had owed him five thousand ducats in the first place. He is not the thief, for it is he who has been robbed, not only of money but of his very youth. Here Michelangelo returns to his earlier rhetoric, in which he spoke of his work for the Pope as a matter of life and death. Although he insists on his innocence, Michelangelo, revealingly perhaps, says he could be mistaken in certain details (concerning the dates of the negotiations). There are clearly aspects of his account that others think mistaken or fabricated.

Michelangelo's letter ends quite strikingly with the charge that all of this discord between Michelangelo and the Pope arose from the "envy" of Bramante and Raphael. They sabotaged the tomb in order to "ruin" him. Michelangelo is quick, here as elsewhere, to invent the envy of others. His autobiography differs from Vasari's biography of him precisely on this account. When Michelangelo speaks of Ghirlandaio, for example, he emphasizes the latter's envy of him, whereas

Vasari says nothing of Ghirlandaio's envy. We recall here that Michelangelo, who could find envy in others, was himself guilty of envy, as when, earlier in the letter, he resents those who get rich by lying abed while he labors in poverty. The final remark of his letter concerning Raphael—that "what he knew of art he learned from me"—is especially striking in the very context in which it was written. For at this time, when Michelangelo was writing to the anonymous prelate, he was at work in the Cappella Paolina, where, it has been observed, he relied heavily on Raphael's tapestry composition for his own fresco of the conversion of Saint Paul. Raphael was on Michelangelo's mind all right. And he remembered his dead rival a bit nervously at the very moment when he was about to plunder the latter's treasury.

Michelangelo had written to Fattucci in December 1523 of his complaint to Bernardo da Bibbiena and Attalante of inadequate payment for the ceiling and of his threat to leave Rome unless properly reimbursed for his labors; he then said that Bibbiena told Attalante to pay him off and that he finally received two thousand ducats from the Camera. Dwelling on his deficit, saying that he had nonetheless lost more than he had gained in his work for Julius, Michelangelo writes tellingly that Bernardo and Attalante had "saved my life." The rhetoric here is suggestive, recalling the letter of 1506 in which Michelangelo had complained that if he had remained in Rome he would have lost his life. Returning to the matter of the tomb at the end of one draft of his letter to Fattucci, Michelangelo says that although he was still owed money, he was nonetheless called an "impostor" or fraud— a charge that clearly rankled. In both drafts Michelangelo also complains about being paid inadequately for his bronze statue of Pope Julius II in Bologna. At the end of two years of sheer "misery," he had only four and a half ducats to show for his labors. In one version of his letter to Fattucci, Michelangelo emphasizes that he is still owed more than one thousand ducats.

There are two types of lie: those that the liar knows to be untrue statements and those that the liar, sublimely self-deceptive, comes to believe, deceiving himself. Michelangelo employed both kinds, mostly the latter. When he confesses that he lied to Pope Leo X, who had earlier deceived him, he actually admits a lie, but in most other respects one senses that he believes his claims concerning the tomb, his exaggerations and prevarications. What is significant here is not the exact facts, which we do not know, but the rhetoric of

fabrication used to describe his persecution. Turning the charge of usury into an opportunity to portray himself as a martyr, Michelangelo, to use his own word, "fabricates" himself. The verb is charged with significance. As a *fabbricatore*, Michelangelo is a deceiver, a *fabbricatore di inganni*, as the Italians say. (In like fashion in English we speak of a lie as a "fabrication.") To fabricate also means to build, and in this sense Michelangelo, artfully giving form to his own *Bildung*, fabricates himself. That we today pay attention to his rendering of the "tragedy" of the tomb and little to the words of his accusers attests his very success in the art of lying. Yes, Michelangelo was a liar—and a most artful one indeed!

13

THE FABRICATION OF A LIFE

What we might conclude from our analysis of Michelangelo's letters from 1506, 1523, and 1542 concerning the tomb of Julius is that if Michelangelo lost his youth, giving his life, so to speak, in hostage to death, he had, to employ his own word, used the tomb to "fabricate" his life *dramatically* over a period of almost forty years, preparing himself indeed for the autobiography he dictated to Condivi. Let us now turn to the autobiography and read it sequentially in regard to the earlier epistolary accounts of his dealings with Pope Julius II. Such a reading will sharpen our sense of the artifice that informs his autobiography. Michelangelo begins by saying that when he started work on the tomb the Pope showered "many favors beyond measure" upon him and that "many, many times" the Pope went to find Michelangelo in his house, where they had discussions, as if they were "brothers." This is, we might say, how Michelangelo would prefer to recall his dealings with the Pope, probably a fabricated exaggeration of intimacy that recalls the fantasticated account of his time in the household of Lorenzo il Magnifico, when the latter summoned Michelangelo each day to gaze upon and admire his collection of gems.

Michelangelo's letters from Bologna to his father, during the time he was at work on the bronze statue of the Pope, describe only two visits from the Pope. He does not give the impression that such visits were frequent or of significant duration. He surely mentions them because they were important to him, and one suspects that when on

one occasion he says the Pope stayed for twenty minutes, he is swaggering. It is also highly unlikely that the Pope came to see Michelangelo every day in Rome. He seems to elaborate on this fabrication of daily intercourse by saying that the Pope had a bridge extended from the corridor to Michelangelo's room by which he could go to the artist secretly. This claim is suspiciously reminiscent of Pliny's account of Alexander the Great as a frequent visitor to the studio of Apelles. We recall here Michelangelo's claim that he lived in proximity to Lorenzo il Magnifico, in his patron's very house. But whereas Lorenzo was a father to Michelangelo, the Pope was, even more familiarly, a brother to the artist.

Next follows Michelangelo's legendary diatribe against the envious Bramante, who, he claims, interfered in his labors by persuading the Pope that it was a bad omen to have one's tomb made while still alive. Here he is embellishing the account in his letter of 1542 of the architect who persecuted him. He is quick to add (and in his words, "without envy") that had he completed the tomb, the construction of which was interrupted by Bramante, he would have taken the laurels in his art. Evidence of the greatness of the tomb project, he says, is to be found in the two *prigioni* or prisoners that he did bring to completion. Whereas Vasari later says that these figures plausibly stand for the states subjugated by the Pope, Michelangelo insists that the *Prisoners* are the arts (including painting, sculpture, and architecture), which were imprisoned by the very death of the Pope. Even if Michelangelo did think of these figures as personifications of the arts (and this is by no means certain), he clearly exploits this meaning, since the *Prisoners* of the tomb came to personify his own imprisonment by the tomb after the Pope's death, when he was obliged to bring the work to completion. The rhetoric of the tomb, whether originally intended or invented afterward, becomes the rhetoric of autobiography, for the *Prisoners* function allegorically, standing for the artist himself, bound to the tomb as he was to the Pope.

Michelangelo next claims that the Pope sent him to Saint Peter's to consider the location of the tomb. Michelangelo returns from his assignment to tell the Pope that it would be necessary to raise the building, roofing it over to accommodate the tomb. This claim is highly improbable, since, although the tomb was gigantic, the venerable basilica of Saint Peter's was presumably large enough to contain it. Michelangelo next introduces a little fictionalized dialogue in

which the Pope asks what it will cost to do the work. When Michelangelo replies, "One hundred thousand ducats," the Pope supposedly responds, "Let it be two hundred thousand ducats." In other words, the sky is the limit; no price is too high for a building designed to accommodate Michelangelo's grandiose monument. Michelangelo concludes that he was the reason why the part of the building already begun was now completed and that he was responsible for the Pope's rebuilding the rest of the church. If Michelangelo would later emerge in the story of Saint Peter's as the architect responsible for completing the church by designing the dome, he is, as he pretends, in effect, the originator of the church. Even if Bramante was the architect and Julius funded the work, Michelangelo was, he brags, the inventor of the new church. This claim is, in fact, as implausible as the earlier claim that he was given license by the Pope to invent the pictorial scheme for the Sistine ceiling frescoes. Reading Michelangelo, however, we discover that he was responsible for everything great that the Pope undertook in painting, sculpture, and architecture—or so he would have us believe.

Michelangelo goes on to tell the story of how he fled from Rome after failing to gain access to the Pope, repeating an old story that, we have seen, he recounted on several occasions in earlier letters. Here again, as in the story of the price for work on Saint Peter's, he adds a dialogue. Following his version of 1542, he maintains that a Bishop said to the papal groom, "Do you know who this is?" Now, however, Michelangelo adds the servant's response, "I am bound to do what my patron wishes." Commenting on this rejection, Michelangelo insists that up to this moment no door had ever been closed to him. Whereas in 1542 Michelangelo said he wrote to the Pope, saying that hereafter the pontiff could find him elsewhere, he now claims with heightened dramatic effect that he responded directly to the groom who offended him: "And you can tell the Pope that from now on, if he wants me, he can come to me, can search for me elsewhere."

As this story takes form, it grows even more dramatic and forceful. In 1506 Michelangelo merely said that he was turned away, although he did say, as he no longer does, that he came to the Pope five consecutive days before fleeing. In 1542 he added the words of the Bishop who defended him, and now in his autobiography he quotes the insolent words of the groom who refused him entry. Although there is a kernel of truth in the anecdote, the different versions, with

sundry details subtracted or added, indicate varying degrees of rhetoric or, should we say, subterfuge on Michelangelo's part. Moreover, as we have already had occasion to remark, the whole episode may have been a super-*inganno*, an excuse for him to leave Rome for Florence, where he preferred to work, as he told Giuliano da San Gallo in the first place.

And the story gets better and better. Michelangelo next says that the Pope sent couriers after him. He had mentioned them in 1542, but now he claims that he told them that if they attempted anything he would have them murdered. All five of them. Forsooth! The language of violence here suggestively recalls Michelangelo's earlier claim about an indignant friend, Sebastiano del Piombo, who was so enraged by the notary drawing up the contract for the papal tomb that he was going to see to it that the notary was hanged. And indeed, we also recall, Michelangelo affirmed that if he remained in Rome the city would become his tomb, as if he would have been assassinated. Such language conforms to a pattern of violence in Michelangelo's writing.

Michelangelo continues to embellish the narrative from his earlier versions of events, now claiming that the Lord of Florence called him and said, "You've done something not even the King of France would have done." Here Michelangelo paints a picture of himself as a type of monarch, a rival of the Pope, like the King of France himself! He was so vexed by these circumstances, he adds, that he contemplated going to work for the Sultan of Turkey. This remark is often accepted at face value, but is it likely that Michelangelo in fact thought of working for "the Turk"? Is it not more plausible that Michelangelo is here demonstrating his rage at the Pope by saying in effect that—driven to this extreme by the Pope's lack of appreciation—he was now preparing to work for the Pope's antagonist, the infidel?

When Michelangelo next discusses his trip to Bologna, where he is forced to beg the Pope's forgiveness, he follows the account in Vasari's earlier biography of him. The assumption is, or might be, that Vasari already had a version of these events from Michelangelo himself at an earlier date. Such an assumption is, however, based on a great deal of uncertainty. What remains unclear is how much, if anything, Vasari had from Michelangelo in the first place, since so much in Vasari's account is fictional and does not accord with Michelangelo's own rhetorical account of events.

Michelangelo says that when, finally, he asked for the Pope's pardon, a certain Monsignore, who was present, interrupted, saying, "Your Holiness pay no heed to his error, because he has erred through ignorance. Outside their art, painters are all that way." The Pope, who flew into a rage, replied, "It is you who are ignorant and you are a miserable wretch, not him. Get out of my sight and may you be cursed." And when the Bishop did not move, he was driven out of the room by the papal servants under a hail of blows. Maybe this episode took place, but it is more likely that it is another Vasarian invention, blithely accepted and exploited by Michelangelo. Many will accept the story as true because it appears in both Vasari and Condivi, whose texts "agree" with each other, but as we will see in the chapter following, Michelangelo could easily republish and give his imprimatur to a Vasarian fiction. The story of Julius's rage is believable, if we suspend disbelief, because it conforms to the reputation of the Pope, famous for his fury. But is it likely that a Pope would curse a Bishop for ridiculing an artist and have him beaten for it? It is perfectly possible that nothing like what Vasari and Michelangelo claim took place in Bologna really happened, that indeed Vasari invented the story as a dramatic way of finding a scapegoat for Michelangelo. Even if it was not true, why should Michelangelo not accept it?

Michelangelo not only repeats Vasari's account here, but he adds to it a telling quotation from the Pope, which conforms to the novelistic style of his autobiography. He tells us that the Pope said to him, "You were to have come to us, whereas you have waited until we came to you." The Pope means that by coming to Bologna he has himself come to Michelangelo, implying that he has, in effect, submitted to the will of the artist, suffering his own humiliation. The Pope's words are suspiciously like the speech Michelangelo purports to have given to the papal groom after being denied access to the Pope, when he says that in the future the Pope will have to come to him. It is perfectly possible that, again fabricating the Pope's speech, Michelangelo has put words in His Holiness's mouth.

As he continues to tell the story of his dealings with Pope Julius, he adds that Bramante persuaded the pontiff to have Michelangelo paint the Sistine ceiling to disgrace him, either because he knew the artist could not accept the commission, lacking the experience and confidence in his abilities, or, if he did undertake the work, he would not succeed so well as Raphael. Once again we encounter Michelangelo's

insecurity in regard to Raphael. His account to Condivi is not true to a contemporary version of events, an oft-quoted letter from Paolo Rosselli of 1506, suggesting that Bramante was firmly set against Michelangelo's painting the ceiling because he lacked experience. If this was true, then Bramante did not urge the Pope to offer the job to Michelangelo in order to embarrass him. Michelangelo perhaps correctly recalls Bramante's hostility toward him, but he seemingly alters the evidence in order to underscore Bramante's duplicity.

Michelangelo tells Condivi various things about his painting of the ceiling. He says, for example, that "many times" the Pope wanted to see Michelangelo's work and when he came into the chapel, Michelangelo offered "a hand" to help him onto the scaffolding. The image is particularly heady, for it suggests the image of the hand of God descending from heaven, emerging from the vaulted empyrean. The anecdote also puts the artist in a position of superiority to that of the Pope—in compensation for the artist's deeper, pervasive sense of himself as a captive of his patron.

As the story further unfolds, Michelangelo puts emphasis on his frequent associations with the Pope and on the turbulence of their relations. One day the Pope impatiently asks the painter when he will finish his work, to which Michelangelo replies, "When I am able." In a rage the Pope threatens to throw the artist from the scaffolding (presumably after Michelangelo has reached out his helping hand), and Michelangelo says defiantly, under his breath, "You will not have me thrown off." In another instance, already discussed above, Michelangelo rejects the Pope's idea of having the holy figures of the ceiling painted in gold because they were poor and the color of wealth was inappropriate. We get a sense of the artist and Pope in unremitting adversarial confrontation. Michelangelo insists that the Pope loved him and was jealous of anybody around him. Once, when Michelangelo was angry with the Pope, Julius sent presents to appease the artist. Michelangelo had requested leave to go to Florence for Saint John's day, also requesting money of the Pope. When asked by the Pope when he would finish his work, Michelangelo once again said, "When I am able." The Pope supposedly then struck the artist, who fled, and the Pope, Michelangelo claims, sent both money and an apology!

When we recall that, according to the notes of Julius's master of ceremonies, Paris de Grassis, the Pope did not come to the chapel to

examine the frescoes for many months after the first half of the work was done, we must pause to question Michelangelo's claims that the Pope came to see him "many times" during the period of work on the ceiling. The Pope was probably concerned with more pressing matters than the decoration of his chapel. Without soaring dimly into the intense inane of psychoanalytic speculation, we can reasonably suggest that Michelangelo's account of his relations with the Pope is a fictionalized way of sustaining his honor by showing how important he was to his patron. In effect, Michelangelo aggrandizes himself through the picture he paints of the Pope's fierce devotion.

It is reasonably well established that Michelangelo fabricated himself. What escapes attention is the fact that Michelangelo also helped fashion our received image of the Pope. Granted, we have contemporary references to the Pope's wrath in generalized accounts from the Venetian ambassador and Machiavelli, but it is Michelangelo who invented the dialogues, repeated and seemingly authenticated by Vasari, that graphically memorialize the rage of the wrathful Pope. *Michelangelo's autobiographical stories of his titanic clashes with the fierce Julius II are among the most memorable of all novelle in Renaissance literature!* They are another instance of *mythopoiesis* in his autobiographical art, recalling his contribution to the legend of Lorenzo il Magnifico. Michelangelo's dramatic, fictionalized account of his relations with Julius is evidence of the poetry of his autobiography, evidence of the significance of his autobiography as literary art.

No less than the construction of the Pope's tomb was the painting of the Sistine ceiling an *agon*, a colossal struggle. Michelangelo highlights the enormousness of this struggle when he describes the physical infirmities that resulted from his labors. His description of bodily damage underscores the relations of his autobiography to his poetry, since it is no less fictive than the poem about the ceiling, in which he describes the physical strain of his labors. He pretends that he had painted the ceiling for such a long time with his eyes raised upward that when he looked down he saw very little. Therefore, he adds, when he had to read a letter, or look at other very small things, he needed to hold them above his head in his outstretched hands. Since Michelangelo subsequently made many beautiful drawings and wrote numerous letters in a fine hand afterward, we can assume that he was indeed still able to see small things and read looking downward— unless, of course, we are to imagine Michelangelo making all those

drawings or writing all those letters on sheets of paper held above his head. Indeed! The autobiographical fiction here is no different in kind from the assertion in his poem on the Sistine ceiling that he did everything "without eyes." There is no reason to doubt that Michelangelo did have troubles with his eyes. We are merely calling attention to the poetic license with which Michelangelo embellishes the facts.

To underscore his tendency to lie or exaggerate poetically, let us turn to one more admission of deception on his part. He tells Condivi that he was so loyal to Pope Julius that, during the period of painting on the *Last Judgment*, he "pretended" to be preparing the cartoons, when in fact he was working on the tomb—thus deceiving Pope Clement VII. But was he in fact working on the statues for the tomb in the 1530s, as he claims, or was he merely saying this in order to defend himself against the charges of Julius's heirs? Is this confession of a deception a further deception? Michelangelo reminds us of the proverbial liar so caught up in his lies that he comes to believe them. Later when he says that he was persuaded by agents of the heirs of Julius to exaggerate his obligation to Pope Julius in order to gain more flexibility in his dealings with Pope Clement VII, his verbal compliance was written into his contract without his consent, as he points out with great annoyance. As the Italians say, "L'ingannatore s'inganna"—"the deceiver deceives himself." Although Michelangelo doesn't say so, he exemplifies the deceiver gulled by his own deceptions.

Even so, out of all this deception and self-deception, Michelangelo is able to forge a glorified image of himself bound up with his aggrandized image of the Pope. He does this nowhere more successfully than in the final impression he leaves us of the Pope's tomb as a monument to his own glory. As we have seen, the expressive power of the *prigioni* or prisoners of the tomb represents Michelangelo's sense of his own captivity to the tomb. The allegorical figure of Active Life on the tomb, as we have already observed, is identified with Matilda, who is not only an appropriate figure on a papal tomb, because of her *patrimonio* to the church, but also because she is, in Michelangelo's imagination, his very ancestor. The tomb has become, finally, a monument to Michelangelo himself.

This sense of the tomb is nowhere more graphic than in Condivi's account of the figure of Moses, which eventually became the central presence on the monument. When Condivi says, either echoing Michelangelo or conveying Michelangelo's sense of things, that the *Mo-*

ses was not only "thoughtful and wise" but "tired and full of care," Condivi suggests implicitly an identification of *Moses* with Michelangelo himself, since Michelangelo, at the end of his arduous labor, is similarly wise, tired, and worn with care. Fabricating his autobiography, Michelangelo had exploited the fabric of the tomb of Julius, the central monument in his life, so effectively that, at the last, he made this papal monument a sort of double tomb, both to the glory of the Pope and to his own even greater glory. It remained the most significant work in stone in the modern world until, three hundred years later, Napoleon clove the rocks of the Simplon.

14

BIOGRAPHY AS ART

"While the industrious and distinguished spirits were striving by the light of Giotto to demonstrate to the world their skill, which the benevolence and the proportionate mixture of the humors had given to their genius, and desirous of imitating the greatness of nature with the excellence of their art as well as they could in order to arrive at that highest knowledge, which many call intelligence, and nonetheless laboring in vain, the most benevolent Ruler of Heaven turned His eyes with mercy to the world and saw the vanity of so many efforts, the most fervent but fruitless studies and the presumptuous opinion of men, as far from the truth as darkness is from light, and in order to rid us of so many errors, He decided to send to earth a spirit, who was universally capable in every art and profession of showing by himself the perfection of the art of design in contours, shading, and illumination in order to give relief to the things of painting, and with good judgment, in sculpture, and in the making of buildings comfortable, secure, healthy, cheerful, proportionate, and rich in the various ornaments of architecture."

This first sentence of Vasari's life of Michelangelo (which must be savored in the original Italian to be fully appreciated) is the greatest single sentence of his entire *Vite*, one of the most majestic statements of the age and arguably one of the most powerful word-pictures in all Italian prose. It is a reflection of Vasari's own genius as artist and poet. Although Vasari's myth-making abilities and rhetori-

cal skills have always been appreciated, and although we have considered aspects of his literary talent, we still underestimate his poetic skill. This is so for two reasons. First, we do not probe so deeply as we might into the foundations of Vasari's art and, second, we often, despite our skepticism, lapse into the belief that what Vasari writes is historical reportage, not artifice. In the following pages, I wish to continue the exploration of aspects of Vasari's biography of Michelangelo and its relations to Michelangelo's autobiography in order to make more explicit the art involved in the molding of the persona of Michelangelo. Yes, we know that Vasari was a writer of fiction. But, having acknowledged this fact, let us not fail to discriminate the nuances and discern the depths of this artifice.

Like the epic poets, like Homer and Virgil, Vasari begins his *vita* of Michelangelo *in medias res*, "in the middle of things," for his opening words—"while the industrious and distinguished spirits"—speak of the time when artists were still striving to give proof to the world of their skill before the advent of Michelangelo. Like Dante, who writes "nel mezzo del cammin," in the middle of the journey, Vasari is writing a Christian epic, and he turns to the liturgy, to the Introit of the Mass at Christmastide, based on the *Book of Wisdom*, where it is said, "While all things were in quiet and silence and the night was in the midst of her course, Thy Almighty Word, O Lord, came down from heaven from Thy Royal Throne." Vasari's *mentre* or "while" resonates with the *dum* or "while" of the Mass, just as his image of God as Ruler of Heaven sending a spirit into the world to bring perfection in art resonates with the description of the Lord descending from his Throne. Vasari is writing of a Messiah sent from Heaven by a just Ruler, who has descended from his Throne to redeem art.

Vasari is also describing the moment of creation or birth through the art of Michelangelo himself. The sheer length of Vasari's periodic sentence creates the effect of spaciousness, suggesting the image of a vast cosmic space, over which God presides, as he does in the Sistine ceiling. Vasari has rendered the nativity of Michelangelo, exploited Michelangelo's own scenes of creation, as if he were describing a moment of creation as Michelangelo might have painted it in the Sistine ceiling. If Vasari's epic sentence is biblical and liturgical, it is also Michelangelesque, the translation of Michelangelo's pictorial grandeur into prose.

Vasari's sentence sweeps over his entire book. Its allusion to "light"

and "darkness" turns back to the "light" of Giotto, reminding us of the "first lights" in the works of those initial artists of the "renaissance" or artistic rebirth, who emerged in darkness. Nevertheless, they were not the true light, which came after them. His sentence also foretells the description of the Sistine ceiling. For if he says that artists were as far from truth as darkness is from light, he later says that the Sistine Chapel frescoes have removed the blinders of darkness, bringing light and truth to art, using the words *lucerna, lume, illuminare,* and *chiarezza* with an apocalyptic luminosity. When Vasari speaks of God the Creator in the *Separation of Light from Darkness,* with beautiful alliteration, as sustaining himself—"si sostiene sopra sé solo"—he echoes his earlier description of Michelangelo in the first sentence, where the godlike artist is similarly self-sufficient, working "per sé solo." Remarking that Michelangelo brought "perfection" to all three arts—painting, sculpture, and architecture—Vasari alludes to the mystery of the Trinity to suggest the aesthetic trinity of the arts, all mysteriously united in *disegno.*

Vasari moves from theology to fiction when he discusses Michelangelo's formation as a young artist in the shop of Ghirlandaio. In 1550 Vasari says that in Santa Maria Novella, where Ghirlandaio was painting, Michelangelo made a drawing of the scaffolding, of Ghirlandaio's students, and of the tools of art in a "new manner" that stupefied Ghirlandaio, who said of Michelangelo, "That one knows more than I do." The story, less a report of what happened than a fiction, nicely memorializes Michelangelo's new manner which surpasses Ghirlandaio's, doing so in Ghirlandaio's very own words! And it emblematically focuses on the tools of art, the *masserizie* that Michelangelo drew, which recall those tools in Vasari's later account of Michelangelo's remark about the chisels and hammer he took in with his mother's milk.

In 1568 Vasari embellishes this story when he writes that after another disciple of Ghirlandaio made a pen drawing of young women, Michelangelo went over the drawing, also in pen, with broader strokes, correcting its style with great spirit and in such a way that one could clearly see the differences between the two *maniere* or styles— that of the teacher's anonymous student surpassed and that of the bold young virtuoso. Vasari next says that the sheet was now in his possession, kept as a "relic" of Michelangelo's art, which he had from Granacci. He goes on to say that when he was in Rome in 1550 he showed the drawing to Michelangelo, who, recognizing the drawing,

was pleased to see it. Michelangelo then observed, Vasari says, that he knew more about art when he was a child than he did as an old man.

Vasari's story is utterly believable, especially since it resonates with the similar story in Condivi's biography of Michelangelo, where it is said that when the artist saw the relief of the battle of the Lapiths and Centaurs years after he made it, he modestly said with regret that he was in error not to pursue sculpture, to which he was inclined. Here the suggestion is of Michelangelo similarly recognizing the skill of his youth years later, and of his doing so with modesty. I would contend that the stories are related because Vasari freely writes his tale out of Condivi's, changing it to focus on his theme of the two *maniere*, Ghirlandaio's and Michelangelo's. Vasari says that Granacci gave him the drawing for his *Book of Drawings*, but Granacci died in 1543, which is probably before Vasari began collecting specimens of drawing for a book. We might wonder about the circumstances in which Granacci supposedly gave him the drawing, and we might also wonder about Vasari showing the drawing to Michelangelo in Rome. Why would Vasari, who did not live in Rome but only worked there for extended periods, have had the drawing with him? Did he just happen to have packed it in his bag before setting out for Rome? His story of the drawing is probably a fiction, a fiction about a fictional drawing that makes graphic Michelangelo's youthful prowess and celebrates his sub-sequent modest self-assessment—not to mention Vasari's friendship with the artist. Here as elsewhere Vasari seeks to magnify his relations with Michelangelo, leaving an impression of a friendship that, in all probability, was less intimate than he would have us believe.

There is another story added to the *Lives* by Vasari in 1568 that bears close scrutiny. This is the famous account of how Michelangelo came to sign the *Pietà* in Saint Peter's (Fig. 32). The tale was not told by Vasari in 1550, nor was it reported by Condivi in his biography of the artist in 1553. It seems to have first appeared in an unaddressed letter, presumed to have been sent to Vasari from Rome by an uniden-tified correspondent in October 1564, not long after Michelangelo's death. Vasari took it over, modifying it and making it his own in his revised biography of Michelangelo.

Vasari's version goes like this. One day Michelangelo came upon a group of Lombards in front of the *Pietà*, who were praising it. When one of them asked who had carved it, another replied, "Our Gobbo of Milan." Michelangelo remained silent, but it seemed strange to him

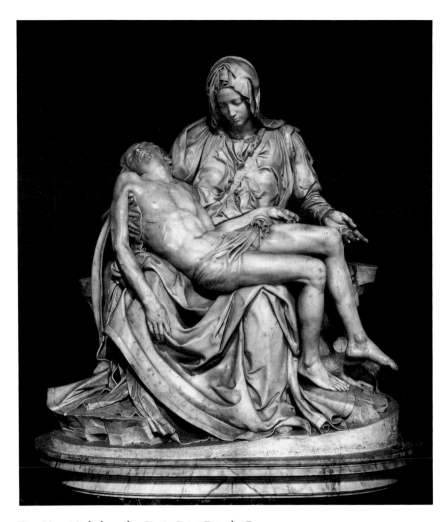

Fig. 32. Michelangelo, *Pietà*. Saint Peter's, Rome

that his labors should be attributed to somebody else, so one night he entered the church with a lamp and chisels and carved his name on the sash covering the Madonna's breast (Fig. 33).

The story is often repeated as if it were true. But is it? And if not, what is it really about, what meaning does it poetically unveil? Consider the fact that although artists often signed their works with prominently lettered signatures in the borders, no artist has ever signed a

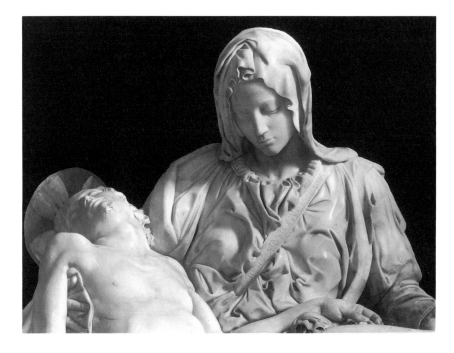

Fig. 33. Michelangelo, *Pietà* (detail). Saint Peter's, Rome

work so boldly as did Michelangelo when he carved his name in large letters on the very breast of the mother of God. One art historian, sensing the implications of the signature, tried to protect the image of the artist by observing "neither to Michelangelo, nor to the artists of his time, would there have been the least suggestion of irreverence in such a fact, nor any conflict between the universal and personal levels of symbolism in the group." The story told by Vasari deflects attention away from the probability that Michelangelo had in fact signed the work when he originally carved it. Why? Because Michelangelo's signature could have been construed as a demonstration of the artist's *superbia* on the breast of the very personification of *umiltà*. The fable of Michelangelo signing his work after it was attributed to somebody else thus ingeniously protected him from the imputation of sinful pride, justifying his signature, instead, as the defense of his very name and honor.

Another of Vasari's fictions, which appears in both versions of the biography of Michelangelo (but interestingly not in Condivi's account)

concerns the *Doni Tondo* (Fig. 34). According to this *novellino*, after receiving Michelangelo's painting, Doni decided that the seventy ducats agreed upon as the price for the picture was too much to pay, upon which he sent the artist only forty ducats. Michelangelo next sent word to Doni that he should now either pay one hundred ducats or return the painting. Angolo next replied that he was finally prepared to pay the original seventy ducats, but Michelangelo, offended by Doni's lack of "faith," insisted on a payment of one hundred forty ducats, and Angolo was thus obliged to pay double the price of the original terms. Reminiscent of stories about other artists, including Leonardo, who refused to be known as a "penny painter," the tale is

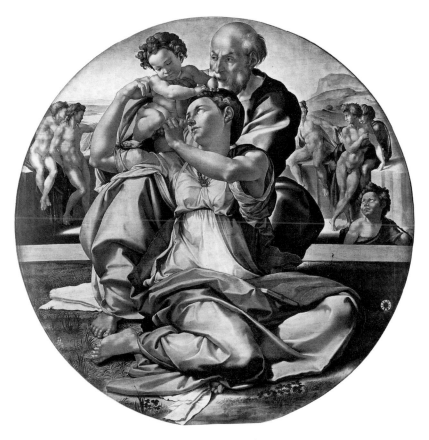

Fig. 34. Michelangelo, *Doni Tondo*. Uffizi, Florence

another instance of the painter's triumph over his patron—an analogue of the stories of Michelangelo's superiority, in certain respects, to Pope Julius II. Perhaps the story was not repeated by Condivi because it could have been misconstrued by those who accused Michelangelo of usury as another instance of his avarice.

I again invoke Julius II, having postponed to the last two of the most delicious stories concerning the Pope and Michelangelo—tales I deliberately passed by in the previous chapters concerned with their stormy relations. The first of these stories is about the bronze statue of the Pope, which Michelangelo made in Bologna. In the first edition of the *Lives* Vasari says that when the Lords of the city came to see the statue and beheld the menacing figure of the Pope, they asked the artist whether the Pope's gesture was a blessing or a malediction—to which Michelangelo replied, the latter. Although this story is a fiction, it has often been retold, as if true, since, in its verisimilitude, it comments on the militancy of the Pope, who had taken Bologna by force.

Retelling the story to Condivi, Michelangelo changed it significantly by presenting the dialogue as taking place between himself and the Pope. In Michelangelo's version, it was the Pope who asked if the right hand of the statue were blessing or menacing those who beheld it. Michelangelo added a story of his own when he said that he asked the Pope whether he should put a book or sword in the Pope's other hand—to which the pontiff replied, "A sword! What do I know of letters?"

Also a fiction, this tale is *ben trovato*, since the sword alludes to the fact that the Pope took Bologna by force, leading his army triumphantly into the city. It defies conventional decorum, however, because popes were traditionally represented with keys in their hands, and Michelangelo's work was no exception. Contemporary documentation indicates that the bronze figure of the Pope, before it was destroyed, held a key, not a sword, in his left hand. Enjoying Michelangelo's fiction about the sword and finding it useful, Vasari assimilated it to his revised biography of the artist in the 1568 edition of the *Lives*.

It is worth noting that before Michelangelo told the tale of the sword and the book, Machiavelli, a great admirer of the Pope's audacity in taking Bologna, invoked these symbols in a similar fashion but in a different context. The Venetians, who, Machiavelli said, were

made to hesitate by the Pope's triumph over Bologna, symbolized their state with images of their patron saint, San Marco, holding a book in hand. In his poem, "On Ambition," however, Machiavelli mockingly referred to this iconography, noting that "San Marco to his cost and perhaps in vain / learns late that one has / to hold the sword and not the book in hand." Although we cannot claim that Michelangelo's story of Pope Julius's choice of the sword over the book for his statue has a specific connection with Machiavelli's poem, we can conclude that by analogy to Machiavelli's poem, Michelangelo's tale of Pope Julius's sword is about a Machiavellian prince, whose power depended on the sword. The Vicar of the Church with sword in hand in Michelangelo's *novellino* is the same bold, militant figure who occupies a central place in *The Prince* and is the opposed counterpart of the saint with only a book to defend his state.

The other delightful story concerning Michelangelo and Julius that I wish to recall here is the *novellino* in the first edition of the *Lives* that explains Michelangelo's flight from Rome. Vasari's fable goes like this. Pope Julius was desirous of seeing Michelangelo's work in the Sistine Chapel but was unable to do so, because the artist kept the chapel locked. As the Pope's desire to see the work increased, Michelangelo became more fearful that his disciples, corrupted by bribery, would betray him. To test their fidelity, he resorted to a trick or artifice, if you will. He pretended that he was departing Rome, leaving the key with his disciples. He next locked himself in the chapel, whence his assistants went to the Pope with the news that Michelangelo had departed. They expected a nice tip for their piece of intelligence. When they all arrived at the chapel, the Pope was the first to enter and, as soon as he had taken his first step, Michelangelo began to hurl down upon the pontiff planks or *tavole* from the scaffolding. The artist was like an irate Moses who "cast the tables out of his hands, and broke them beneath the mount." No less angry than fearful, the Pope fled the chapel. At the same time Michelangelo escaped from the chapel through a window. He next brought the key to the chapel to Bramante and, hoping the latter would pacify the Pope, fled to Florence. So the story goes.

Vasari's tale, low comedy verging on farce, is only obliquely referred to by the author in his revised biography of Michelangelo, where he takes over from Condivi the account of Michelangelo's flight from Rome, unremunerated by the Pope. Vasari says in the revised

biography that the Pope, wishing to see Michelangelo's work, had to enter the chapel in disguise. The very image of the Pope needing to sneak into his own chapel, *travestito*, as Vasari says, is not only absurd, it is indicative of the story's very nature as travesty. This fable is little discussed because it is overshadowed by Michelangelo's own version of events, themselves fabrications, as we have seen. Yet the tale is a charming index of how Vasari introduced into his historical fiction a story of Michelangelo's tumultuous dealings with the Pope, which Michelangelo would later magnify in different ways in order to aggrandize himself.

As Vasari had first explained in an elaborate fiction why Michelangelo fled Rome, so Michelangelo would later explain in another fiction the circumstances in which he *came* to the Eternal City, doing so in a fable inspired by Vasari. Michelangelo's tale is worth retelling here, because it is another vivid example of how Michelangelo poetically adapted the Vasarian art of biography to his own poetic life-story.

Michelangelo tells Condivi that after he made his *Cupid*, which was sent to Rome and passed off as an antique, the Cardinal who acquired it, learning that it was a forgery, wished to find the identity of the artist responsible for carving it. Having heard that the sculpture came from Florence, the Cardinal sent a gentleman there in search of the artist. Going to Florence on the pretext of finding an artist needed for work in Rome, he was led to the house of Michelangelo. He asked the artist for a specimen of his work, and Michelangelo, having nothing to show him, took up a pen and with ostentatious ease drew a hand, which stupefied the visitor. When the gentleman asked Michelangelo if he had ever made sculpture, he responded that among other things he had carved a *Cupid*. Michelangelo then explained that he had been cheated, bilked of the full price by the dealer who sold the work. The visitor promised Michelangelo that if he came to Rome he would help the artist get his money back. And Michelangelo went to Rome, not only in the hope of recouping his money but also to see the greatest city in the world, which was a "great field" for the display of one's own skill. Thus, we learn the reasons why Michelangelo went to Rome, in a story about multiple deceptions.

Michelangelo's story, itself an *inganno*, belongs to the series of related fables of origins in his autobiography, for example, the story of how he entered the Medici household. Such tales, in turn, belong to the family of fictions that explain the origins of works of art, accounts

of how Michelangelo carved his first work, the *Faun*, how he came to conceive the program for the Sistine Chapel frescoes, how he persuaded the Pope to build the new church of Saint Peter's. The story of Michelangelo identified as the creator of the *Cupid* is the tale of the "discovery" of a great artist. As such, it is related to the fable of how Giotto was discovered by Cimabue, who brought the young artist to Florence. It is even more closely related to another story about Giotto. I am speaking of the great tale of Giotto's O.

Vasari tells us, we recall, that the Pope sent a courtier to Tuscany in order to find an artist worthy of doing work at Saint Peter's. When he came to the artist's house, Giotto drew a *tondo* or O without a compass, and from this work the Pope recognized the artist's excellence, whereupon the latter was invited to Rome. In Vasari's story the O was emblematic of Giotto's name, since it echoes the double-O of Giotto. In Michelangelo's tale, based on Vasari's, the hand that he drew was similarly emblematic of his own hand, the hand that the visitor sought. Just as Giotto went to Rome after he was discovered, so did Michelangelo. The interest of Michelangelo's related story, which is a fiction, lies in its inventive refashioning of a story by Vasari. By adapting (or abducting) Vasari's tale of Giotto's O to his own autobiography, Michelangelo created an autobiographical fable that made the circumstances in which he was discovered and invited to Rome momentous. It is probable that in reality these circumstances were rather less dramatic and eventful, for the origins of his journey to Rome did not depend on the discovery of his originality. Rather, as an ambitious young artist, he set off for Rome, with a letter of introduction from Lorenzo di Pierfrancesco de' Medici to Cardinal Riario, hoping to achieve success in the Eternal City.

When Michelangelo seized upon his own hand as an emblem of his skill in art, he was embroidering Vasari's previous celebration of his hands like those of God. In other words, Michelangelo invented the story of his drawing of a hand rendered marvelously, on the basis of Vasari's previous praise of his *divinissime mani* or "most divine hands." The emblematic drawing of the hand by Michelangelo is no less fictional than the drawing that Michelangelo supposedly made, revising one in the manner of Ghirlandaio, demonstrating a "new manner."

We have by no means plumbed the depths of fiction in Vasari's fabrication of Michelangelo or in Michelangelo's metamorphosis of

Vasari's literary manner in the service of his own self-creation. Suffice it to say, however, by now we have seen that Vasari's biography of Michelangelo and Michelangelo's autobiography are profoundly poetical works of art in their own right, no less imaginative than the paintings and other artistic inventions from their respective hands. In the past we have underestimated Vasari's biography of Michelangelo and Michelangelo's autobiography when we have called them "sources" or "documents," for these biographies are not mere sources of information or documents of events. What they "document," if anything, is the artful manner in which the self is fabricated or constructed in Renaissance biography, which is closer to the artifice of the portrait or autobiographical poetry than is supposed, just as many Renaissance pictures (as we have seen) are closer by implication to biography than we had ever imagined.

15

THE METAMORPHOSES OF MICHELANGELO

In the family of fables about Michelangelo there are stories that dwell most wonderfully on the metamorphoses of his work, stories that descend from the tradition of Ovid's *Metamorphoses*. They are an important reminder of the role of Ovid in the formation of Renaissance biography, a reminder of the interpenetration of poetry and biography, of the very poetry of biography.

In the unsigned letter presumed to have been sent to Vasari from Rome after Michelangelo's death, which includes the *novella* of how Michelangelo came to sign his *Pietà*, there is a delightful Ovidian fiction concerning the *Moses* (Fig. 35). The writer says that long ago at the time when Michelangelo was carving the *Moses* and had nearly completed the work, he visited Michelangelo in his home. He suggested to Michelangelo that the statue would be improved if the head were in a different position. Michelangelo did not respond, but two days later, when his visitor returned, Michelangelo said to him: "You know, Moses heard us speaking the other day and, in order to understand us better, turned his head." Going to see the statue for himself, the visitor discovered the *Moses* had moved. He noted, however, that above the tip of *Moses'* nose there remained a little of the old skin that had been part of his cheek. Considering it nearly impossible, Michelangelo's friend could not believe what he had seen.

Although the *novellino* of the *Moses* remains obscure, it played an invisible role in the metamorphoses of Michelangelo. Vasari did not

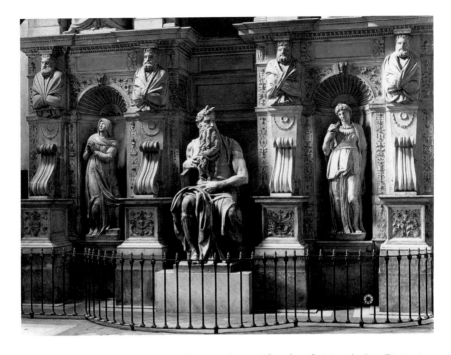

Fig. 35. Michelangelo, *Tomb of Pope Julius II* (detail with *Moses*). San Pietro in Vincoli, Rome

retell it in his revised biography of Michelangelo, but he used it and employed it so subtly that he totally transformed it into another tale. Herein lies another story of Vasari's artifice. According to our mythographer, after Michelangelo completed his *David*, the Gonfalonier of Florence, Piero Soderini, criticized it, suggesting that the nose was too large. Michelangelo then climbed the scaffolding and, pretending to employ his chisel, dropped some marble dust to the ground. "How's that?" he asked. "That's much better," replied Soderini. In the end, as in so many of Vasari's fables, the artist emerges as superior to his critic, who is duped.

Vasari's story is very different in details and in its main point from the tale of the *Moses*, but there are clues to their connection. Both stories concern individuals who criticize Michelangelo's sculptures, suggesting changes in works of great accomplishment, and in both instances Michelangelo in a sense does and does not respond to his

critic. The stone above the tip of *Moses'* nose particularly captured Vasari's imagination and, adapting it, he transformed it into *David's* nose. It drew Vasari's attention because, although incidental to the *Moses*, the nose was central to Michelangelo's life, a primary anatomical part of his life's story. As Vasari emphasized elsewhere, Michelangelo's nose was mortifyingly bashed in by a rival artist in a traumatic, central episode of his youth.

The tale of the *Moses* is also a delightful explanation of the statue itself. Numerous interpretations of the statue have been put forward, suggesting different ways in which the figure of *Moses* evokes the biblical narrative. Some of these interpretations depend on the way in which *Moses* turns his head, as if to regard something, as if to listen. The story of the *Moses* is clearly focused on this motion. When Michelangelo says, "You know, Moses heard us speaking the other day and, in order to understand us better, turned his head," he does nothing less than explain the origins of the figure's turned head. The *novellino*, like so many stories about art, is about the origins of art—that is, it is a story about how a work of art came to be the way it is.

The tale of the *Moses* comments on the marvelous powers of Michelangelo's art, on the *maraviglia* of his sculpture. It is, however, ironic and ambiguous, if not paradoxical, like so much of the art of Michelangelo, for although it suggests that the *Moses* has come alive and moved, the patch of old skin from the cheek still visible above the tip of *Moses'* nose paradoxically implies that Michelangelo, taking the visitor's advice, had indeed recarved the head of the statue, leaving a trace of its original appearance. This explanation is consistent with Condivi's observation that Michelangelo elsewhere left traces of the unworked stone in his sculptures in order to demonstrate what had been transformed in his art—in effect, as an index of Michelangelo's powers of metamorphosing stone. In the end, when Moses seemingly comes alive, turning to listen to Michelangelo and his companion, he is like the creation of a modern Pygmalion.

The Ovidian sense of Michelangelo's identity as a modern Pygmalion is also encountered in another fable from the middle years of the century, this one appearing in Anton Francesco Doni's book *I Marmi* (The marbles), which describes a dialogue between a Florentine and a pilgrim in the Medici Chapel. When the pilgrim beholds Michelangelo's *Dawn* (Fig. 36), he is stunned by what he sees, stilled into wonder, as if he had been transformed into marble. At this point

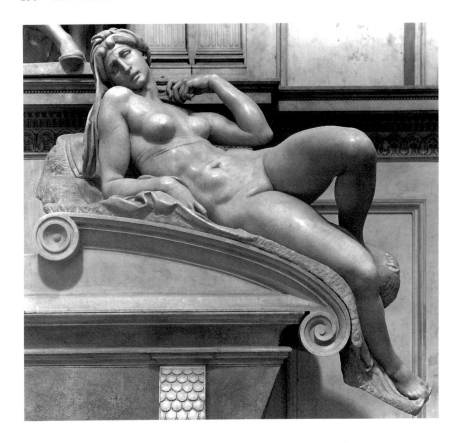

Fig. 36. Michelangelo, *Dawn*. Medici Chapel, San Lorenzo, Florence

Dawn speaks, telling how on an earlier occasion, when Michelangelo
had visited the chapel with a friend, the companion was so suffused
with awe, beholding the *Night*, that he too was transfixed. *Dawn* goes
on to say that while Michelangelo's friend was frozen still, *Night*
actually moved, and now *Dawn* herself moves before the pilgrim
regains his senses. A distinguished scholar of Michelangelo once ob-
served that Michelangelo's *Dawn* looks so much as if she were slowly
awakening before us that she should be called *Awakening*. This is
precisely the implication of Doni's Ovidian story of the statue of
Dawn, who has awakened from stone to speak to the visitors of the
chapel. The pilgrim says that, speaking, Michelangelo's statue had
acted as if incarnate, whereas, frozen still, he himself had petrified. In

Doni's delightful story and story within a story, Michelangelo appears as a type of Pygmalion, his sculptures seemingly beings in the flesh who, vivified, speak and move. At the same time Michelangelo's figures are like the murderous Medusa, who transforms her beholders into stone. Doni's fables thus comment both paradoxically and metaphorically on the creative and destructive powers of art. It is as if the new Pygmalion, Michelangelo, had carved the Medusa.

Speaking of the *Night*, Doni's *Dawn* draws our attention to a statue rich in personal implications for Michelangelo. We recall that Michelangelo wrote a poem about *Night* in which he assumed the very *persona* of the statue, to use his very word. Doing so, he metamorphosed himself in Ovidian fashion into a "being in stone," thus using poetry as an autobiographical commentary on art, just as he employed the poetry of his autobiography to interpret his works. This is what Michelangelo did, we recall, throughout his career. When he carved the *David* (Fig. 37), he wrote on a related drawing the phrase, "David with his sling, I with my bow." The bow has a double meaning here, standing both for a weapon and for the bow that is part of his drill. Michelangelo is suggesting the analogy of his weapon to that of his heroic subject. No wonder at least one art historian has spoken of the *David* as an idealized self-portrait of the artist in his youth, even though the statue is not a portrait of the artist in the ordinary sense of the word. Attacking the monolith out of which he carved the *David*, Michelangelo implicitly conceived the giant stone as itself a sort of Goliath, but he paradoxically metamorphosed this metaphorical Goliath into a David, transforming himself into a type of David in the very process.

In this context we also recall Condivi's description of the *Moses* as a thoughtful old man full of care, as if he were describing the artist himself at the time he finished the tomb of Julius, and we remember Michelangelo's allusions to himself as a prisoner, as if, reenacting another atonement, he made himself one with his prisoners in stone, because they were, in a sense, images of himself and of his own struggles. Michelangelo identified himself so closely with his subjects, in a sense metamorphosing himself into them, becoming the lithic beings of his statuary, that, not surprisingly, one scholar has even proposed that the stunning mask of *Night* is also a self-portrait (see Fig. 22). In a sense we need not concern ourselves with the question whether the mask is literally a portrait of Michelangelo.

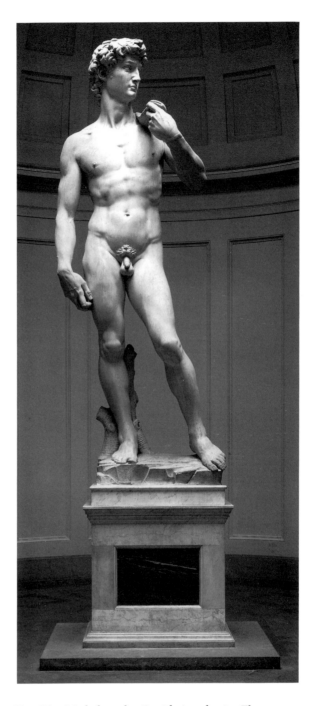

Fig. 37. Michelangelo, *David*. Accademia, Florence

Those who believe it is a likeness of Michelangelo will compare the image to Michelangelo's similarly bearded effigy in various portraits, while others will more skeptically insist that not all bearded figures carved or painted by the artist are his *simulacra*. How, we might ask, is the mask related to the artist? What does it tell us about the artist?

Before we reflect upon the personal associations of the mask, let us ask why a mask might be next to *Night* in the first place. Just as the owl, as a nocturnal bird, placed between the legs of *Night*, is an appropriate symbol of the night, so is the mask, for night is the time of darkness, a euphemism for death, the ultimate terrorist ("the night cometh when no man can work"), and also euphemism for death's twin-brother, sleep, both sources of fearful apprehension ("Now I lay me down to sleep . . . if I should die before I wake"). It is of course under cover of darkness that deceptions, epitomized by *Night*'s mask, are best carried out. Night, the time of sleep, produces visions and dreams, "fictions and falsehoods," says Sir Thomas Browne, "wherein we are confessedly deceived." "Men loved darkness rather than light," the fourth Gospel assures us, "because their deeds were evil." Both mask the unknown. Death is the absolute fear ("Dies irae, dies illa. . . . Quantus tremor est futurus"), sleep the begetter of goblins and monsters, as Goya would say and as various artists indicated in images of sleeping figures with the grotesques or monsters of their dreams nearby. Such monsters of dream, deceptions or *inganni*, are themselves *fantasie*, things most strange, *bizzarie* closely related to those of poetic *invenzioni*. This is clearly the sense of the statue understood by Vasari in his comic story of Bugiardini's copy of the *Night* surrounded by strange caprices: nightcaps, pillows, and bats— poetic inventions all!

The mask of *Night* has a furrowed brow, like Michelangelo's *David*, reminding us that this expression is a conventional sign of the pensiveness and boldness of both the warrior and the poet. This is not necessarily to argue that the mask is a portrait but to claim that it is the artist's petrified persona, in the root sense of the word, which means mask. Michelangelo is forever assuming masks or personae. In his famous poem in response to one by Francesco Berni, for example, he assumes the persona of his facetious friend Sebastiano del Piombo, putting his own thoughts into the mouth of the latter. Part of the charm of this paradoxical poem resides in the fact that Michelangelo's facetiousness is appropriate to Sebastiano, who was well known for his

wisecracks, and is also, doubly, true to his own sense of fun. Michelangelo's poem has everything to do with personae, since he is also playing with that of Berni, who had helped create that of Michelangelo, seemingly lifted "to heaven a thousand times an hour." When Michelangelo, assuming the mask of Sebastiano, has the latter say that Michelangelo's marbles have inadequate life in them to render the glory of Berni's name, he is talking about rendering the persona of the poet who glorified his own persona in the first place.

If the word "persona" originally intended a mask, it also can mean the person himself. In Neoplatonic philosophy and in Christian theology much is made of the distinction between the outer appearance of the individual and the inner self or person. Michelangelo's mask is carved so carefully that when we look inside its eyes we find an inner shell, indicating it is hollowed out, empty. There is only a persona here, in the sense of a mask; the persona *is* the person. Although the mask is artificial and empty, it is paradoxically rendered with an astonishing vitality, seen in the furrowed brow and nuances of the fleshy face, that gives it the vivid quality of somebody alive, as alive as a real person. To use the language of Michelangelo's poem to Berni, written in the persona of Sebastiano, clearly Michelangelo's marbles do have adequate life in them, presenting the very mask or persona of Michelangelo as a living presence.

One further aspect of the mask of *Night*, already discussed above, has a bearing on its role as Michelangelo's persona. We have already observed that, whereas the statue of *Night* and the mask are highly polished, Michelangelo left unfinished or *non finito* the roughly worked stone directly above the mask. He shows the coarse stuffs emerging from this unfinished stone, descending to the more exquisitely formed face of the mask, of which the feathery beard is the peak of perfected finish. By showing the transition from the raw stone above to the increasingly refined forms of the mask, Michelangelo makes visible the stages in his own metamorphoses of stone, tracing the very origins of his own work. Forever the storyteller, Michelangelo uses his persona to tell the story of his mask's own making.

As a display of the virtuosity of Michelangelo's seemingly divine hand in metamorphosing stone, the mask is, then, a powerful indication of his presence in the work. Appearing at the lower right of the *Night*, the mask is almost an emblematic signature of the artist as a nearly toothless grotesque, like those monstrous faces seen on the

frieze of the wall behind it, like the grotesque persona of Michelangelo's self-deprecating comic poetry, in which he appears with a face "that causes fright," like the old *Faun* that, as he later pretended poetically, he carved for Lorenzo, in Lorenzo's garden, at the very beginning of his career—at that *original* moment in his career as sculptor. If the mask is a symbol of the art of deception, it is here, finally, the supreme sign of Michelangelo's artifice, of his *inganno*, of his persona—profoundly allusive, ambiguous, ludic, paradoxical, and poetic. Pygmalion and Medusa at once, Michelangelo not only made the dead stones come alive, teasing these mute stones into speech, he also had the power to petrify himself, thereby creating a seemingly eternal monument to his own glory, for he metamorphosed the various personae of his art into his own masks.

16

ELYSIAN FIELDS

When Michelangelo undertook his major works in San Lorenzo, the unrealized facade, the Medici Chapel, and the Library, he did so for the glory of the Medici. The magnificent marble facade of the Medici church, had it been realized, would have been a work of unprecedented splendor in Florence. The Medici Chapel is a grand mausoleum in honor of the Medici Dukes buried there, as well as of their namesakes, the Magnifici, Giuliano and Lorenzo. The Medici Library is similarly a display of great magnificence, above all the powerful staircase of the vestibule, a work of grand spectacle and petrified pomp. All in all, Michelangelo's projects at San Lorenzo, both realized and unrealized, are works in the service of the Medici, celebrations of their power and glory, of their place of supremacy in Florence after the ascendancy of the family to the papal seat, in the time of their ducal power. No church in Florence so fully represents the political power of a single family as does the church of San Lorenzo, and this glory is manifest thanks to the grandiose architectural forms and sculptures of Michelangelo.

As we have seen, however, in Florentine literature of the sixteenth century, it is the glory of Michelangelo's art at San Lorenzo, not the political meaning of this art, that is celebrated. Already Michelangelo alludes to his own aspiration to glory when he says in a letter of May 1517 that the facade of San Lorenzo will be a "mirror of all Italy," by which he means not just a mirror of political power for all princes but

a mirror of art. When Vasari writes about the work of Michelangelo at San Lorenzo, he discusses not its political meaning but the greatness of its creator. Assimilating the political and military significance of this work to the artist himself, Vasari speaks of Michelangelo as a liberator in art, who breaks the chains that bound the arts. The dialogue of Anton Francesco Doni's *I Marmi*, set in the Medici Chapel, is about the marvelous powers of Michelangelo to metamorphose stone into beings that seemingly come alive. When Anton Francesco Grazzini tells the tale in *Le Cene* of the craftsman Tasso, beating up a visiting abbot in San Lorenzo after the visitor had mocked Florentine art, including Michelangelo's art in the church, the emphasis is again on the art, not on its political meaning, although there is a strong current of nationalism in Tasso's spirited defense of Michelangelo. Grazzini's *novella*, Doni's poetic Ovidian dialogue, Vasari's biography of Michelangelo, all effectively metamorphose a building that is a seat of dynastic glory into the center of Michelangelo's artistic grandeur.

When Duke Cosimo de' Medici arranged for Michelangelo's funeral in San Lorenzo in 1564, he essentially exploited the power of Michelangelo's image, seeking to assimilate it to that of his family, in whose grandeur Michelangelo had fashioned himself in the first place by working for them. Michelangelo had served the Medici. Now, in a sense, the Medici served Michelangelo, celebrating him in order to glorify themselves and the state under their rule. We recognize here the "origins" of the shared glory of artist and patron. Just as Michelangelo had fabricated his own glory out of his works for the Medici, now the Medici fashioned their own magnificence out of that of Michelangelo's works made to their glory. In a symbiotic relationship, Michelangelo's art is central to the origins of the legend of Medici patronage in the same way that Medici power is the basis for Michelangelo's assertion of artistic greatness. We are reminded once again of Michelangelo's exploitation of the fable of his childhood in the household of Lorenzo il Magnifico after the latter discovered him in the garden, where he made his marvelous *Faun*. Now in the funeral of Michelangelo, where Lorenzo's reception of Michelangelo in the garden is depicted, the Medici appropriate this fable, using it to assert their own glory.

We find the interweaving of artistic, family, and state glory in Vasari's description of the decorations made for Michelangelo's funeral in San Lorenzo. In one painting for the catafalque, discussed by

Vasari, the image of the river Arno, personifying Florence, has a cornucopia full of flowers and fruits, signifying the very source of fruitfulness in the arts in Florence. These Florentine arts, Vasari adds, have filled the world with extraordinary beauty, most notably Rome. Whereas Florence was a new Rome, now it would appear that Rome itself, refashioned by Florentines, had its origins in Florence, most notably in Michelangelo, since he brought the glory of art with him from Florence to Rome. Michelangelo is instrumental in reversing the relations between Florence and Rome, just as he is in inverting those between himself and the Medici. Rome now basks in the glory of Florence, thanks to Michelangelo, just as the Medici shine in the reflected light of Michelangelo.

When Vasari, speaking of the flowers and fruits of the Arno, writes of the fruits of art that emerge in Florence, he is playing on the fact that Florence or *Fiorenza* is the city of flowers or *fiori*. He returns to this theme immediately below in his description of the funeral picture at San Lorenzo illustrating the scene of Lorenzo il Magnifico receiving Michelangelo in the garden. Vasari writes of the "first flowers and fruits" of Michelangelo's genius that resulted from his introduction to the Medici garden. Doing so, he unites the flowers and fruits of his art, cultivated by the Medici, to those of Florence, the very city of Flora, of flowers. In this extended metaphor of the city as a *paradiso* or garden, which includes the Medici garden, where Michelangelo will flower, the identities of the artist, the Medici, and the state are all united, illustrating and illuminating each other. The Medici garden epitomizes the city of flowers, and Michelangelo stands for the fruits cultivated by the Medici in their garden to the greater glory of the state. Once again Michelangelo participates in a *pastorale*, which traces his origins in art to a garden in a city which is itself a garden.

Just as Michelangelo's first moment in art has deep pastoral roots, so does his last moment. Vasari describes a large funeral painting in San Lorenzo near the altar, which portrays Michelangelo in the Elysian fields, surrounded by the greatest artists, ancient and modern—as if to suggest that Michelangelo is the greatest artist in the history of art. In this painting, the ancients, Praxiteles, Apelles, Zeuxis, and Parrhasios, on one hand, and the moderns, Cimabue, Giotto, Masaccio, Donatello, Brunelleschi, Pontormo, and Salviati, among others, all notably Florentines, on the other hand, receive Michelangelo, "full of love and wonder," Vasari says, just as the ancient poets re-

ceived Virgil, according to Dante, in Limbo. The inscription of the painting—"Tutti l'ammiran, tutti onor gli fanno"—echoes Dante's words describing the way in which all the philosophers there honor Aristotle. Michelangelo is thus honored, by analogy, as philosopher and poet. He is, to use Dante's language, celebrated by a *bella scuola* of artists in a meadow of fresh verdure—*un prato di fresca verdura*.

The pastoral image of Michelangelo fêted by the greatest artists of all times disingenuously evokes Raphael's *pastorale* of poetry, *Parnassus*, where all poets, ancient and modern, surround Apollo. Only here Michelangelo occupies the central place of honor. Like the poets of antiquity and the moderns, like Virgil, Horace, Dante, and Petrarch, Raphael situates the history of poetry directly in this sweet covenant with nature. Raphael's *Parnassus* suggests, as we have seen, that Raphael's own painting, his own *poesia*, places him in the very history of poetry that it illustrates. In like fashion, the Parnassian painting of Michelangelo in the Elysian fields places the artist at the summit of the steady eurythmic activity of painting and sculpture. In the compounded teleologies of politics, genealogy, and art, which trace the illustrious ascendancy of Florence as a new Athens or a new Rome, the rise of the Medici, who rule the city, and the elevation of Michelangelo, personification of both civic distinction and Medicean grandeur, its power and glory, the artist's life takes its place at the very pinnacle of history. Biography and history fuse in this funeral painting, as they did in the *pastorali* of Botticelli, Signorelli, Titian, and Raphael, in which the poet-painters implicitly define themselves and their lives by tracing their origins to the ancient poets.

If Michelangelo began his life in art in a garden, he now returns, in afterlife, to an unparagoned pleasance, honored for eternity in a sort of classical Eden. The image of this garden participates in the Elysian fields of Dante's Limbo, which is the *fons et origo* of all subsequent garden imagery in the *Commedia*, the meadow where Dante beheld Leah gathering flowers, the sacred wood of Matilda, the "cloud of flowers" in which Beatrice appears, and, finally, and perfectly, the rose of Paradise.

With the funeral image of Michelangelo in a Dantesque meadow of flowers we describe the circle, for we recall that when Michelangelo carved the *Active Life*, conceiving her as the Leah of Dante's dream, he metamorphosed her into his ancestor, the Countess Matilda, beheld by Dante in a similar floriferous setting. As Michelangelo had

traced his origins back through Dante to the greenworld that prefig-
ured salvation, now, on the occasion of his death, the Florentines
represented him, again invoking Dante, as returning to such a
greenworld—the pastoral realm of the Elysian fields that typified the
origins of his art in nature, as they stood for the beginnings in nature
of all poetry and all art, the mysteries of beauty.

BIBLIOGRAPHICAL ESSAY

In addition to what follows, the reader will find an extensive Michelangelo bibliography in *Michelangelo's Nose*, which puts emphasis on the scholarly sources most important to my own work, and a brief Vasari bibliography in *Why Mona Lisa Smiles*, which lists several notable works that focus on Vasari's literary accomplishment.

There are various editions of Vasari's *Lives* available, including that of Milanesi. I have used the 1550 edition of Luciano Bellosi and Aldo Rossi (1986) and the 1568 edition of Paola della Pergola, Luigi Grassi, and Giovanni Previtali (1967). The standard complete translation of the *Lives* remains that of Gaston Du C. de Vere (reprinted in 1979). For the letter of October 1564 probably sent from an anonymous correspondent to Vasari, including the fables of Michelangelo's *Pietà* and *Moses*, see Karl and Hermann W. Frey's edition of Vasari's correspondence (1930).

I have used Enzo Noè Girardi's edition of Michelangelo's letters (1976), of which the introductory essay is especially valuable, pointing toward a fuller reading of these letters from a literary standpoint. The standard English translation of the letters is that of E. H. Ramsden (1963), useful for its detailed notes and appendices. The principal edition of Michelangelo's poetry is that of Enzo Noè Girardi (1960). Girardi's chronology is followed by James M. Saslow in his edition (1991), which gives the original Italian and serviceable English translations. For a recent translation of Michelangelo's poetry that is beauti-

fully attuned to the nuances and complexities of Michelangelo's diffi-
cult style, see the edition of Sidney Alexander (1992). The latter
volume is valuable because it presents as a group the corpus of poems
Michelangelo planned to publish in his own lifetime. More future
work might well be done on the shape and aesthetics of this projected
edition, abandoned at the death of the editor, Luigi del Riccio. In this
context, Ernst Steinmann's book on Michelangelo and his age (1930)
still remains an important work.

For the biography of Michelangelo by Condivi, see Emma Spina
Barelli's edition (1964), which is richly annotated. There are several
translations of Condivi, the most recent being that of George Bull in
Michelangelo: Life, Letters, and Poetry (1987). Not to be forgotten,
however, is the now-rare translation of Herbert Horne (1904), which is
the most fluent rendering of Condivi's text in English. Although schol-
ars of Michelangelo use Condivi's text extensively, they rarely focus
their attention on it. An exceptional case, however, is Johannes Wilde's
suggestive lecture on Condivi in his published lectures (1978).

All bibliographies necessarily have their limits, and this is certainly
true of that on autobiography. In the vast scholarship on this topic,
which includes the widely cited work of James Olney (1972) and Roy
Pascal (1960), Michelangelo's autobiography has been virtually over-
looked, even though it stands significantly in the line of descent from
Dante, who virtually invented the autobiography of the modern poet
or artist. John Freccero's writings on Dante's self-consciousness as a
poet (1986) are a valuable guide to the understanding of Michelangelo's
own self-consciousness, as are the commentaries in the translation of
the *Commedia* by John D. Sinclair, which has been often reprinted.

On the subject of Renaissance self-consciousness, Ernst Cassirer's
book on Renaissance philosophy, first published in 1927, remains the
locus classicus. This work is supplemented by Charles Trinkaus's book
on Petrarch (1979). See also the edition of Petrarch's *rime sparse* by
Robert Durling (1976) for the valuable introductory essay and notes
on Petrarch's self-consciousness. Of related interest, David Quint's
study of "origin and originality" (1983) points toward a fuller account
of the myths of poetic origins in Renaissance culture.

The Renaissance texts alluded to or quoted in the text are available
in various editions. I have used Grazzini's *Le Cene* in the edition of
Riccardo Bruscagli (1976) and Sacchetti's tales in the edition of Emilio
Faccioli (1970). The story of the Fat Carpenter and also the fable of

Geta and Birria are both available in *Novelle del Quattrocento*, edited by Aldo Borlenghi (1962). I have used Ezio Chiorboli's edition of Doni's *I Marmi* and Emilio Bigi's edition of Lorenzo de' Medici's poetry (1965), in which the reader can find the poem *Ambra*. My allusions to Machiavelli are indebted to Sebastian de Grazia's remarkable study of the author (1989).

The discussion of Renaissance pastoralism above is dependent on Renato Poggioli's suggestive book (1975). In this regard, Ernst Kris and Otto Kurz's book on the legends of the artists (first published in 1934) has an important discussion of the stories about the origins of artists in nature. The pastoral character of Renaissance painting has been discussed by A. Richard Turner (1966). I have found especially fruitful his observation that in the *Fête Champêtre* the courtly musician is the figure of the poet. Erwin Panofsky's classic essay on Piero di Cosimo in *Studies in Iconology* (1962) is an important basis for my consideration of the pastoralism of the painter's work, although I revise Panofsky's understanding of the relations between this work and the painter's biography. For the myth of Prometheus illustrated by Piero, see Olga Raggio's essay (1958). The pastoral theme is abundantly illustrated in Claudia Lazzaro's recent book on Italian Renaissance gardens (1990), where the Boboli grotto with Michelangelo's *Prisoners* is discussed.

A number of recent discussions of Michelangelo have had a bearing on my work. Notably, I should cite again David Summer's major study (1981), particularly his treatment of poetic fantasy and inventiveness. John Paoletti's essay on Michelangelo's masks (1992) has both raised important questions and reintroduced into discussion a lost drawing by Michelangelo (known from copies), which has a particular bearing on Michelangelo's self-consciousness. John Gere has also brought back into consideration another lost drawing by Michelangelo, also known from a copy, which is that of the Count of Canossa; see his *Drawings of Michelangelo* (1975). William Wallace's recent essay on Michelangelo's design for the *Noli Me Tangere* (1988) focuses our attention on Michelangelo's inventive powers. The same author's essay on Michelangelo in *The Genius of the Sculptor in Michelangelo's Work* (1992) is the best overall assessment of the problem of Michelangelo's origins as sculptor. In the same volume, Kathleen Weil-Garris Brandt discusses classical stories that may have a bearing on Michelangelo's story of his *Faun*: Pliny's account of a

Silenus found in a block of stone and Cicero's related story of a Pan discovered in another block. She also introduces into the discussion of the *Faun* Pliny's account of Polygnotis's rendering of open mouths revealing teeth. It is possible that Michelangelo's fable of his own related *Faun*, which he claims to have invented in the Medici garden, is related to this classical tradition.

Choosing to ignore the possibility that Michelangelo's account of the *Faun* is a fable, Weil-Garris Brandt is representative of a large number of scholars who still accept Vasari and Condivi's writings at face value. For another example of such exquisite literal-mindedness, see James David Draper's discussion of Vasari and Condivi in his book on Bertoldo in the Medici household (1992). Alternatively, a number of recent scholars, following the earlier example of Walter Pater, have explored the highly rhetorical or fictive structures of Vasari's biographies and Condivi's biography of Michelangelo, notably Patricia Rubin (1990), Catherine Soussloff (1990), David Cast (1992), and Carl Goldstein (1992), all of whose writings, explicitly or implicitly, raise questions about the use of Renaissance biographies as sources of information. This body of writings can be related to the recent essay of James Hankins (1991), which explodes the myth of a Platonic Academy in fifteenth-century Florence. What is needed in the wake of this conflict between the radical literalists and the more skeptical students of rhetoric is a thorough reconsideration of the question of how we read those texts that are called "documents." Whereas the word "document," in its original sense, intended an "example" or "lesson," it has now come to mean a source of information. The question remains: What kind of information is found in a document?

It should by now be clear in the light of recent scholarship that the story of Michelangelo's life and art needs to be rewritten. When we look back to Howard Hibbard's monograph (1974), an excellent, if conventional, view of the artist, we find that it depends on a literal reading of Vasari and Condivi, which accepts many manifest fictions as if they were in fact true. Even though we are now relatively more aware of the fictional character of the biographies of Michelangelo, we still underestimate the effect of such fiction on current scholarship. Take, for example, the story of Michelangelo's origins as architect. Vasari announces Michelangelo's entry into the field with his victory in a competition for the design of the facade of San Lorenzo, in which his adversaries were Antonio da San Gallo, Andrea and Iacopo

Sansovino, Raphael, and Baccio d'Agnolo. Did a formal "competition" really take place, as modern scholars have supposed, or is this not a misreading of Vasari's rhetorical account, which magnifies Michelangelo's victory over all rivals and which we, his compliant readers, *ingannati*, swallow whole? The story, so often repeated in the modern literature, ignores or, we might say, conceals Michelangelo's origins in architecture. Consequently, in the scholarship, little is said about Michelangelo's sources, beyond a passing allusion to his uses of Giuliano da San Gallo's design for the facade of the church.

A close examination of Michelangelo's architecture, however, would show that he depended far more than has ever been observed on the poetic fantasy of Giuliano, whose Gondi Chapel in Santa Maria Novella is an important source for Michelangelo's Chapel of Leo X, whose sacristy in Santo Spirito is a major source for Michelangelo's Medici Chapel, and whose courtyards of the palace of Bartolommeo della Scala and Palazzo Gondi are filled with highly plastic, poetic inventions that foretell Michelangelo's designs for both the Medici Chapel and the library in San Lorenzo. Moreover, a close analysis of Michelangelo's design for the facade of the church shows its deep connections with the Arch of Constantine, Alberti's facade of Santa Maria Novella, and Bramante's architecture in Rome, and it is not unlikely that, although Michelangelo is said to have disparaged the work of Baccio d' Agnolo, his own architecture owes more than a little to the latter's designs. But by short-circuiting the story of Michelangelo's origins as architect, by disguising them in the account of Michelangelo's victory or advent, Vasari has encouraged art historians to ignore Michelangelo's sources. In other words, Vasari's rhetoric remains that of modern scholars, who even embellish it. Not only do we underestimate Vasari's rhetoric, but we also underestimate its role in shaping the way in which we look or *do not look* at Michelangelo's art! As Martin Kemp recently observed (1992), art historians "cannot ultimately escape the charge" that they are the "practitioners of a peculiar variety of historical fiction." As a wag once remarked, "*All* art history aspires to the condition of fiction."

This is not to say that we should abandon our goal of reconstructing the historical past, however imperfect our efforts. But we do need to acknowledge the unsuspected fictions that lurk in our accounts. One of the principal fictions in our current writing of Italian Renaissance art history remains in our acceptance of many of the fables of Vasari and Michelangelo as literal truth. When we begin to see that these

fables are poetic or rhetorical renderings of events, either of Michelangelo's invention or of Vasari's in response to Michelangelo's works, we come to see that the biography of Michelangelo is even richer and more complex than we had previously supposed. These fictions do not merely circumscribe or give definition to Michelangelo's life-story, they are central events in it!

SELECTED BIBLIOGRAPHY

Buonarroti, Michelangelo. *Rime*, ed. Enzo Noè Girardi. Bari, 1960.

Cassirer, Ernst. *The Individual and the Cosmos in Renaissance Philosophy*, trans. Mario Domandi. New York and Evanston, 1964.

Cast, David. "Finishing the Sistine." *Art Bulletin* 73 (1991): 669–84.

The Complete Poetry of Michelangelo, trans. Sidney Alexander. Athens, Ohio, 1992.

Condivi, Ascanio. *The Life of Michelangelo Buonarroti*, trans. Herbert Horne. Boston, 1904.

———. *Vita di Michelangelo Buonarroti*, ed. Emma Spina Barelli. Milan, 1964.

Dante Alighieri. *Inferno*, trans. John D. Sinclair. New York, 1974.

———. *Purgatorio*, trans. John D. Sinclair. New York, 1975.

———. *Paradiso*, trans. John D. Sinclair. New York, 1975.

de Grazia, Sebastian. *Machiavelli in Hell*. Princeton, 1989.

Doni, Anton Francesco. *I Marmi*, ed. Ezio Chiorboli. 2 vols. Bari, 1928.

Draper, James David. *Bertoldo di Giovanni, Sculptor of the Medici Household: Critical Reappraisal and Catalogue Raisonné*. Columbia, Missouri, 1992.

Drawings by Michelangelo, intro. by John A. Gere. London, 1975.

Freccero, John. *Dante: The Poetry of Conversion*. Cambridge, Mass., and London, 1986.

The Genius of the Sculptor in Michelangelo's Work. Montreal, 1992.

Goldstein, Carl. "Rhetoric and Art History in the Renaissance and Baroque." *Art Bulletin* 73 (1992): 641–52.

Grazzini, Antonfrancesco (Il Lasca). *Le Cene*, ed. Riccardo Bruscagli. Rome, 1976.

Hankins, James. "The Myth of the Platonic Academy." *Renaissance Quarterly* 44 (1991): 429–75.

Hibbard, Howard. *Michelangelo*. New York, 1974.

Kemp, Martin. "Lust for Life: Thoughts on the Reconstruction of Artists' Lives in Fact and Fiction." In XXVIIe *Congrès International Histoire de l'Art*. Strasbourg, 1992.

Lazzaro, Claudia. *The Renaissance Garden*. New Haven and London, 1990.

The Letters of Michelangelo, ed. and trans. E. H. Ramsden. 2 vols. Stanford and London, 1963.

Lieberman, Ralph. *"The Battle of the Centaurs, The Madonna of the Steps*, and the Emergence of the Michelangelesque." Unpublished talk.

Medici, Lorenzo de'. *Scritti Scelti*, ed. Emilio Bigi. Turin, 1965.

Michelangelo. *Lettere*, ed. Enzo Noè Girardi. Arezzo, 1976.

Michelangelo: Life, Letters, and Poetry, trans. George Bull and Peter Porter. Oxford, 1987.

Novelle del Quattrocento, ed. Aldo Borlenghi. Milan, 1962.

Olney, James. *Metaphors of Self: The Meaning of Autobiography.* Princeton, 1972.

Panofsky, Erwin. *Studies in Iconology: Humanistic Themes in the Art of the Renaissance.* New York and Evanston, 1962.

Paoletti, John. "Michelangelo's Masks." *Art Bulletin* 72 (1992): 423–40.

Pascal, Roy. *Design and Truth in Autobiography.* Cambridge, Mass., 1960.

Petrarch's Lyric Poems: The Rime sparse and Other Lyrics, trans. and ed. Robert M. Durling. Cambridge, Mass., and London, 1976.

The Poetry of Michelangelo, trans. James M. Saslow. New Haven and London, 1991.

Poggioli, Renato. *The Oaten Flute: Essays on the Pastoral Ideal.* Cambridge, Mass., and London, 1975.

Quint, David. *Origin and Originality in Renaissance Literature: Versions of the Source.* New Haven and London, 1983.

Raggio, Olga. "The Myth of Prometheus." *Journal of the Warburg and Courtauld Institutes* 21 (1958): 44–62.

Rubin, Patricia. "What Men Saw: Vasari's Life of Leonardo da Vinci and the Image of the Renaissance Artist." *Art History* 13 (1990): 34–46.

Sacchetti, Franco. *Il Trecentonovelle*, ed. Emilio Faccioli. Turin, 1970.

Soussloff, Catherine M. "Lives of Poets and Painters in the Renaissance." *Word and Image* 6 (1990): 154–62.

Steinmann, Ernst. *Michelangelo im Spiegel seiner Zeit.* Leipzig, 1930.

Summers, David. *Michelangelo and the Language of Art.* Princeton, 1981.

Trinkaus, Charles. *The Poet as Philosopher: Petrarch and the Formation of Renaissance Consciousness.* New Haven and London, 1979.

Turner, A. Richard. *The Vision of Landscape in Renaissance Italy.* Princeton, 1966.

Vasari, Giorgio. *Der literarische Nachlass Giorgio Vasari*, ed. Karl and Hermann W. Frey. Vol. 2. Munich, 1930.

———. *Lives of the Most Eminent Painters, Sculptors, and Architects*, trans. Gaston Du C. de Vere. New York, 1979.

———. *Le vite de' più eccellenti architetti pittori et scultori italiani da Cimabue insino a' tempi nostri*, ed. Luciano Bellosi and Aldo Rossi. Turin, 1986.

———. *Le vite de' più eccellenti pittori scultori e architettori*, ed. Paola della Pergola, Luigi Grassi, and Giovanni Previtali. 9 vols. Novara, 1967.

Wallace, William. "Il 'Noli me Tangere' di Michelangelo: Tra sacro e profano." *Arte Cristiana* 76 (1988): 443–50.

Wilde, Johannes. *Michelangelo: Six Lectures.* Oxford, 1978.

INDEX